The Road to
MARYLAKE

KELLY MATHEWS

THE
History
PRESS

Published by The History Press
Charleston, SC
www.historypress.net

Cover images courtesy of Marylake Archives.

First published 2017

Manufactured in the United States

ISBN 9781467138871

Library of Congress Control Number: 2017948447

*To the many who have walked the road to Marylake
and the many more who may one day have the fortune to do so.*

*This book was completed in Aurora, Ontario—"Canada's Birthday Town"—on
Saturday July 1, 2017, on the 150th anniversary of Canadian Confederation.*

CONTENTS

CONTENTS

FOREWORD

This is holy ground.

If you've ever been to Marylake, you've been on holy ground! In this book, *The Road to Marylake*, Kelly Mathews gives a clear and convincing account of how and why we are talking about Marylake as holy ground. From the natural beauty of God's pristine creation to the time of Sir Henry Mill Pellatt, the short stay of the Basilians and the past seventy-five years of the Augustinians (first the German Province, then the Canadian Province and now under the jurisdiction of the Chicago Province), the grounds around Lake Marie have become Mary's Lake or simply Marylake.

The shrine, under the patronage of Mary, Our Lady of Grace, has been the center of Marian devotion for the Greater Toronto Area and of spiritual refreshment for generations of pilgrims and retreatants, as well as the home of the Augustinians in Canada for the past seventy-five years.

While the farming done mostly by the brothers has ceased and the number of friars has dramatically decreased, the Augustinians remain committed to carrying on with this spiritual endeavor: masses, confessions, retreats, pilgrimages, as well as the Sacred Heart Parish, the relatively new Villanova College and soon the largest rosary path in the world—all on these hallowed eight hundred acres of Marylake. It is truly an Augustinian Centre that we need to continue, and with the help of a lay board and executive director, as well as Augustinian friars from around the world, we intend to do just that.

It is a great pleasure for me to introduce this book to you and to encourage you to visit and support Marylake now and in the future. I am grateful to Kelly for her diligent research and fine presentation of Marylake's rich history. Holy ground indeed!

Sincerely in Christ and St. Augustine,
VERY REVEREND BERNARD C. SCIANNA, OSA, PhD
Prior Provincial of the Augustinians of
Midwest United Statesand Canada

Fr. Bernie

Acknowledgements

\mathcal{A}mong the sea of people to thank, I can't thank enough Joseph Gennaro, executive director at Marylake Monastery and Shrine. Over the course of the research process, Joe has become a good friend. Thank you for always being so welcoming and for answering what I'm sure must have felt like an endless barrage of questions and e-mails. I feel that Marylake is in good hands with Joe leading its administration.

Some of the moments that have brought me the most joy through this process were in the early days when I was on my own in the basement of the monastery in the Marylake Archives and Library. I appreciate the trust that was placed in me while reviewing documents and digging through boxes upon boxes of material on my own—information that was utilized in creating an accurate picture of the history at Marylake. Joe, thank you for your willingness to share and open up the archives and library at Marylake without restriction; thank you for your kindness and your smile. I would also like to thank the Sisters of Good Counsel at Marylake for the lovely lunches I enjoyed while working there and Father Paul for the lovely lunchtime conversations—everyone always made me feel so welcome, and there in itself lies the beauty of Marylake. It has a special way of making everyone feel at home.

To Father Bernie, I can't thank you enough for agreeing to write the foreword for this book. From the onset, I was convinced that the voice at the start needed to be a spiritual one. I am thrilled that this land history document was able to capture a part of the Augustinians' history in Canada,

and I hope this book is seen as a celebration of the seventy-five years of the Augustinians at Marylake.

I would like to recognize the support of Michelle Sawyers, MLIS, congregational archivist at the General Archives of the Basilian Fathers (GABF). Michelle was always quick to reply to e-mails, scan and share content. Michelle stands out as someone who really cares about others' research. Her professionalism and kindness were always appreciated. She also makes excellent reading recommendations!

It goes without saying that a book like this would not be feasible were it not for archival institutions such as the Archives of the Roman Catholic Archdiocese of Toronto, the City of Toronto Archives, the Ontario Archives, the King Township Archives, the Marylake Archives, the General Archives of the Basilian Fathers and so on, as well as the many newspaper archives that were utilized to weave this history together. It is entirely due to the letters, images and articles housed in these facilities that this book was possible, and I am indebted to the work they do in preserving these resources and, more importantly, in their willingness to share them—thank you.

To my parents, Darlene and Dale Mathews, thank you so much for going through this process with me again and for your help with the title of the book—we all knew when we finally got it right! Thank you for listening to me read chapters over and over and for providing your gentle feedback. To my twin sister, Kimberly Heaton, thank you for the many rounds of editing and your time. To my closest friends, thank you for knowing when to pull me away from my computer and when to leave me be. To my co-workers, the ones who asked how things were going, thank you; it meant a lot to me.

The following people and sources have been an absolute treasure and I can't thank you enough:

Marylake Archives
King Township Archives
General Archives of the Basilian Fathers
Archives of the Roman Catholic Archdiocese of Toronto
Archives of Ontario
City of Toronto Archives
Canadian Catholic Historical Association
York Region Branch Ontario Genealogical Society
The Catholic Canadian Register
Newmarket Era Archives

The Royal Architects Institute of Canada Journal
Toronto Daily News Archives
Toronto Star Weekly Archives
St. Michael's College Archives
Casa Loma Archives
Queen's Own Rifles of Canada Archives
King Township Historical Society
King Township Heritage Advisory Committee
King Township Museum and Cultural Centre
King Township Public Library
King Ridge Women's Institute, Tweedsmuir Histories
The Online Biographical Dictionary of Architects in Canada
The Online Dictionary of Canadian Biography
Oak Ridges Trail Association—Trail Talk Archived Issues
Father Paul Koscielniak, OSA, Marylake
Reverend Michael B. Martell, OSA, pastor, Sacred Heart Church, King City
Kevin Bellefontaine, Eyedeas Designs
Mark and Christine Smith, Chrismar Mapping Services Inc.
Kimberly Heaton, Workpress: Professional Editing Services
Trelawny Howell, great-grand-niece of Sir Henry Mill Pellatt
Debbie Schaefer, councillor King Township Ward 5
Brad Peacock, Seneca College plumber and HVAC technician and fellow
 land history enthusiast
Linda Stapleton, Seneca College Sport and Recreation director
Sharon Bentley, librarian, King Township
Patricia Treble, journalist
Lousie Di Iorio, King Township Archives
Elsa-Ann Pickard, King Township Archives
Kathleen Fry, curator and manager, King Museum
Peter Iaboni, chairman of the King Township Historical Society
Robert Shirlow, collector
Carol Field, King Township resident
Ed Millar, King Township resident
Bob Sillcox, King Township resident
Paige Sillcox, King Township resident
Beverley Flanagan, King Township resident
Winnifred Rosaline Smith
Tammie Buckler
Adam Ferrell, director, Arcadia Publishing and The History Press

INTRODUCTION

The Road to Marylake is a nonfiction land history document that examines the evolution of an estate property in King City, Ontario, from its original patents to today (2017). Known from 1910 to 1935 as Lake Marie Farm and Estate, this property was once the sprawling country retreat of the famous Canadian financier, philanthropist, royalist and military officer Major General Sir Henry Mill Pellatt, famous for his imposing castle in Toronto, Casa Loma. Lake Marie is now home to the Marylake Augustinian Monastery and Shrine. Without question, had it not been for Sir Henry's vision, passion and sense of grandeur, there would be no Marylake as we know it today.

At the beginning of this story we find Sir Henry Mill Pellatt, responsible for amassing many individual parcels of land to create his rural farm and estate, which he named Lake Marie after his first wife, Lady Mary Pellatt (née Dodgson). At the turn of the twentieth century, the landed gentry in Canada were still expected to hold a country seat. And while most Ontarians and Canadians know of Pellatt and his famed Casa Loma, his role in bringing hydroelectricity to Toronto and his service with the Queen's Own Rifles of Canada, a great majority do not know that at the same time that he was piecing together his castle, literally stone by stone, in Toronto (between 1910 and 1914), he was also starting to piece together Lake Marie.

What was built as a place for weekend retreats, hunt events and summer socials for Sir Henry Mill Pellatt and his first wife, Lady Mary, became a more oft-used residence in 1923 when circumstances forced them to vacate

Casa Loma (more to be discussed on this in the first chapter). Although the original 1,214-acre Lake Marie Estate has since been sold off to four different entities, the majority of the original Pellatt land in King remains the home of the Marylake Augustinian Monastery and Shrine, which is owned and operated by the Augustinian Fathers (Ontario) Inc. and has been so since 1942. Under the leadership of the Basilians, the property was once managed by a group of Catholic leaders, laymen and clergy who created the Marylake Agricultural School and Farm Settlement Association, which they operated between 1935 and 1942.

With each successive master came a different purpose. Over the past 107 years, this land has not only indulged the social appetite of one the wealthiest and most ambitious men in the Dominion of Canada, but it has also played a role in early Catholic social action as a venue for the back-to-the-land settlement scheme—a program that developed out of necessity as a result of the Depression. Once a place of respite for the rich, Lake Marie transitioned into a land of opportunity during the Basilian occupation for the disproportionately large number of Catholic families suffering from the grips of the Depression in Toronto, to later become a place of worship, respite, reflection and pilgrimage under the current leadership of the Augustinians, who have been in residence for the past 75 years. Until 1998, one thing that remained constant over the successive periods of ownership was farming and agriculture. And while the land may not provide so much for the belly today, it continues to feed and fuel and soul.

The aim of this book is to weave together the many characters and circumstances that helped build, shape and transform this land and its use. This is not a book about the life of Sir Henry Mill Pellatt, nor is it about Catholic social action or the back-to-the-land movement; however, as the land changed hands over the course of the past century, it is important to have some understanding of these people and themes, as they reflect the times and perhaps provided the impetus for each successive change of ownership. If this history had three main characters, they would be summarized as Sir Henry Mill Pellatt, the Basilians and the Augustinians, each of whom equally transformed this land to meet the vastly different requirements of its tenants.

This book examines the property in the following subsections: Pre-Pellatt Occupation (prior to 1910), Pellatt Occupation (1910–35), Basilian Occupation (1935–42) and Augustinian Occupation (1942–today). The year 2017 represents the seventy-fifth anniversary of Augustinian ownership.

Specifically, this book will focus on the original Lake Marie Estate, which consisted of land in both Concession III and Concession IV in King Township. The following Marylake Heritage Maps are meant to provide the reader with a few perspectives. First, it provides the geographic boundaries for the entire estate at its peak, which included 1,214 acres of land, including in the main parcel in Concession IV: Lot 11, 12, 13, 14, as well as 14 acres in Lot 15; and in Concession III: the West ½ Lot 12, Lot 13 and all of Lot 11. The map shows the buildings, features, additions and boundary changes that occurred during each residency.

Many forget that Pellatt once owned four hundred acres of the former Eaton family estate in King City in the adjacent Concession III property to the east. Divided by the Fourth Concession in King (present-day Keele Street), Lake Marie as an estate originally spread across two concession blocks and was encapsulated by a cement post fence approximately 7.5 miles/12 kilometers long, remnants of which exist today.

For those who read my first book, *Eaton Hall: Pride of King Township*—a land history book on the adjacent Eaton country estate—it helps to provide the context that Sir Henry Mill Pellatt began piecing together Lake Marie in 1910, which was ten years before Sir John Craig and his wife, Lady Flora McCrae Eaton, purchased their first parcel of land in King City and thirty years before Lady Eaton moved into Eaton Hall. It wasn't until January 1922, two months before Lady Eaton's husband passed away, that Sir Henry Mill Pellatt sold off 400 acres of his Lake Marie Estate in the Third Concession to the Eatons, who were, at that time, just beginning to put together their country residence, Eaton Hall Farm and Estate. This sale reduced the Pellatt country estate to 814 acres and encapsulated it entirely within the confines of Concession IV.

It is important to note that the original 1,214-acre Lake Marie Estate, once owned entirely by Pellatt, is today owned by four distinct entities: Augustinian Fathers (Ontario) Inc. (581 acres, since 1942), Seneca College King Campus/formerly Lady Eaton (400 acres, since 1971), the Archdiocese of Toronto (200 acres, since 1942) and St. Thomas Villanova Catholic School Foundation (33 acres, since 1999). The portion of Marylake today owned by the Augustinians is a 581-acre property—less than half its original size—and includes a private lake, Mary Lake, once Lake Marie. However, many still consider Marylake to be 814 acres, which includes the land owned by Villanova College and the Archdiocese of Toronto. The 200 acres owned by the Archdiocese of Toronto have been rented by the Augustinian Fathers (Ontario) Inc. since 1942.

The history of Marylake is incredibly fascinating and has captivated locals and visitors to King Township for over a century. The land and buildings have all experienced change, but the meandering kilometer-long road to Marylake has remained the same. When Pellatt's guests arrived at the estate, they would have found themselves going under a beautiful stone entrance gate built with stones quarried from the estate lands, in the same Scottish and French Baronial style as seen at his palatial Casa Loma. Instantly, you would be set upon the feudal gatehouse, both of which are now designated with King Township (Bylaw 84-107). Since then, hundreds of thousands more have walked the road to Marylake in search of a higher spiritual purpose. From the time of the Augustinian purchase seventy-five years ago, it has been a retreat and pilgrimage destination for those looking for a respite from the trials and noise of everyday life. Regardless of the owner or occupants, Marylake has always provided a sense of peace for those who have happened upon it.

A reminder to those who come to this book that there are many limitations placed on an author such as word allowance, number of pages, number of images and so on. The presentation of history for this book, not dissimilar from *Eaton Hall: Pride of King Township*, is a collection of primary resources on a particular landmark that when woven together paint an accurate picture of what happened on this land, by whom, when and why. The hope is to merge these primary sources into somewhat of an eloquent story. However, this story is not fiction. I can warrant that every effort has been made on my part to only share information that is factual and have done my utmost to ensure that it is clear when the information is conjecture.

This book and the research for it have been such a big part of my life over the past year. However, it goes without saying that there is no way that this book has told the entire history of Marylake. Marylake, as I have come to realize, means so many things to so many people—many with a deep connection to the property. My hope is that this book will be seen as a celebration of Marylake, a piece of property in King Township with a rich and vibrant history.

As for the timing for the release of this book, I had three celebrations in mind when I started my research: first, release the book to coincide with the 150th anniversary of Canadian Confederation (1867–2017); second, to release the book to coincide with the 220 years since the first land patent was awarded in King Township (1797–2017); finally, and most importantly, to coincide with the 75th anniversary year of the Augustinians at Marylake

(1942–2017). I hope that the Augustinians will see this book as a celebration of their 75-year stewardship of Marylake.

I hope you enjoy reading *The Road to Marylake*, and I hope you have the opportunity to walk the grounds and experience its history firsthand.

Note: The titles Lake Marie, Lake Marie Farm, Lake Marie Estate, Lake Marie Farm and Estate, Mary Lake and Marylake (and any derivative thereof) are used interchangeably throughout the document depending on the period and ownership. Regardless of the moniker, to be clear, this text is referring to the same property.

Referencing the Pellatts: Sir Henry Mill Pellatt will be shortened to either Henry Jr., Sir Henry or Pellatt. His father will be addressed as Henry Pellatt Sr. or Henry Sr., and his first wife as Lady Mary Pellatt or Lady Mary.

Marylake Heritage Map - Part A

FEATURES LIST BY BUTTON (* = no longer there)
Pre-Pellatt Occupation, Pre-1910 (bold font) Pellatt Occupation, 1910-1935 (regular font)
Basilian Occupation, 1935-1942 (no new builds) *Augustinian Occupation, 1942-2017 (italicized font)*

FEATURES LEGEND (For Maps Part A and B)
1. Entrance Gate
2. Gatehouse
3. *Villanova College*
4. Saw Mill*
5. Implement Shed*
6. *Pellatt Spur Line**
7. *Chapel of Grace*
8. *St. Thomas Cottage**
9. *Our Lady of Grace Shrine & Monastery*
10. Pellatt's Lakeside Cabana/*Seasonal**
11. **Pioneer Log Cabin**
12. **Staff Cottage**
13. Pellatt Bungalow/*Original Monastery**
14. Pellatt Barn/*St. Joseph Hall**
15. Pellatt Garage/*St. Joseph Hall**
16. Home Cattle Barn
17. Hen House/*Workshop*
18. Small Poultry Houses*
19. Home Barn & Granary
20. Dairy/*Blessed Frederick Hall/Convent*
21. Green House*
22. Staff Cottage*
23. Farm Managers Residence/Boarding House/*Father Clement Hall/Retreat Centre*
24. **East Turkey Barn**
25. Gravel Pit*
26. North East Farm House & Barn
27. *Novices Log Cabin*
28. Deer & Elk Park/*Enclosure**
29. Pump House
30. *Former Apiary*
31. *Storage Silo*
32. **North West Farm House & Barn**
33. Mount St. Francis Colony*
34. West Farm House & Barns*
35. West Farm Complex*
36. Large Red Horse Barn
37. **Schomberg and Aurora Railway**
38. **Eversley Train Station**
39. **Hamlet of Eversley**

PROPERTY FEATURES
A. *Lakeside Gazebo*
B. *Lady of Grace Fountain*
C. *The Great Crucifix*
D. *Monument to St. John the Baptist*
E. *Sepulchre (Jesus's Tomb)*
F. *Outdoor Stage I*
G. *Outdoor Stage II*
H. *Outdoor Stage III*
I. *Marian Grotto*
J. *Marian Shrine**
K. *Public Washrooms*
L. *The Rosary Path*
M. *Oak Ridges Moraine Trail*

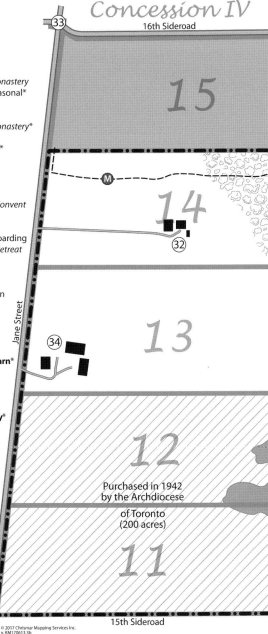

Concession IV

16th Sideroad

15

33

M

14

32

Jane Street

34

13

12

Purchased in 1942
by the Archdiocese
of Toronto
(200 acres)

11

15th Sideroad

© 2017 Chrismar Mapping Services Inc.
v. KM170613.3b

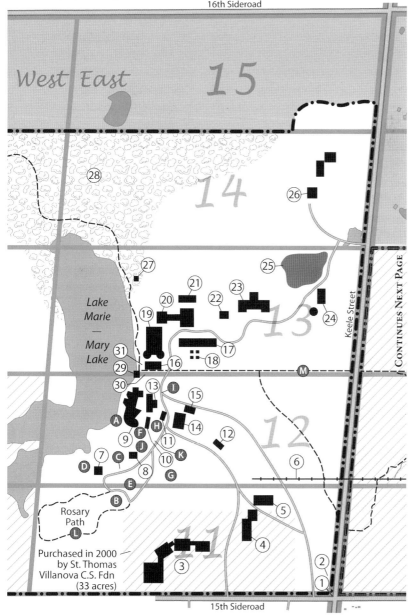

MAP LEGEND

(12) Features (See List)

(A) Property Features (See List)

■ Marylake-Related Buildings - 1910 to present-day

Forest

- - - - Trail

•—•— Property Boundary

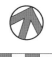

200 metres

Concession IV

16th Sideroad

West East

15

14

(28)

(26)

(27)

(25)

Lake Marie — Mary Lake

(21)
(20) (22) (23)
(19) *13* (24)
(31) (17)
(29) (16) (18)
(30) (13) (I) (15)
(A) (H) (14)
(F) (9) (J) (11)
(7) (C) (K)
(D) (8) (10)
(E) (G)

(12)

12

(M)

Keele Street

CONTINUES NEXT PAGE

(6)

(5)

(4)

(3) *11*

(2)

(1)

Rosary Path (L)

Purchased in 2000 by St. Thomas Villanova C.S. Fdn (33 acres)

15th Sideroad

Marylake Heritage Map - Part B

FEATURES LIST BY BUTTON (* = no longer there)

Pre-Pellatt Occupation, Pre-1910 (bold font) Pellatt Occupation, 1910-1935 (regular font)
Basilian Occupation, 1935-1942 (no new builds) *Augustinian Occupation, 1942-2017 (italicized* font)

FEATURES LEGEND (For Maps Part A and B)

1. Entrance Gate
2. Gatehouse
3. *Villanova College*
4. Saw Mill*
5. Implement Shed*
6. *Pellatt Spur Line**
7. *Chapel of Grace*
8. *St. Thomas Cottage**
9. *Our Lady of Grace Shrine & Monastery*
10. Pellatt's Lakeside Cabana/Seasonal*
11. **Pioneer Log Cabin**
12. **Staff Cottage***
13. Pellatt Bungalow/*Original Monastery**
14. Pellatt Barn/*St. Joseph Hall**
15. Pellatt Garage/*St. Joseph Hall**
16. Home Cattle Barn
17. Hen House/*Workshop*
18. Small Poultry Houses*
19. Home Barn & Granary
20. Dairy/*Blessed Frederick Hall/Convent*
21. Green House*
22. Staff Cottage*
23. Farm Managers Residence/Boarding House/*Father Clement Hall/Retreat Centre*
24. **East Turkey Barn***
25. Gravel Pit*
26. North East Farm House & Barn
27. *Novices Log Cabin*
28. Deer & Elk Park/Enclosure*
29. Pump House
30. *Former Apiary*
31. *Storage Silo*
32. **North West Farm House & Barn***
33. Mount St. Francis Colony*
34. West Farm House & Barns*
35. West Farm Complex*
36. Large Red Horse Barn
37. **Schomberg and Aurora Railway***
38. **Eversley Train Station***
39. **Hamlet of Eversley***

PROPERTY FEATURES

A. *Lakeside Gazebo*
B. *Lady of Grace Fountain*
C. *The Great Crucifix*
D. *Monument to St. John the Baptist*
E. *Sepulchre (Jesus's Tomb)*
F. *Outdoor Stage I*
G. *Outdoor Stage II*
H. *Outdoor Stage III*
I. *Marian Grotto*
J. *Marian Shrine**
K. *Public Washrooms*
L. *The Rosary Path*
M. *Oak Ridges Moraine Trail*

Concession III

16th Sideroad

CONTINUES PREVIOUS PAGE

15

14

13

12

11

Keele Street

Henry Pellatt's Spur Line (1917)

Lots 11, 12 & 13 West and 11 East purchased in 1922 by Sir John & Lady Eaton (400 acres) Purchased by Seneca College 1971 (400 acres)

15th Sideroad

MAP LEGEND

 12 Features (See List)

 A Property Features (See List)

■ Marylake-Related Buildings - 1910 to present-day

Forest

– – – Trail

■–•– Property Boundary

200 metres

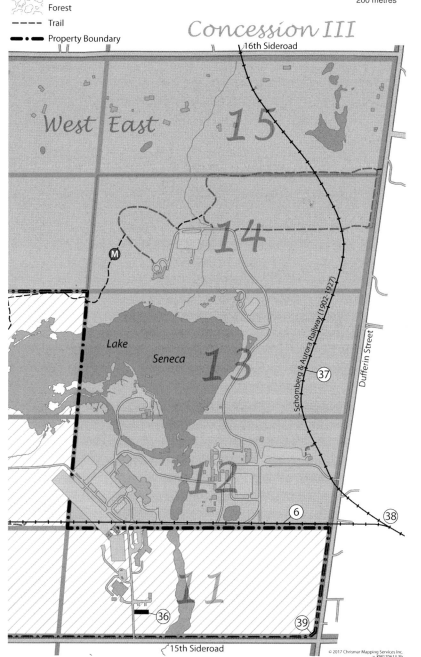

Concession III

16th Sideroad

West East

15

14

M

Lake Seneca

13

Schomberg & Aurora Railway (1902-1927)

Dufferin Street

37

12

6

38

11

36

39

15th Sideroad

© 2017 Chrismar Mapping Services Inc.
v. KM170613.3b

1

SIR HENRY MILL PELLATT

Devant si je puis (Foremost if I can)
—Pellatt family motto

Foremost if I can. Does the motto maketh the man? In life, Sir Henry Mill Pellatt won exquisitely, exceeded only by the magnitude of his superlative loss. Pellatt was one of Edwardian Canada's wealthiest men, and he has been remembered, revered, renounced and repudiated in equal measure. Stories told about Pellatt cast him in several lights, and not all of them flattering. Contradictorily, history has recorded Pellatt as an acclaimed success, an enormous failure, a princely philanthropist, a loyal and benevolent military leader and a duplicitous crook. An enigma to be sure.

Since the turn of the last century, society has been trying to understand the conundrum that was Sir Henry Mill Pellatt. In a March 1, 1920 article for *Maclean's* magazine, the author writes of Pellatt: "No one appears to know just where to place him. He has many good friends and a host of hearty enemies. In addition to that, he has in some way got himself so inextricably mixed up with the financial interests of the country that even his enemies have on numerous occasions come hurrying to his assistance, less through harm to Pellatt, harm should befall them." *Maclean's* journalist J.L. Rutledge goes on to say that "in the financial life of Canada and of the Dominion he [Pellatt] has for many years past been unquestionably 'among those present' and suggests we all just 'let it go at that.'" And while contemporaries past or present may not agree on Pellatt as friend or foe,

none can argue that the life he lived was not intriguing and many can appreciate the architectural treasures he left behind.

While the intention of this chapter is not to tell the entire life story of Sir Henry Mill Pellatt—of course it would be impossible to do so within these confines—the intention is to provide a digest of some of the many facets and enterprises of this man. The goal is to have the reader venture into subsequent chapters with a greater sense of Sir Henry, the man who built Marylake and on whose architectural and agricultural vision everything since has been appended.

It's hard to believe that a man, once considered one of the wealthiest persons in the dominion of Canada, died with cash assets totaling a meagre $185.08. On Wednesday, March 8, 1939, at 7:30 p.m., Pellatt peacefully departed this world. The sun would have just set on that frigid winter's day. The temperature high was recorded at -1.7C at the midday, the low -12.8C that evening. One and a half centimeters of snow fell over Toronto that day and gently blanketed Pellatt's then twenty-five-year-old Casa Loma, while its master, not in residence, died ten kilometers away toward the setting sun. The man who built the famous Casa Loma died in a small home he rented with his former chauffeur Thomas Ridgeway at 28 Queen's Avenue in Mimico Ontario, township of Etobicoke, in the district of York. He ended his days living in stark contrast to the zenith of his life but almost identical to how he entered it, virtually penniless.

Born in Kingston, Ontario, on January 6, 1859, eight years before Canadian Confederation, Sir Henry Mill Pellatt was eighty years, two months and two days old when he died in 1939. Canada was six months away from entering World War II. According to his death registration, Pellatt died of a cerebral embolus with the following contributory factors: "Chronic Myocardial Degeneration; Chronic Valvular Disease-Mitral; and, General Arterio Capillary Sclerosis." His physician, Dr. Charles J. Copp, who attended to him for the last thirteen years of his life, indicated on the registration that he had last seen Pellatt on February 27, 1939, just ten days before he died. On the registration, Pellatt's marital status is listed as "widow," his profession as "financier." Three days after his passing, on Saturday, March 11, 1939, the Queen's Own Rifles of Canada honoured Sir Henry with a funeral and procession befitting a high-ranking officer. It was the biggest funeral Toronto had ever seen. It was a suitable grand finale to their former figurehead and an appropriate ode to one of the grandest of lives Toronto, nay, Canada had ever seen.

On April 26, 1930, a little over a month after he passed away, Pellatt's former chauffeur and final housemate presented a document to Pellatt's son and only offspring, Colonel Reginald Pellatt, that included a seven-page list of the items Pellatt kept with him until his final days at his Mimico residence. The document was titled "List of Articles Delivered to Colonel Reg. Pellatt by Thomas Ridgeway." This list speaks volumes about what Pellatt valued in life. Subheadings of items on this list included "Silver Cups, Trophies & Presentations," "Framed & Illuminated Addresses," "Framed Photographs, Pictures and Letters, Etc.," "Photos, Albums and Books" and more. The list itself is astonishing and includes items gifted to Pellatt from three of the five monarchs who reigned during his lifetime, including Queen Victoria, Edward VII and George V, as well as several governor generals, lords, dukes and duchesses.

Pellatt was one of six children and had three sisters (two elder, one younger) and two brothers (both younger). Pellatt was the third-born child and first born of three sons to stockbroker Henry Pellatt Sr. (February 25, 1830 July 24, 1909) and Peterborough native Emma Mary Pellatt née Holland (February 17, 1836–October 13, 1901). Pellatt traced his ancestry in England back to AD 1230. Henry Sr. immigrated to Kingston from Scotland in his twenties, armed with a very green career in banking and a strong desire to make it in this brave new world.

It would be understandable if one assumed that Pellatt began his life in wealth, but that was not the case. In the very year that he was born (1859), his father faced his own financial trials in Kingston and moved his family to present-day Toronto to seek his success in the burgeoning metropolis, leaving his debts and debtors behind. Henry Sr. left Kingston with virtually nothing. He was twenty-nine years old and had to start life over again in a new job with a young wife and three children. However, despite his failed business dealings and debts left in Kingston, Henry Sr. was clearly regarded as a person of esteem, for he was gifted a silver serving tray and silver goblet from his peers in Kingston upon his departure, valued at no small sum to be sure. These two items happen to be two of the items treasured by his son and can be found on the list of items that Sir Henry kept with him until his death. The silver serving tray and goblet, of course, were the same age as Sir Henry, having been gifted to his father in the year of his birth.

Toronto was good to Henry Sr. It wasn't long before he enjoyed success in Toronto, though it was not a smooth journey at the start. In 1864, just five years after leaving Kingston, Pellatt Sr. was forced to declare bankruptcy after being let go from the Bank of Upper Canada, where he worked as

a clerk. However, it was a direct result of this termination that he started his own business with the title accountant, broker and notary public. It wasn't long before Pellatt Sr. paved a name and remarkable career for himself in Toronto. Three years later, on July 1, 1867, the day of Canadian Confederation, Pellatt Sr. partnered with Sir Edmund Boyd Osler (knighted in 1912) as brokers, accountants and estate and insurance agents. This was eleven years before the Toronto Stock Exchange had formally been incorporated by an act of the Ontario legislature. Thus began what would be a fifteen-year run of the successful firm of Pellatt & Osler.

With Henry Sr.'s newfound success, the Pellatt family, soon to include six children, could afford to send Pellatt (and his siblings) to the best schools. Pellatt attended the Toronto Model School in St. James Square and then the prestigious Upper Canada College (UCC). In school and society, Pellatt was surrounded by the most affluent Toronto families and was most certainly in the inner circle. Although described by many as a hard worker, he made his mark in school not through academics but through athletics, for which he had a natural ability. Pellatt was considered the all-around athlete and excelled at cricket, lacrosse, football and the quarter mile and mile distance runs. Several of his personal scrapbooks can be found at the City of Toronto Archives. Pellatt saved every single article in which his name was mentioned for a five-year period in sport between 1875 and 1880. The list of his athletic achievements was endless.

Pellatt did not pursue a formal education after his short stint at UCC, favoring instead to learn through apprenticeship. At the age of seventeen he joined the firm of Pellatt & Osler as a junior clerk, beginning his apprenticeship in 1876, earning $16.66 per month. It is known that with his entire first month's salary he purchased a gold ring for his mother, which she is said to have worn until her death. Pellatt would later say that his first investment was a token of love and esteem for his mother. Sadly, there must have been a falling out with his mother later in life, as Pellatt was the only one of the six siblings not mentioned in his mother's will. Henry Sr. fulfilled the role of teacher for his eldest son in the firm, and in this arena, Pellatt was a very apt pupil. It was in that same year that Pellatt became a volunteer with the F Company of the Queen's Own Rifles Regiment of Canada (QOR), and on November 2, 1876, he officially enlisted as a rifleman.

It was also during his earliest years at his father's firm that Pellatt began to focus especially on his gift in the sport of amateur running. His particular pleasure was the one-mile run. Pellatt was apprenticing at his father's firm, volunteering with the QOR and allotting time for training with the Toronto

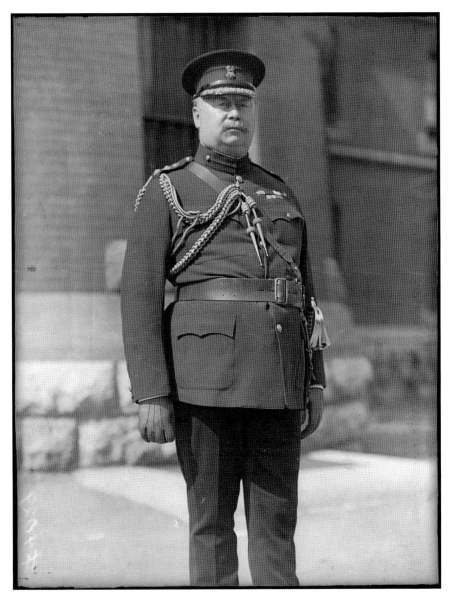

Colonel Sir Henry Mill Pellatt in his Queen's Own Rifles uniform, circa 1910. *City of Toronto Archives.*

Lacrosse Club. He was driven to be sure. He had a great deal of success in the sport, winning the Canadian One Mile Running Championship in Montreal on October 5, 1878, in four minutes and fifty-two seconds, and unless Pellatt didn't keep a record of any race he lost, Pellatt won every race he entered.

With his running title achieved, Pellatt hung up his racing shoes and dedicated himself wholeheartedly in the family business and to the QORs. In 1882, Osler and Pellatt went their separate ways. A few months later, the sign on the door of the firm and its stationery read Pellatt & Pellatt.

At the same time that Pellatt became a full partner, his father was the president of the Toronto Stock Exchange of which Pellatt was now a registered member. Incidentally, according to his obituary, Henry Sr. was the most active inaugurator and first president of the Toronto Stock Exchange (established in 1878), a position he held for three years. At the age of twenty-three in the year 1882, Henry Jr. was about to start what can only be described as the most ambitious, notorious and remarkable career of early Toronto; he would also marry that year. Ten years later, his father retired, leaving Pellatt at the helm of the family business. Though Pellatt did not pursue higher education, thirty-six years after leaving UCC he was awarded an honourary doctor of civil law degree in 1912 by King's College, Windsor, Nova Scotia, now called King's College at Dalhousie University.

It would be impossible to talk about Pellatt without talking about his life of service with the Queens Own Rifles of Canada. Less than two months after registering with the QOR in November 1876, Pellatt had his first and only experience of active duty with the QOR in Belleville in January 1877 when the Queen's Own was called on to suppress a riot of Grand Trunk Railway Company workers who were challenging a series of recent layoffs and pay cuts. The experience lasted two days and was a success for the QOR. Over the course of the next eight years, Pellatt received the following promotions and appointments with the QOR: corporal (1878), lieutenant (1880) and captain and brevet major (1883). It was twelve years before his next promotion, which was to major (1895). Later, on June 17, 1921, Sir Henry was promoted to the rank of major general upon his retirement with the QOR, and three days later (June 20, 1921), he was appointed honorary colonel of the QOR.

In 1897, Pellatt accompanied the Canadian contingent of the QOR in the role of major of the infantry division to England on the occasion of the Diamond Jubilee of Her Majesty Queen Victoria. It was for his part in this event, commanding the Colonial Guard of Honour for the Queen in front of St. Paul's Cathedral in London, that Queen Victoria gifted Pellatt with an autographed portrait of herself. On the list of items that Pellatt kept until his death was the invitation to the ball for the Queen's Diamond Jubilee, which took place during that trip, as well as the autographed photograph of Queen Victoria.

On March 30, 1901, Pellatt was appointed commanding officer of the Queen's Own Rifles and promoted lieutenant colonel. He remained the commanding officer of the QOR for the next twenty years. At the time of his appointment in 1901, the British Empire was fighting in the Boer War (1899–1902), Sir Wilfrid Laurier was the prime minister of Canada and, two months prior to his appointment, Queen Victoria had passed away, officially ending the Victorian Era. Upon her death, her son Edward VII acceded the throne, and in 1902, Pellatt was appointed to command the coronation contingent, which proceeded to England to represent Canada at the coronation of the new king. He also brought the QOR Bugle Band to perform at the coronation entirely at his own personal expense. With respect to this grand gesture, a 1920 *Maclean's* article said that "the general public pretty well believed that he had taken leave of his senses." Another item that Pellatt kept until his death was an album containing photos of officers from the coronation contingent in 1902.

Pellatt wasn't just trying to build a name for himself in the financial world and with the military—he was attempting to build a reputation in the commonwealth. Until this point, he was still *just* Mr. Henry Mill Pellatt. He was another name in a long list of Canadians joining the ranks of the landed gentry, or new money as they were often referred. In what could almost be categorized as an insecurity, Pellatt ensured that he was part of every society in which one might find a member of the elite. Pellatt was a member of the Albany Club, the National Club, the Toronto Club, the York Club, the Kingston Boys Club, the Rideau Club and others. But that wasn't enough. Pellatt craved something more distinguished.

Recognition as a knight bachelor, awarded at the pleasure of a current monarch, was a title Pellatt coveted. It would allow him the privilege of using the pre-nominal "Sir" and post-nominal "Kt." Although not a hereditary title, it would elevate him to a status above his peers and, of course, add a certain regal cachet to his person. Pellatt petitioned heavily and unabashedly for this honour. Fredrick William Borden was the minister of militia at the time and had recommended Pellatt for a CMG designation (Companion of St. Michael and St. George). This in itself was an incredible honour. But that fell short of the rank and recognition Pellatt aimed for. In a 1904 letter to Borden, Pellatt pleads, if not begs, him to reconsider the CMG honour and consider pushing his name forward for the knight bachelor recognition. In this letter, Pellatt is grateful for the honour esteemed upon him with the CMG but writes "what **I want** you to do is to propose my name for the title of **Knight Bachelor, which is** only one higher than a CMG, but it will give

me a better standing for business purposes." Pellatt goes on to indicate that such businesses would include his dealings with the Grand Trunk Pacific as well as "several other things too numerous to mention." In his final plea, Pellatt urged Borden to "please see if you cannot get [the] courage to take this up for me and put it through."

On November 8, 1905, after much petitioning on his own behalf, Pellatt was created a knight bachelor by King Edward VII for his service with the Queen's Own Rifles of Canada, although later, in 1937, Pellatt would say to a *Star* reporter, "I was knighted in 1902 for my work in bringing the first electric power from Niagara, not, as some people persist in saying, for some military activity." In case there is any confusion, on every list of Canadian knight bachelors, the date of Sir Henry's designation is confirmed to be 1905, with Governor General Earl Grey citing his contributions and benevolence to the military via the QOR. Pellatt was forty-six years old when he was knighted and represented the fifty-sixth knighthood awarded to a Canadian since the first knighthood was conferred upon a Canadian in 1824. He was the fortieth appointment post-confederation and the only Canadian to receive the honour in that year. Mr. Henry Mill Pellatt was now Sir Henry Mill Pellatt, Kt. And the knight's tale in Toronto began. Canadians, however, tended to deride such titles and perceived them as antiquated and superfluous. In 1919, Parliament banned Canadians from receiving such designations. Fortunately for Pellatt, his title was grandfathered, and he retained and used his title until his death for a total of thirty-four years.

In 1910, five years after receiving his knighthood, Sir Henry outdid his 1902 funding of the Atlantic crossing with the QOR Bugles Band, and this time, took the six-hundred-plus-man regiment (including its equine contingent) of the QOR to Aldershot, England, for six weeks of military maneuvers at his own expense (August 13–October 3, 1910). This trip was often rumoured and reported to have cost him $100,000 to $150,000, the equivalent of $2 million to $3 million today. Another token cherished by Henry to his last days was a silver punch bowl presented to him by the officers and men of the Provision 1 Battalion, QOR. For this grand demonstration of generosity, Pellatt was created commander of the Royal Victorian Order (CVO) by King George V, who later sent him a fallow of deer from Windsor Castle for his deer and elk enclosure in King—Lake Marie. Pellatt, now very decorated, was styled Colonel Sir Henry Mill Pellatt, Kt., CVO. In 1910, the Pellatt legacy appeared to be at its apex, but the legend was soon to fail. World War I and the ensuing Depression were just around the corner, and their effects would, among other business failings, prove to be ruinous.

Sir Henry's first wife was his childhood sweetheart, Mary Dodgson. Mary was born in Toronto on April 17, 1857, to John Dodgson and Margaret Carr, both of England. Mary was a year and nine months older than Sir Henry. Mary's father, a clerk, died when she was ten years old, and her family moved from Parliament Street to Sherbourne Street in Toronto, where they found themselves living among the social and political elite, near neighbours with the Pellatt family. Mary attended the prestigious Anglican school Bishop Strachan. Pellatt and Mary married on June 15, 1882, when Mary was twenty-five and Henry twenty-three. As Sir Henry did not receive his knighthood until 1905, Mary spent the first twenty-three years of her marriage as simply Mrs. Pellatt. With Pellatt being knighted, she was able to use the title Lady Mary Pellatt and did so for the next nineteen years. They were married for forty-one years, until her death on April 15, 1924, just two days before her sixty-seventh birthday and two months to the day before their forty-second wedding anniversary.

Lady Mary was a Daughter of the Empire and not only organized but also served as the first regent of the Queen's Own Chapter of the Imperial

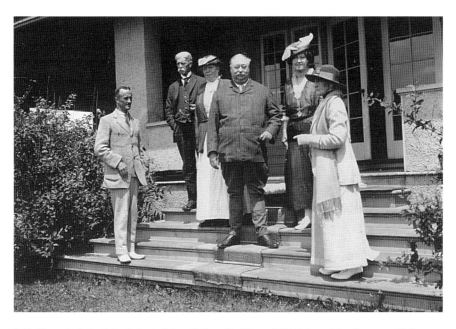

R.S. Timmis, Judge Ward, Lady Mary Pellatt, Sir Henry Mill Pellatt, Mrs. Panet and Miss Walton at Lake Marie in 1922, two years before Lady Pellatt died. *Metro Toronto Reference Library.*

Order of Daughters of the Empire (IODE). She also served as the first commissioner of the Girl Guides of Canada and was warranted the chief commissioner of the Dominion of Canada Girl Guides by Agnes Baden-Powell on July 24, 1912. On many occasions, Lady Pellatt entertained the all-girl troop at both Casa Loma (as early as 1913) and Lake Marie. Lady Pellatt resigned as commissioner in 1921 citing poor health and was awarded the Silver Fish—their highest award—in 1922. Her highest volunteer recognition was awarded on February 25, 1915, when she was elevated to the rank of Lady of Grace in the Order of St. John of Jerusalem for her work with the Girl Guides.

Many cite Lady Pellatt's date of death as April 14, 1924, but her death registration and her tombstone confirm her date of death as April 15, 1924. Her cause of death on her death registration is indicated as "Fatty Degeneration of Heart & Auricular Fibrillation." It says the duration of the above cause of death had been "1 year." It also lists the contributory cause of death as diabetes with a duration of ten years. Less than a year after being exiled from Casa Loma, and on the same day the Home Bank of Canada began its investigation into the financial dealings of her husband that ultimately led to its collapse, Lady Mary died at their small, no. 3 Spadina Gardens apartment in Toronto at the age of sixty-six. This four-floor apartment building, built in 1906, is on the City of Toronto's Heritage Inventory and is exactly one kilometer south of her recently departed castle. Of note, Lady Pellatt's death registration lists her age at the time of death

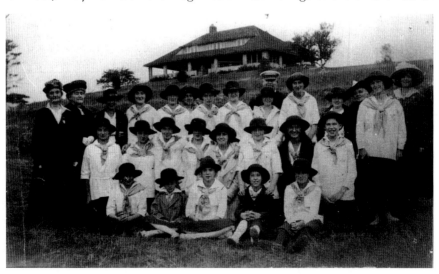

Sir Henry with Girl Guide Troop at Lake Marie. *King Township Archives.*

as sixty-seven, but technically, she would not have turned sixty-seven until two days later. The official cause of death, being degeneration of the heart, makes the story of her death all the more poignant. Indeed, Lady Pellatt died of a broken heart. Many newspapers at home and abroad bemoaned the death of this great lady. She is interred at the Forest Lawn Mausoleum with her husband.

Sir Henry and Lady Mary had one son, Reginald Pellatt, referred to often as "the scion." Reginald was born on June 30, 1885, three years after his parents wed. In his professional and service life he mirrored his father, registering as a stockbroker with the Toronto Stock Exchange and joining the Queen's Own Rifles of Canada. Eventually, Reginald would take over the firm Pellatt & Pellatt in 1925 when Sir Henry decided to step out of the role at the age of sixty-six. It wasn't long after the birth of his first son and only child that Sir Henry began to accumulate mass sums of wealth. This was achieved predominantly through his early and aggressive investments in the Canada Northwest Land Company (NWLC), the Manufacturers Life Insurance Company Ltd. (MLI), the Canadian National Railroad (CNR) and the Grand Trunk Railway (GTR), as well as through his ownership of the Toronto Electric Light Company (TELC), which he had established two years prior in 1883. Canada was still in its infancy during these years, and Pellatt capitalized on the country's early industrial and speculating opportunities: land, transportation (railways), life (insurance) and power (electric).

By 1892, Pellatt's NWLC and CNR shares were worth a small fortune. Pellatt rode his success train full speed ahead into the ensuing decade. At the turn of the last century, Pellatt was fifty years old and either the president, director or chairman of over one hundred companies, and he is said to have had a net worth of approximately $17 million, which is the equivalent of approximately $360 million today. Sir Henry certainly had his fingers in many pies. It would appear that if he was not the head or figure head of almost every major enterprise in Canada he certainly was the neck. In a 1974 publication titled "Key to Toronto," journalist Victoria Lemley says it best: Pellatt had a stronghold in all corners of the dominion, "the fisheries in the West; steel in the East; the mines in the North; and, electrical power in the South." She forgot to add the land and railways connecting all four.

An anecdote often repeated about Pellatt was that by 1910, he was one of twenty-three men who essentially controlled the country. In a *Maclean's* article written in 1911, a year after this statement was first made public, and after painstaking research by the Honourable H.R.

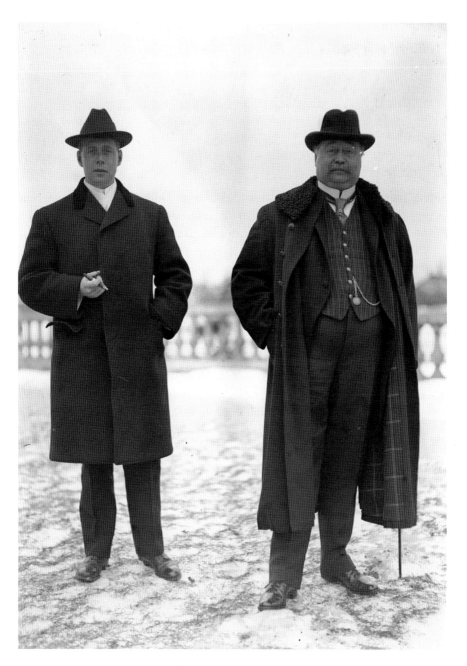

Sir Henry and his only child, Reginald Pellatt, circa 1911. *City of Toronto Archives.*

Emmerson, author Arthur Conrad indicated that since this finding was made public the year prior via the *Montreal Standard*, three of those twenty-three gentlemen had passed on, which left just "twenty capitalists now in control of the situation." The list of these gentlemen follows in order of the number of corporations in which each is interested, which was used as an indicator of overall control: Senator Cox, W.D. Matthews, F. Nicholls, Senator Mackay, Sir. H.M. Pellatt, Sir W. Mackenzie, Sir W. Van Horne, E.B. Osler, Z.A. Lash, R.B. Angus, C.R. Hosmer, Lord Strathcona, H.M. Molson, R. Forget, D.B. Hanna, E.B. Greenshields, Sir D.D. Mann, Sir T. Shaughnessy, W. Wainwright and H.A. Allan. Pellatt was ranked among the top five individuals who essentially regulated Canada. Through this Emmerson study, Pellatt was also among those listed as one of the top ten wealthiest people in Toronto, with an estimated personal worth of $3 million (approximately $65 million today). Topping this list was Sir William Mackenzie with an estimated fortune of $15 million followed by John Craig Eaton, son of Timothy Eaton, with an estimated wealth of $12 million.

Pellatt had added to his monopoly on February 18, 1903, by joining a powerful private syndicate to harness hydroelectricity from Niagara Falls. The newly incorporated Electrical Development Company of Ontario (EDC) was a marriage between Pellatt's Toronto Electric Light Company and partners William Mackenzie and his Toronto Railway Company and Frederic Nicholls of the Canadian General Electric Company. This merger of giants formed a new holding company called the Toronto Power Company (TPC). The TPC purchased water rights from the Niagara Parks Commission for $80,000 a year. Their power-generating station was designed to harness hydroelectric power for Toronto and what should have been an endless volume of cash for the syndicate. The Toronto Power Generating Station was opened in Niagara Falls in 1906.

At this point in time, Pellatt had an invested interest in almost every natural resource in Canada, holding a large claim in not just hydroelectricity but also steel, iron, coal, timber, silver and gold. Couple this with his grip on transportation (via land, sea and air), life insurance and real estate (although some will argue there was nothing *real* about it), it's evident that Pellatt intended to be, and for a while was, a key player—some would argue manipulator—in early dominion industrial growth. He was without a doubt one of Canada's greatest venture capitalists.

But not everyone applauded Pellatt's success in profiteering off of natural resources and the like. An article in the *Globe* on February 10, 1900, asserts

that "these rights [to natural resources such as hydroelectric power] were given away for nothing because of the nineteenth century's short-sighted eagerness for development" and warned that "the twentieth century will be kept busy wrestling with millionaires and billionaires to get back and restore to the people that which the nineteenth century gave away."

The period in which Pellatt began to build Casa Loma (1909–13) is often referenced, rather romantically, as the halcyon days. However, that could not have been further from the truth. It was during these years leading into World War I that Pellatt was beginning to feel pressure from all sides. Under the leadership of Adam Beck, for example, many were petitioning to see hydroelectricity return to public versus private ownership. Many of Pellatt's business practices were being scrutinized, if not denounced altogether; the royal commission on life insurance in 1906 put more than a crinkle in his reputation; Sir Henry's wife was entering a ten-year period of a decline in health; and the City of Toronto was in the process of reevaluating the value of his castle for tax assessment purposes, to name but a few stresses.

Regardless, Pellatt, along with architect and friend Edward James (E.J.) Lennox, brought his vision for Casa Loma to fruition. Lennox had already designed other landmarks for Pellatt in the years prior, including the Pellatt Office Block on King Street (1903); the Toronto & Niagara Power Company Transformer Substation at Davenport near Spadina (1904); phase one of the Casa Loma Estate, which included a lodge house/residence (328 Walmer) for Pellatt (1905), followed by the stables (330 Walmer), water tower, boiler house and greenhouse (1906); the Niagara Falls Power House (1906); and the Toronto Electric Light Company on Esplanade East at Scott Street, its office and a warehouse (1910).

In a 2012 City of Toronto Staff Report on the amending of the designation bylaws as they pertain to Casa Loma (1 Austin Terrace), we learn that the permit to commence work on Casa Loma, specifically to start the "foundation for dwelling" was issued in December 16, 1909, and that work stopped for most of 1910 while Sir Henry was with his regiment in Aldershot, United Kingdom. The permit (#18643) lists E.J. Lennox as the architect and E. Gearing as the builder. The report confirms that twenty-five lots were purchased by Mary Pellatt (not Sir Henry) and registered under Plan 980. The report goes on to say that the cornerstone was laid in April 1911. Already smelling trouble, Pellatt was astute to purchase the land in Lady Mary's name. At this point, over three hundred workers were hired for what would initiate a three-year period of construction. The final product, although never completed fully, was a ninety-eight-room castle with thirty

bathrooms, twenty-five fireplaces, fifty-nine telephones (with its own private telephone system and switchboard), a $75,000 pipe organ and five thousand electric lights. The kitchen range was large enough to cook an entire ox, whole. This private residence was said to have cost $3 million to build. Surrounding his castle was a wall that would impress even U.S. President Trump. Said to be four feet deep, ten feet high and half a mile long, the wall, with stones quarried from throughout Ontario, was rumoured to cost over $50,000 in 1914, about $1 million in today's dollars.

Families born of the aristocracy had priceless heirlooms and furniture to hand down from generation to generation. Pellatt, always a connoisseur of finer things, had already amassed a collection of fine furniture pieces, a collection he started as early as age twenty-two. His homes prior to Casa Loma were decorated to the highest standard. However, Casa Loma was much larger, and he required décor on a large scale. Pellatt continued to hunt down heirlooms of nobles and the elite abroad, utilizing a New York firm to manage the decorating. It is said that Pellatt spent $1.5 million on the furnishings. All the while giving the impression of never-ending wealth, the Pellatts lived a strained, if not choked decade in their castle. In fact, Pellatt's palace almost sunk him on several occasions. At one point, just after the war, when Pellatt's financial circumstances were starting to unravel, one of the banks carrying his debts had suggested that he should give the bank a mortgage as a security to cover his loans. Journalist J.L. Rutledge for *Maclean's* in 1920 indicated that at this point in time the castle was still considered an asset versus a liability and that "this was only a temporary matter." The idea was that the mortgage would not be registered. Shortly thereafter, the mortgage papers arrived at the bank, and a clerk who knew nothing about this special arrangement proceeded to register the mortgage—making the information accessible to the public. This is when the media jumped on the story and commenced with tales of Pellatt's imminent demise.

From the moment the Pellatts took up residence in their castle in 1913, a cloud was brewing. And just as the Pellatts were settling into their not-yet-complete abode, Canada was preparing for World War I (1914–18). World War I wreaked havoc on Pellatt's companies and investments, and he returned to what had provided good return earlier in his career, real estate speculating—though not for the sake of owning land, but for the ability to inflate its value and trade on phantom profit. This is often regarded as another one of Pellatt's duplicitous practices. The sleight of hand has been explained with Pellatt purchasing land and then artificially increasing its value by selling it at a much higher price from one company he controlled to another.

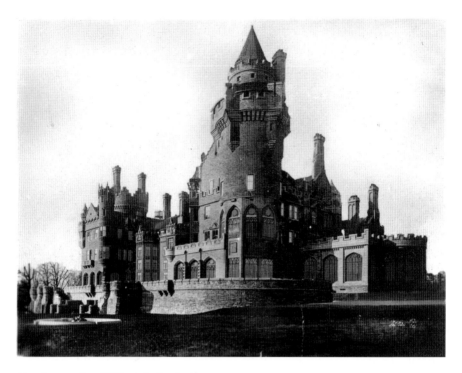

Casa Loma, circa 1915. *Author's collection.*

One example included Pellatt purchasing property in Toronto for $316,000 and then shortly thereafter selling the property to one of his landholding companies, Home City Estates Ltd., for $1,205,000—four times its actual value. It is through the newly inflated value that Pellatt tries to borrow more money to raise funds on the stock market. Later, we will see him revert to these trickeries as he starts to purchase land in King, many parcels of which were purchased via the Standard Cement Company Ltd., believed to have been owned by Pellatt, and then sold to to Pellatt personally at no cost.

As the 1920s rolled around, Canada, just fresh out of World War I and soon to be entering the Depression years, was in decline. People were not buying land—they were not buying much of anything—and if that wasn't bad enough for Pellatt, in 1922, Pellatt's Toronto Power Generating Station was acquired by the government after the allowance of private utilities ended under the leadership of Sir Adam Beck. The station was taken over by the publicly owned Hydro-Electric Power Commission of Ontario (HEPCO).

It was at this time that Pellatt & Pellatt was one of the largest debtors to the Home Bank of Canada and, not long after, played a key role in bringing the

bank to its knees. Pellatt's ship was sinking but not yet sunk. Given his history of luck with investing in natural resources, Pellatt recognized the boom of the automobile industry and took one last kick at the can and created La Paz Oil in the States. But the well was dry. Pellatt was now well past his prime, and the threat of insolvency loomed.

Loan payments to the Home Bank of Canada went unpaid for years at a time, and three of the Home Bank's largest client accounts had debts owed that were so large, the bank couldn't afford to let them fail, so they continued bankrolling on a prayer. On the day the bank collapsed in August 1923, Sir Henry was its largest debtor, owing $4.5 million to the Home Bank of Canada, or the equivalent of over $75 million in today's dollars. The Canadian economy had entered the early days of the postwar recession. The value of Home Bank stock plummeted, and the firm's outstanding liabilities were far in excess of its assets. The Home Bank was finished. On Saturday, August 18, 1923, all seventy-one branches across Canada, from Quebec to British Columbia, closed their doors for good. In fact, it is due in large part to the stock manipulations by folks like Pellatt that banking governance would change forever in this country. Pellatt, the wannabe baron, was now virtually barren, and tens of thousands of lives and organizations suffered as a result of his backhanded dealings. One can't help but recall this somewhat famous quote when considering the contrasting spectrum of those affected by the collapse of the Home Bank of Canada: "If you owe the bank a hundred dollars, the bank owns your soul.…If you owe the bank a million dollars, you own the bank!"

The majority of depositors affected by the closure of the Home Bank were working-class Roman Catholics, including over sixty thousand prairie farmers and an overwhelmingly substantial portion of Toronto's Catholic community. The Home Bank, which had been incorporated on July 10, 1903, reorganized as the Home Savings and Loan in 1871, succeeding the Toronto Savings Bank (TSB) of 1854. The TSB was the result of efforts made by Bishop Armand-François-Marie de Charbonnel (Bishop Charbonnel) along with members of the Society of St. Vincent de Paul for Catholic laymen. A 2013 online article for torontoist.com indicates that it was because working-class Irish immigrants often sought financial guidance from the bishop that the Roman Catholic diocese established the institution to safeguard their savings. The Toronto Savings Bank counted nearly every Catholic priest, parishioner and organization as a depositor and customer. The bishop hoped the TSB would be a safe place for Roman Catholics to invest funds for charitable purposes and to provide the poor Irish immigrants

with a depository of their own as a means of saving for housing, education, retirement or periods of illness.

In a letter located at the General Archives of the Basilian Fathers, dated August 22, 1923, four days after the closure of the Home Bank, the superior general of the Basilian Fathers, Robert Francis Forster of Toronto, wrote in a postscript to a letter to a Reverend M.J. Ryan, CSB, in Detroit that since their last correspondence "the Home Bank has closed its doors….[W]e had our money there…[and] now we don't know if we have any money." That feeling of dread and helplessness was felt across the country. In fact, the very afternoon prior to the closure, regular working-class customers continued to deposit their hard-earned money in earnest, unaware of the bank's circumstances and unware of the fact that numerous major depositors, including the bank's vice president and a federal cabinet minister, had begun withdrawing significant sums in the few days prior to the collapse with full knowledge of the disaster to come.

In the end, the depositors received a mere $0.25 on the dollar from the liquidator against sales of the Home Bank's assets. An additional $0.35 on the dollar was paid to those only those having deposits of $500 or less from a special relief fund approved by Parliament in 1925, two years after the collapse. For reference purposes, $1 in 1923 is equivalent to approximately $14 today.

In 1903, just twenty years after it was founded, the Home Bank forced Pellatt to sign over all of his assets to an investment company, thus effectively rendering him destitute, rather than force him into bankruptcy. Few wept for Henry that day. If anyone thinks that Pellatt was sensitive around the term "bankruptcy" they would be correct. Although difficult to imagine or believe, Sir Henry Mill Pellatt never filed for bankruptcy, ever. It is possible that people confused news of his father filing for bankruptcy, which was true. And since his father had the same name, it would be an easy thing to mistake, especially since Pellatt's financial losses were so extreme. However, the very fact that Sir Henry was permitted to continue using the prenominal "Sir" until his death is the first indication that he did not file for bankruptcy. In the United Kingdom, there is an Honours Forfeiture Committee that convenes under the United Kingdom Cabinet Office to consider cases where an individual's actions subsequent to their being awarded a British honour raises the question of whether they should be allowed to continue to be a holder. Causing the foreclosure of a bank, leaving over sixty thousand people without their life savings, would certainly have qualified for his forfeiture of the title. But Pellatt was never

charged or tried with a crime related to his financial dealings, nor was he forced into bankruptcy.

Interestingly, an article for the *Toronto Daily Star* from July 14, 1927, titled "May Press Action Despite an Apology" with the subtitle "London Evening Standard Regrets Remarks Concerning Sir Henry Pellatt" reads, "The London Evening Standard has published an apology of the British United Press for statements printed in its columns having reference to Sir Henry Pellatt and Sir Henry's famous house, Casa Loma." The article Pellatt was reacting to was titled "A Wonder House None Will Buy" and stated that Sir Henry went bankrupt by the time his mansion was completed. Henry was vexed. In short order, Henry initiated legal action on the grounds that he had never been declared bankrupt and that this published statement was damaging to his reputation and financial standing. The *Evening Standard* humbly replied that "there is no justification for statements made and tender apologies." Pellatt was quick to reply that notwithstanding the apology, he could not say that legal proceedings would cease and that he was leaving these decisions and matters to his hired legal counsel in England.

Many talk about Pellatt having to hand over Casa Loma to the City of Toronto in 1923 at the time of the Home Bank closure, but that was not actually the case. Casa Loma had always been in Lady Mary's name and thus protected from his trustees. But it was at this time that Lady Mary and Sir Henry reluctantly came to terms with the fact that they could no longer afford to live in their castle. Sensing his imminent downfall, Pellatt attempted to save his sinking ship by transferring and/or selling off his assets, including his property at Lake Marie in King Township. Pellatt first sold 400 acres of his Lake Marie property in January 1922 to the Eaton family in an attempt to unload some of his non-liquid assets, and then, two months after the collapse of the Home Bank, Pellatt signed over his remaining 814 acres of Lake Marie to his wife on October 31, 1923. She died six and a half months later. Through the documented land transactions at Lake Marie we see the introduction of another holding company called the Estates Holding Company, which later shows up on all of the land transfer documents as Caledon Securities Inc. Pellatt was cash poor. Everything he owned, built and earned now belonged to one of his holding companies.

Just ten months after the collapse of the Home Bank, two months after the death of his wife and a week after what would have been his forty-second wedding anniversary Pellatt could do nothing but watch as his castle's furnishings, reportedly costing over $1.5 million ($22 million today), were auctioned and sold via the Jenkins Art Galleries over a five-day

period, June 23–27, 1924, for just a fraction of their value. A promotional booklet created by the Kiwanis Club in 1938 quoted Pellatt confessing to a reporter, "It is a sale which breaks my heart." Proceeds from the sale amounted to roughly $250,000 ($3.5 million today), about 16 percent of the actual value. In another article, Pellatt quips, "The process was something like having a tooth pulled. Once over, one proceeded to forget all about it." Although the two quotes are somewhat contradictory, there is no doubt the loss of his prized belongings cut him deeply, especially when they did not fetch the sum expected.

When Lady Pellatt died in April 1924, Sir Henry continued to manage Casa Loma, which was owned by the estate of Lady Mary Pellatt, of which he was the sole executer. Pellatt devised many schemes to try to revive it, and there was no shortage of plans as to what might be done with it. But while plans were being devised, the castle sat relatively empty. To make matters worse, due to the enormous cost to heat it, Pellatt had no choice but to shut off the heat to the castle due to the fact that the furnace consumed eight hundred tonnes of coal in a single winter, which equated to a $8,000 per year expense, well over $100,000 today.

While the castle took on further abuses at the hands of mother nature, Pellatt remained open to every possibility for its future use, even—to the chagrin of his neighbours and friends—an ill-fated hotel venture. The new enterprise suffered from the disease that would plague the castle through most of its existence: a failure to thrive. The hotel scheme for Casa Loma was officially finished in January 1930, with the market crash two months earlier heralding the beginning of the Great Depression.

Pellatt's personal finances took a beating with the stock market crash of 1929, as did that of every potential buyer or investor for Casa Loma. Yet even though it was estimated that Canadian stocks lost a total value of $50 billion on paper in 1929 and that by the mid-1930, the value of stocks for the fifty leading Canadian companies had fallen more than 50 percent from their peaks in 1929, Pellatt continued to look for someone or something to finance his citadel. A series of schemes gained audience with Pellatt between 1930 and 1934 that the research for this book discovered, such as a head office for a large American company, a hospital, a military museum, an art museum, a movie studio, a government office, the new Government House to replace Chorley House, a seniors rest home, an academic institution, a hostel for the large number of unemployed in the city, a soldiers' hostel, a millionaire's club, a convalescent facility, a technical high school, a home for the Dionne quintuplets, the North American headquarters for the Orange

Order, a railway station, an elite social club, an apartment complex, an industrial exhibition hall, a second city hall, a monastery, a home for the reigning monarch of England in Canada and even a new home for the Pope, which had been long discussed leading up to World War II. In reference to the Pope potentially taking up residence, in a *Toronto Star* article from July 8, 1940, titled "Catholics Can't See Pope at Casa Loma," one Anglican rector suggested that the Pope and the Archbishop of Canterbury take up residence at Casa Loma. The ardent reply from a monsignor at St. Cecilia's Church in Toronto was "let them stick to their posts....The King will not leave England and the Pope will not leave Rome." Although each of these new schemes brought with them a renewed sense of optimism and hope, none of them came to fruition.

Then, early in 1934, Pellatt, as the executor of Lady Pellatt's estate, forfeited Casa Loma to the City of Toronto for what amounted to $27,305 in back taxes. Interestingly, this story is often told relaying the mere pittance for which Pellatt officially lost the castle, but $27,000 in 1934 would equate to $500,000 in back taxes today, no small sum at all. Although the Pellatts moved out of Casa Loma in 1923, it wasn't until a decade later in 1934 that Sir Henry finally had to part with his castle for good. In an article for the *Globe and Mail*, Pellatt spoke to the reporter of the tax situation: "When I built Casa Loma, the taxes were only $400 a year. Then at the end of five years they jumped my taxes to $1,000 a month [$250,000 per year today]. No man could pay that, I couldn't, so I got out." But it wasn't just the taxes that had to be paid to maintain this castle. There was annual depreciation, heating, staffing and maintenance to name a few. Unpaid taxes just happened to be the only reason that could force him out. It wouldn't be for another four years that the West Toronto Kiwanis Club (known today as the Kiwanis Club of Casa Loma) would reach an agreement with the city and commence the management of the castle as a tourist attraction, which it continued to do for seventy-five years. Since 2013, Casa Loma has been operating under a long-term lease with the Liberty Entertainment Group.

The social elite in early prewar days had decidedly given up their tax-laden properties in the city in favour of more spacious and less expensive estates in the country. Better roads and better vehicles also made these properties on the periphery of the city more accessible. In fact, Pellatt later stated his one mistake as it pertained to Casa Loma was that he "built it too close to the city." Of course, when he purchased the land, it was most certainly on the outskirts, but as the city sprawled toward him, the taxes went up. He

reflected that he wished he had built it at Lake Marie in King and once said in an article for the *Detroit News* in June 1937 that "I should have moved it out to the country stone by stone."

Throughout the decade after Lady Mary's death, Henry continued to reside at their Spadina Gardens apartment and retired—more like retreated—to his summer residence in King City, Lake Marie, more and more frequently. Lake Marie continued to be the site of many fundraising and local events over the remainder of his life. The King of Casa Loma however, was no more. Everything Pellatt owned, which wasn't much, was now in the control of trustees. Now a senior citizen, Pellatt had to try to build a new life for himself, and it wasn't long after the death of Lady Mary, less than three years to be specific, that Pellatt would bring the second Lady Pellatt to Lake Marie.

Many only know of Pellatt's first wife, Lady Mary. His second wife was Catharine Welland Merritt of the Welland Canal Wellands, born on November 29, 1866, in St. Catharines. Pellatt was sixty-eight years old when he took Catharine—the new Lady Pellatt—as his bride on March 12, 1927, in St. Catharines, her hometown. Details of the wedding were posted in an article for the *St. Catharines Standard* titled "Sir Henry Pellatt and Miss C.W. Merritt Were Quietly Married at Old St. George's," St. George Church in St. Catharines, Ontario. It goes on to say that "the bride was the founder of the Queen Mary's Needlework Guild in Canada; Groom received the Order of the Knight Bachelor for his services to the Militia in Canada; Sir Henry owned Casa Loma in Toronto." The new Lady Pellatt was sixty years old on her wedding day; she had not been married prior and had no children of her own.

It wasn't until Saturday, June 25, 1927, three months after their wedding, certainly in fairer weather, that Sir Henry and his new lady hosted a reception at Lake Marie Farm. The *Toronto Daily Star* wrote about this event two days later on June 27 in the "Women's Daily Interest" section with an elaborately long title: "A Fete of Friendship Is Reception at King—Sir Henry and Lady Pellatt Genial Host and Hostess—Charming Function—Grounds and Residence a Picture of Beauty—Log Cabin Admired." This was their first reception since their marriage, and the couple invited several hundred guests to their Lake Marie residence.

Sir Henry's second marriage was a short one. Catharine died on December 19, 1929, at their 78 Crescent Road home. Her death registration lists the cause of death as "carcinoma uteri," also known as cancer of the uterus. Her funeral took place two days later on December 21 at St. George

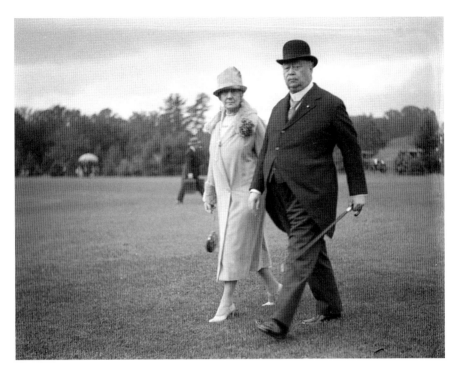

Sir Henry and his second wife, Lady Catharine, at their wedding reception at Lake Marie, 1927. *City of Toronto Archives.*

Church, where she had celebrated her wedding just two years and nine months prior. Coincidentally, on her death registration it says that she had been diagnosed with cancer exactly two years and nine months before her death—the same month she was married.

Catharine was buried at Victoria Lawn Cemetery, St. Catharines. Her stone reads "Catharine Welland—Eldest Daughter of J.P and E.A. Merritt & Beloved Wife of Sir Henry M. Pellatt CVD." On December 20, 1929, the *Toronto Daily Start* announced, "Life of Service Ended by Death of Lady Pellatt," with the subtext "Catharine Welland Merritt was Scion of Prominent Canadian Family—Noted War Worker." The article continued, "The end was not unexpected. Last June [June 1929] Lady Pellatt become ill at Lake Marie, Sir Henry Pellatt's summer home in King Township. She was taken to Wellesley Hospital in Toronto on August 9, where the best-skilled medical men took charge of her case, but after a few weeks they decided that recovery could not be hoped for. In October she was taken to her home on Crescent Road."

Catharine has an extraordinary family history, and though this chapter won't go into great detail about her history, which would be a book in and of itself, there are some points worth mentioning that of course help answer a question of broad interest: how did this "spinster" (as she was labeled on her marriage certificate) from St. Catharines come to marry Sir Henry Mill Pellatt at the tender age of sixty? The aforementioned article states that Catharine had known Sir Henry since she was twelve years of age, and many other sources cite them as childhood friends. If they met when Catharine was twelve, and they were eight years apart in age, Sir Henry would have been twenty when they met—not what I would call "childhood" friends, at least not on Pellatt's part. It also means that they met three years before Pellatt married Lady Mary.

Catharine was the eldest of the seven children of Jedediah Prendergast Merritt and her mother, Emily Alexandrina Prescott Merritt. It was through her grandfather the Honourable William Hamilton Merritt that Catharine inherited Oak Hill Estate, which she sold in 1928 (a year before her death). Her grandfather was the prime mover of the first Welland Canal project and considered one of the most important persons in the development of Canada. There is a monument to him at the entrance to St. Catharines, which Catharine herself planned. Catharine was the organizing secretary of the IODE and the Canadian Council of the Girl Guides. Lady Mary Pellatt also happened to be deeply involved with both of these organizations, which lends one to believe there was no way they could not have known each other. After Catharine's death, Sir Henry spent his last decade alone.

After the death of the second Lady Pellatt, Sir Henry spent most of his time at his country estate in King. The local and Toronto papers shared stories about Sir Henry, this once imposing figure of a man, softening and welcoming people to join him in his last stronghold, Lake Marie, which he most certainly enjoyed and shared with others in his later years. Two months prior to his death, on the occasion of his eightieth birthday, Sir Henry enjoyed a final salute from the members of the QOR with a spectacular banquet at the Royal York Hotel. Remaining members of the contingent that he took to Aldershot in 1910 as well as members of the Bugle Band he took with this coronation contingent of 1902 were on hand to celebrate the incredible life of their benevolent leader.

This book will unlock some of the stories of happier times, including the farming, Pellatt's family and friends at Lake Marie, the Canada/Dominion Day celebrations, the fundraising events, the Queens Own Rifles of

Henry Pellatt on the verandah of Lake Marie Bungalow. *City of Toronto Archives.*

Canada events and, eventually, the transfer of Lake Marie to the Marylake Agricultural School and Farm Settlement Association in 1935 and then to the Augustinian Fathers (Ontario) Inc. in 1942. The Augustinians have capably stewarded the land that we know today as Marylake since that time. The story of Marylake is just beginning.

2

PRE-PELLATT OCCUPATION

Come! Which would you prefer—a glass of milk from my own dairy, or a bottle of champagne from the cellar—for they each cost me the same!
—the Honourable John Strickler Martin, former Minister of Agriculture for Ontario (1923–30)

*W*hy Sir Henry Mill Pellatt purchased land in King Township specifically is unknown. What we do know is that at the time he was piecing together Lake Marie in King and building Casa Loma in Toronto, he was also purchasing large parcels of land in Pickering and Port Credit to reportedly set up rural farm estates in these areas as well. In fact, at one point in the early part of the last century, Pellatt had a stronghold to the north, east and west of Toronto with his estates in King (York), Pickering (Durham) and Port Credit (Peel)—all within twenty-four to forty kilometers of his citadel at the center of York in Toronto, Casa Loma. Initially, Lake Marie was meant to be a retreat for Pellatt and not a working farm. But what started out as a baron's refuge turned out to be a 1,214-acre country estate property with several producing farms, each outstanding from both an architectural and operational perspective.

There was a new ambition amongst the Canadian elite at the turn of the last century and that was the title of gentleman farmer, a concept quite common in the already well-established motherland but a relatively new pursuit in fledgling Canada, where most farmers were farming for livelihood, not for recreation. The term gentleman farmer was used to describe a city

gentleman, or member of the landed gentry/aristocracy, who had either a separate country estate with a producing farm or who had a farm as part of his main estate and farmed mainly for pleasure rather than for profit. The gentleman farmer would usually employ labourers and farm managers to handle the estate's affairs. The main difference between a farmer and a gentleman farmer is that for the later, the chief source of income was derived not from any revenue that the farming would yield. The gentleman farmer, like Sir Henry, had other sources of income that funded this hobby farming, another nouveaux term in Canada at the time.

Pellatt was not alone in his quest of the quiet countryside. Many of Canada's elite were in search of a bucolic place to land. Not only was this pattern consistent with their counterparts in England, whom the elite in Canada were determined to emulate, but there were also practical reasons as well. For one, taxes were far lower in the country than in the city, and the popularity of the automobile had also made it far easier to move in and out of rural areas. But Pellatt was peculiar in that he was piecing together not one but three country estate farms. Upon closer examination—and with the exception of Lake Marie—we discover that Pellatt was far more interested in land speculating than farming.

In John Claudius Loudon's 1839 *Encyclopedia of Agriculture*, twenty-eight different types of farmers are defined from the lowliest to the most esteemed. At the low end of the spectrum fell the jobbing farmer, the young farmer and the cottage farmer. On the esteemed end of the spectrum sit the gentleman farmer, the yeomen farmer and the farming landlords. Interestingly, Loudon's definition of the gentleman farmer is not without a snicker. It described the gentleman farmer as somewhat snobby given that they "do not do any of the work themselves" and "do not associate with their minor and personally working brethren." In the text, this is described as "a character extremely liable to ridicule" among all other classes of farmers. Of course, if the definition of gentleman farmer meant that the gentleman never toiled the land or spoke with the working class, then the definition would not accurately define Pellatt at all, for he was known for and quite enjoyed doing both.

In a March 1920 article for *Maclean's* magazine titled "Pellatt the Plunger: A Few Stories about a Spectacular Figure in Finance," journalist J.L. Rutledge reminds his readers that "Sir Henry is not only the owner of Casa Loma, but of a country estate in King Township, Ontario, that comprises 1,800 acres." The note in this article about the total acreage of Lake Marie being 1,800 acres is incorrect, as it never exceeded 1,214

acres; however, if you were to combine the total acreage of Pellatt's three farms, in King, Pickering and Port Credit, you would amass a total of almost 1,800 acres, which is likely what confused the reference. The article continued to speak to this new concept of hobby farming: "This farm [Pellatt's Lake Marie] is perhaps not run on the basis of bread and butter needs, but more to give a rein to Sir Henry's love of good stock and of outdoor life than for any other reason."

"Come!" says the gentleman farmer to his guest, "which would you prefer—a glass of milk from my own dairy, or a bottle of champagne from the cellar? For they each cost me the same!" This famous quote comes from the Honourable John Strickler Martin, who bred poultry and raised cattle in Port Dover and was the minister of agriculture for Ontario between 1923 and 1930. As a person of social position who also happened to be a very successful farmer, he often spoke about mismanagement and the gentleman (hobby) farmer. Martin believed that there was no reason why a successful businessman who turned to his country estate for new interest and relaxation should not also get out of it the sport of bringing it up to a paying basis and spoke often about the role that country estates could and should play in their communities. In a 1929 article for *Canadian Homes and Gardens* titled "The Problems of Management," Martin asserts that "it should be the ambition of every country gentleman to make his estate pay." Martin was also quick to recognize why many gentleman farmers, if not the majority, had come to find that their farming enterprise was more costly than anticipated. Martin believed that gentleman farmers did not often manage their farms in the same businesslike manner as they did their main enterprises or financing regimes and that they often left it to a hired man in the city, who had little to no understanding of farm operations, to manage the operation on their behalf. It is for this reason, Martin said, "It is a small wonder that milk jumped into the champagne class" when you looked at total cost.

Certainly, toward the end of Pellatt's time at Lake Marie, it appears that he let the place go and could have been guilty of Martin's chief concern. A May 1935 report written by Father Michael J. Oliver, CSB, the person who was responsible for spearheading the Basilian purchase of Lake Marie in 1935, said of the farm, "There are no account books nor business records kept so that I have to go by information given me by employees and by my own observation....No books are kept, therefore, it is impossible to know what is going on or correct mistakes; poor management and laxity of management have led to abuses; and, there seems to be no supervising

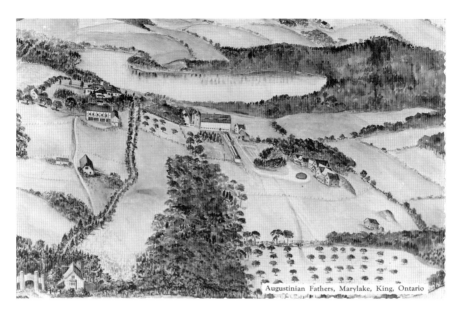

Father Luke, OSA, drawing of Marylake, circa 1943. *Marylake Archives.*

control of the manager." Keep in mind that this report was on the state of affairs at Lake Marie in 1935 when Pellatt, then seventy-six years old, was months away from vacating the property. At this time, Pellatt was more or less a tenant of Lake Marie himself. He had not been the legal owner since the land came under the control of Caledon Securities Ltd. in 1931 and the responsibility of Messrs. Holmstead and Clarkson. By all accounts from earlier publications on the property, Lake Marie, in its heyday, was a glowing example of farming in Ontario. (This will be discussed in great detail in the next chapter.)

Aside from the mere pleasure of mimicking the habits of the aristocracy in England, the concept of gentleman farming reveals an interesting trait of the wealthy—demonstrating what men like Sir Henry Mill Pellatt valued in life. In Pellatt's case, what he valued in life was most certainly his castle, which housed over a $1 million worth of ornamentation; his Queen's Own Rifles of Canada brigade; and the opportunity to demonstrate his wealth in various settings to his friends and peers. But just one glimpse of the rolling hills of Lake Marie, the piercing blue of the deep kettle lake, the design of his farm buildings, the reputation of his prize-winning cattle, the elaborate fence he built to contain his coveted herd of deer and elk, his elaborate stone entrance arch and the

long, winding road to Marylake itself and it becomes very evident that his country estate was among Pellatt's most prized possessions.

A farm had the ability to improve one's social status. In fact, some early British publications declared it the responsibility of the gentleman, yeoman and aristocracy to farm, for it provided jobs and helped fuel the local economy. By the end of the nineteenth century, agricultural shows were also becoming more and more common and provided an opportunity for the gentleman farmer to demonstrate his understanding of science and genetics in livestock. What was once a local event and a special day in the community where you could see your neighbourhood farmer dressed in his Sunday best, walking down the side of a road with his prized cow, horse or hog was now an elaborate display of agricultural one-upmanship with significant cash prizes to be won. Often these prizes, earned by the farm labourers, went to the local gentleman farmer, who was more than happy to accept the blue ribbon on behalf of his working brethren.

Maclean's journalist Rutledge also shared an amusing story about a local agricultural show in King Township. "Recently at this farm near Toronto," speaking of Pellatt's Lake Marie, "was a gathering of the townships agricultural interests, and a display to livestock." Rutledge informs us that farmers had driven in from all parts of the county with their best stock. An Englishman was present and, in response to a display of fine horses about to receive their prizes, apparently said to one of Pellatt's friends who was bestowing the honours of the day that "you'd go a long way to find a better looking lot of horses than that, and every one of them gathered from the same township!" The Englishman was clearly astonished that King could produce such a display of equine superiority. Not a second later, Sir Henry is said to have boomed, "All over the township, hell man, they're all from one farm. Those are all my horses."

Owning a producing farm spoke to one's academic capacity and could afford the gentleman a role among the intellectual as well as the financial elite. Of course the gentleman farmer was very rarely managing the farm, livestock, germination or breeding, but the ownership, participation or funding of agricultural pursuits spoke to the broader scope and faculty of the gentleman himself—in essence, making him more well rounded.

Although this chapter is committed to Pellatt's property in King Township, commentary on Pellatt's other two farms is important here, as it speaks to a different attachment to Lake Marie and also considers some of the trends in Pellatt's farm purchases. Pellatt only kept the Pickering and Port Credit farms for a short period of time, whereas he enjoyed Lake Marie for over

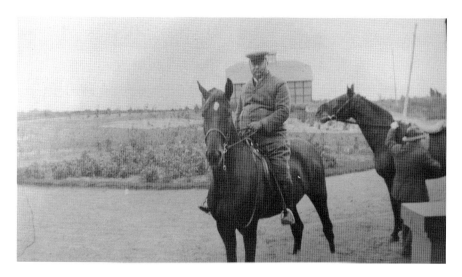

Pellatt on horse at Lake Marie. *City of Toronto Archives.*

twenty-five years. A great deal has been written and published about Lake Marie, virtually nothing on the other two farms. And while it will be plain to see that there was a special sleight-of-hand taking place with the purchase and sale of all three of his farm estates, Lake Marie, named after his first wife, seems to have held a very special place for Sir Henry. In fact, it is not known if Pellatt ever resided or built on his other two farms. It also does not appear that the Pickering or Port Credit farms were ever bestowed a formal estate title such as Lake Marie.

A November 1, 1911 article for the *Toronto World* titled "Gentleman-Farmers Buy Near Pickering" indicates that Sir Henry Pellatt and other wealthy men set out to establish country estates: "Toronto's first citizens are buying large tracts of farmland in Pickering and converting them into big farms on which palatial residences will be erected after the manner of gentleman's estates in the old countries." A section in the article on Pellatt specifically reads, "Sir Henry has bought 560 acres on the Kingston-road (Highway 2), just east of Pickering Village, and will thereon establish his country residence." It goes on to say that "Sir Henry will convert his purchase into a most up-to-date farm and will use all the newest agricultural inventions known to till the soil for him."

In another article dated November 11, 1911, for the *Canadian Statesman*, titled "Back to the Country: Titled and Wealthy Toronto Men Buying Pickering Farms for Residences," it is reported that "Pickering is to become

the post-office address for quite a group of gentlemen farmers, according to the developments that have quietly taken place there over the past few months. The district around Pickering Village has been practically all taken up by wealthy people that will establish large estates and make them high-class farms." Another article described Pellatt's Pickering farm as being 450 acres on the south side of Kingston Road, just east of Brown's Hill, and stated that he now owned the old Grills, Brown and the Post farms and paid $100 an acre for them.

Upon further examination of land registry documents in Durham, it can be seen that Pellatt actually owned four hundred acres in Pickering on land that had been the farmland of notable Pickering pioneers such as the Grills, Post and Brown families, among others. The four hundred acres were purchased in two transactions of two hundred acres, specifically Lot 4 and Lot 5 in Concession II, Pickering. In September 1911, Pellatt paid $17,325 (approximately $375,000 today) for the two hundred acres in Lot 4, which was the former Albert Asa and then his son Asa Post's farm from James Long (and wife). In August 1911, Pellatt spent $36,000 (approximately $775,000 today) for two hundred acres in Lot 5, which was the former S. Brown Farm, from John Jeffrey Grills (and wife). Combined, the entire four-hundred-acre farm estate in Pickering cost Pellatt $53,325 (approximately $1.1 million today). This means Pellatt paid $86 an acre for Lot 4 and $180 an acre for Lot 5, which averages out to $133 an acre for the four hundred acres in Pickering, not too dissimilar from the article above reporting $100 an acre.

A month after purchasing Lot 4, Pellatt mortgaged it for $118,000 (approximately $2.5 million today), almost seven times more than what he had paid for it just a month earlier. This was a consistent practice with almost all of Pellatt's land purchases in the province. Pellatt also made money by selling a right of way in both Lot 4 and Lot 5 to the Toronto Eastern Railway Company just seven months after purchasing the lots for $6,089 each, totaling $12,178 (approximately $265,000 today). Less than four years later, in the summer of 1914, Pellatt granted all of Lot 4 and Lot 5, less the aforementioned right of way, to Lydia Jane Fleming for $1. This means that Pellatt was not in possession of his Pickering property for very long, less than four years, in fact. Given that Pellatt was involved with the Toronto Eastern Railway Company, it should not be surprising that he knew what land the line would pass though, which of course would have be the motivation for purchasing the land in Pickering in the first place. This line, however, never came to fruition. Perhaps also not coincidentally,

Lydia Jane Fleming was the wife of former Toronto mayor Robert J. Fleming, who was also deeply involved in Toronto real estate and finance and worked for Pellatt. According to the online Dictionary of Canadian Biography, although Fleming enjoyed public service, he left his job in 1904 for a much higher salary as general manager of William Mackenzie's Toronto Railway Company. He would hold this position until the company became part of the Toronto Transportation Commission (TTC) system in 1921. His efforts did much to shield the TTC's directors, including Pellatt, and the associated Toronto Power Company from the attacks of reformers on the railway's corrupt control of city transit. Fleming would eventually manage or serve on the boards of several other Pellatt businesses, including Toronto and Niagara Power, the Electrical Development Company and the Winnipeg Electric Railway. This was no hobby farm in Pickering.

Out to the west in Port Credit, Pellatt plays a similar game in terms of buying and selling property. In 1913, Samuel Percy Biggs purchased fifty-five acres in Port Credit for $3,000. Samuel Percy was a barrister and the son of Samuel Clarke Biggs, a politician who was one of the principal directors of the Toronto, Hamilton and Niagara Falls Electric Railway Company (1895). Three years later, Samuel Percy sold this land to Toronto Dwellings Ltd. for $1. Less than one year later, this property sold to the Toronto and North West Railway (TNWR) for $1; the TNWR then mortgaged the property for $600,000, which is the equivalent of $10.5 million today, and then sold it two years later to the Canadian Northern Realties Ltd. for $1. The Canadian Northern Realties Ltd. sold this property two years later to the Toronto and Niagara Power Company (of which Pellatt was president), also for $1, which then sold the land three years later on March 25, 1924, to the Hydro-Electric Power Commission of Ontario (HEPCO). The value of this final transaction was not provided, but it was part of a larger acquisition after the government ended the allowance of private utilities. The transfer did indicate that it included the complete assets of the Toronto and Niagara Power Company. Again, despite the earlier reports, Pellatt did not appear to be farming in Port Credit either.

It is somewhat of a difficult exercise to determine what land was purchased by/for Pellatt, as his properties were often purchased through one of his many business exploits or associates. Certainly with Pellatt's farm estate purchases to the east and west of Toronto, the motives were clear. Pellatt and his friendly neighbourhood gentlemen farmers were planning to make profit, not produce. However, Lake Marie, which he owned parcels of for over two decades, seems to have been designed, built and utilized for the sole

purpose of recreational enjoyment and respite, although it also experienced land shuffling and interesting transfers in its earlier days.

If you look solely at the dates of land purchased in King that are in Pellatt's name, it took Sir Henry four years and seven months to piece together the 1,214-acre Lake Marie Estate between April 1911 and November 1915. However, if you consider and agree that Pellatt's associates and companies had been purchasing land in King for him prior to 1911, it actually took thirteen years to piece together the estate. In total, Sir Henry spent $42,457 on land for the Lake Marie property, which in today's dollar would be just under $1 million ($35/acre). It certainly was worth much more than that. Of the 1,214 acres that Pellatt owned, 814 acres were in Concession IV and included the east and west halves of Lots 11, 12, 13, 14 and 14 acres in the southeast corner of Lot 15. In the adjacent Concession III lands, Pellatt owned the east and west halves of Lot 11 and the west half of both Lot 12 and 13. With the exception of 86 acres in Lot 15, he owned all of the Concession IV block, which was encapsulated by Jane in the west, Keele in the east, 15 Sideroad to the south and 16 Sideroad to the north.

In the adjacent Concession III property, Sir Henry owned four hundred acres, but he only kept the property for seven to nine years (depending on the parcel) before he sold it all to the Eatons on January 16, 1922. When Pellatt was starting to build in King he had been recently knighted; he had just returned from Aldershot with a contingent of the Queens Own Rifles whom he had taken at his own personal expense; he was the knight principle for the Imperial Society of the Knights Bachelor; he was, according to the *Montreal Standard*, considered one of the twenty-three men who essentially controlled the country; he was ranked the eighth-richest man in Toronto; and he had laid the cornerstone for Casa Loma the same month he purchased his first parcel of land in King Township in his own name in April 1911. Pellatt was riding a swelling wave and seemed to be unaware that it was soon to crash.

The first parcel of land he purchased in King included the east and west halves of Lot 11 (200 acres) in Concession IV from John Taylor on April 7, 1911, for $10,000. A couple of weeks later, he purchased the west half of Lot 13 (100 acres) from Bernard McCabe for $15,000. In 1912, Pellatt started to acquire additional land in the Fourth Concession—specifically the east and west halves of Lot 14 ($7,051) and 76 acres in Lot 13 east ($1). The next large real estate purchase came in 1913 when he acquired 285 acres to the east in Concession III for $5,601 via multiple transactions, including purchases from Walter Scott, John L. Ferguson and John Cairns.

He purchased the last 115 acres of his 400 total acres in Concession III in 1915 from Colonel James Mason for $2.

In 1914, Pellatt snatched up 80 acres in Concession IV on the west half of Lot 12 from Thomas Harrison for $4,800. Finally, Pellatt paid $3 for the last 144 acres to the Standard Cement Company in 1915. This purchase included the majority of the lake, which was then called Bales Lake, after a pioneering farmer named John Bales who purchased the east half of Lots 12 and 13 in 1848. John Bales is indicated on the 1860 Tremaine's land map before his sons took over the lots: Charles J. had Lot 13 until 1881 and John Jr. had Lot 12 until 1868. In 1911, Pellatt changed the name of the lake to Lake Marie from Bales Lake, as it had been known for thirty-three years prior. In fact, as late as 1931 the name Bales Lake was still on the land registry documents in reference to Lots 12 and 13 in Concession IV. Today, the lake is registered as Mary Lake, although many write it as Marylake after the name of the current operation, the Marylake Shrine and Monastery. As of November 1915, Pellatt had concluded all of his land purchases in King Township. It is not clear whether or not he had ever planned to enlarge the estate prior his financial reverses of 1923.

The transfer of land in Concession IV is quite confusing and very difficult to follow, much like that of his land in Port Credit and Pickering. At times, it's hard to understand if Pellatt was personally buying the land or another entity, but in all cases, the other entities were either headed by Pellatt himself or his associates. According to the land registry documents, Pellatt paid nothing for the 115 acres he acquired from Colonel James Mason, who just happened to be the one-time general manager and director of the Home Bank of Canada's head office in Toronto and a prominent senior figure with the Queen's Own Rifles of Canada along with Pellatt. This certainly gives the appearance that Mason was purchasing the land for Pellatt.

The 144 acres Pellatt accrued via the Standard Cement Company Ltd., which was a Pellatt company, was also purchased at no cost in 1915. This land had been sold to the Standard Cement Company through a Mr. Daniel Urquhart, who was a well-known barrister and solicitor, president of the County of York Law Association and an associate of Pellatt in Toronto. Interestingly, Daniel Urquhart's brother Thomas Urquhart was the thirty-second mayor of Toronto and served that office from 1903 to 1905. These transfers or purchases do not appear to be politically motivated or connected.

The land in Concession III had a less confusing experience in terms of the number of transactions and people involved, but it certainly gives you a glimpse into Pellatt's moneymaking land schemes. Pellatt purchased his 400

acres in Concession III between 1913 and 1915 for $5,602 (approximately $120,000 today). Six years after the purchase of this land, he mortgaged it all for $60,000 on March 22, 1921 (approximately $700,000 today). He mortgaged the 400 acres through a Mr. Walter Wily (Sir John Craig Eaton's man) and then sold the land to the Eatons, Dame Florence McCrae Eaton, to be specific, on January 16, 1922, for $71,000. Since it is not likely that Pellatt paid any of the mortgage in the nine months since it had been created, one could assume that the Eatons assumed the mortgage and paid Pellatt the variance of $11,000 (about $150,000 today). This would mean Pellatt made a profit of $5,398 (the equivalent of $75,000 today) in the nine years he owned the land in Concession III. This sale reduced the estate to 814 acres and contained the property in Concession IV. It is because of this 1922 sale that Marylake, as it is known today, only includes land in Concession IV, but it has been further reduced in size from its 814 acres with two other entities purchasing parcels, which will be discussed later.

At the time Pellatt was selling to the Eatons in 1922, his financial circumstances were rather dire. At this point, he was a year away from the consequences of the collapse of the Home Bank of Canada, his castle had become a major liability and his many outstanding loans were being called in. In short, he needed to liquefy some of his assets, and he was doing this with land sales across the province and other assets around the country.

As mentioned earlier, Pellatt's land in Concession IV had a much more turbulent and confusing life. Purchased between 1911 and 1915 (1903 if you consider land purchased through the Standard Cement Company), it was in 1921 that Pellatt transferred all of his land in Concession IV to his wife, Mary Lady Pellatt. On the land transfer documents after 1921 you see Standard Cement Company Ltd. and the Estates Holding Company, which later became Caledon Securities Ltd. in 1929. It's a tough juggling act to follow but interesting to see how Pellatt worked to shuffle his holdings first to his wife and then as they were taken over by land holding companies/trustees. Appendix A provides a detailed transaction list for each parcel of land that Pellatt owned in King until the time he disposed of it or had it taken away.

The history of the land that Lake Marie is situated on, of course, did not begin with Pellatt. The first individuals to receive a patent from the Crown for any part of land that was part of the Pellatt country estate lands includes the following:

4ᵀᴴ Concession

Date Granted	Grantee	Acres	Lot
May 17, 1802	Henry Windecker	200	E&W Lot 11
August 31, 1831	Canada Company	100	W1/2 Lot 12
March 8, 1832	Canada Company	100	E1/2 Lot 12 *(Incl. Bales Lake/Lake Marie)*
February 1, 1803	Mary Rott	200	E&W Lot 13
December 2, 1802	Martin Fulty	200	E&W Lot 14 *(also spelled Fultz)*
February 25, 1802	George Thompson	200	E&W Lot 15

3ᴿᴰ Concession

Date Granted	Grantee	Acres	Lot
October 18, 1847	Philip Boisvert	100	Lot 11 North Half *(also spelled Boisverd)*
June 24, 1853	Robert Wilson	100	Lot 11 South Half
May 17, 1802	Hepzebat McWilliams	200	E&W Lot 12 *(also spelled Hepsibah)*
December 1, 1802	Lucretia Stewart	200	E&W Lot 13

The above names are not only confirmed on the land registry records themselves, specifically the original King Township Land Patent Map in the Ontario Archives, but also listed in the 1885 *History of the Country of York, Ontario*, which provides a detailed list of the first patentees in King Township. The year 2017 represents the 220th year since the first parcels of land were awarded in King Township. This was five years prior to any patents being registered on lands once part of the original Lake Marie Estate. If we look to the landownership maps of 1860, 1878 and 1917, we get a sense for who once lived on estate lands and we can also see the locations of some of the original homesteads. Of course, none of the original pioneering homesteads remains at Marylake today.

Land registry and census records give us a bit of insight into some of the earlier inhabitants of the land known today as Marylake. For example, over the eighty-three-year period between 1832 and 1915, the east half of Lot

12 in Concession IV, which included the bottom half of Lake Marie, was transferred sixteen times (one time through a will) and passed through the hands of notable Canadians such as Jesse Lloyd of the 1837 Upper Canada Rebellion; Thomas Sproule, the thirteenth Speaker of the Canadian House of Commons and a member of Parliament; and James Whiting (J.W.) Crossley, insurance agent and bailiff who was also a councillor in King Township in 1901 and the elected reeve of King Township in 1902. In fact, J.W. Crossley is credited for having created the name King City, when the land had formerly been known as Spring Hill. Crossley was also the son of one of the original King settlers, Nathaniel Pearson Crossley, who at one point happened to own the adjacent west half of Lot 12 in the Fourth Concession. N.P. Crossley owned this land until his death in 1896, at which time it was deeded to his sons James Whiting and Daniel Oliver, who sold to Thomas Harrison in 1898.

Jesse Lloyd, known principally for his role in the Upper Canada Rebellion of 1837, was the first private citizen to purchase the one hundred acres on the east half of Lot 12, Concession IV, from the Canada Company on November 9, 1836. The Canada Company was a large private chartered British land development company, incorporated by royal charter on August 19, 1826, under an act of British parliament. Its aim was to aid in the colonization of Upper Canada. The company's mismanagement and corruption was an important contributing factor of the Upper Canada Rebellion in 1837. This is ironic because Jesse Lloyd and his wife bought this land directly from the Canada Company in 1836, one year and one month before the rebellion commenced. Interestingly, Jesse sold this parcel of land, which he had bought for $250, just four months later for $600 to a George Mondey on March 3, 1837, making a respectable profit of $350. This sale was just nine months prior to the start of the Upper Canada Rebellion in December 1837. Perhaps Lloyd was looking to finance his contribution to the rebellion—or making sure he didn't have any loose ends in case the uprising didn't go as planned.

Another early pioneer on Concession IV was a Mr. George Stewart, who was born in 1798 and came to Canada in 1823. He purchased the east and west halves of Lot 11 on November 21, 1826, just three years after arriving in Canada, for $150. According to *The History of the County of York Ontario*, when George Stewart arrived on this land it was described as being "quite uncleared." This reference later applauded Stewart and indicated that it was "by [his] industry and perseverance [that] he succeeded in bringing the greater portion of it under cultivation." The reference goes on to say that

"he [Stewart] accumulated a fine property during his lifetime, and was in a position to give his children a fair start in the world." He had a family of sixteen children, twelve were still living at the time of his death. His will in 1863 left the entire 200 acres to his son Robert Stewart. Robert owned the land for the next 23 years until selling to Benjamin Lloyd (nephew of Jesse Lloyd) in 1886 for $9,000.

Pellatt, like most gentleman farmers, looked to talented architects to design his farm and farm estate buildings. Unfortunately, Pellatt did not keep any architectural records pertaining to the developments at Lake Marie, which means we are not able to concretely recognize or connect any architects to the outstanding designs on the estate. There does seem to be one exception, that being the large red horse barn on the south end of the Seneca College King Campus property today (specifically the east half of Lot 11 in the Third Concession), which has come to be accepted as having being a product of architect E.J. Lennox, the architect whom Pellatt was working with to build Casa Loma at the same time. While it is true that the land the large red horse barn sits on to this day was owned by Pellatt for a nine-year period between March 1913 and March 1922, this research did not come across any conclusive evidence to substantiate it being a Lennox design. It would seem to make more sense that Lennox was associated with Pellatt's

Pellatt Grove street sign, King City. *Author's photo.*

fine brick and stone dairy barn or the stone gatehouse and entrance gate at Lake Marie, as these buildings are reminiscent of Casa Loma. Regardless, evidence has not been found to support Lennox's involvement at Lake Marie, nor that of any architect for that matter. The research for this book endeavored to locate building permits on Lake Marie property between 1910 and 1920, as these would have not only confirmed the build dates but also typically have included the name of the architect(s) involved. However, the King Township building permit records do not go back this far.

Lack of proof as to the identity of the architects involved with early Lake Marie construction aside, Lake Marie has provided King Township with a spectacular glimmer into the history of the gentleman farmer

in Canada. And with the exception of the architectural remnants of the original Pellatt country estate, much of which still stands today, the only other homage to the history of Pellatt in King Township is a street named for him, Pellatt Grove, a quiet cul-de-sac with only six residential addresses in King City, off of McClure Drive, a mere one kilometer south of the entrance to Marylake.

Remnants of large country estate farms like Lake Marie are not particular to just King City or Canada for that matter. Rural areas across North America are dotted with these large country estates created by the exceptional wealth of the late nineteenth- and early twentieth-century captains of enterprise. The concept of the gentleman's farm and country estate inspired the creation of extraordinary homes on some of the most idyllic landscapes. These country homes display some of the very best of classical architecture, giving every appearance of abundant wealth all the while trying to appear modest and less pretentious, a feature best demonstrated through the humble design of Pellatt's bungalow residence at Lake Marie but completely discounted when you consider the absolute magnificence of Pellatt's farm buildings. The next chapter will take the reader on a walk through the many structures that composed the Lake Marie Farm and Estate in its glory days. Keep in mind that what we look back on reminiscently as a country estate was merely "the farm" to gentlemen like Sir Henry Pellatt.

3

A Knight in King

Sir Henry Mill Pellatt was one of the first of the local gentry to go back to the
land in a pilgrimage which has spread widely with the growth of the automobile.
—*Frederick Griffin*

What exactly was on the land prior to the Pellatt purchase is difficult to say, as none of the land transfer documents speaks to dwellings, farm-related structures or outbuildings in the purchase and sale information. However, the 1878 King Land Ownership Map indicates that there were no less than eleven residential dwellings on the land that made up the 1,214-acre Lake Marie estate, erected about three decades prior to Pellatt making his first purchase in King.

Several newspapers and magazines have written their version about how Lake Marie Farm and Estate came to be and have hinted as to what had been there prior and what Pellatt installed in his earliest days of ownership. An article in the *Toronto Star Weekly* from October 1913 titled "Pellatt Farm at King Like a Baron's Estate" provides some helpful descriptions. The article stated that "its official name is Lake Marie in honour of his wife Lady Mary Pellatt. The farm is really several farms thrown into one. Many years ago Sir Henry bought the lake and some fifty acres, pulled down the *old residence* and built in its stead the present bungalow overlooking the lake." The article went on to say that "at first his idea was to merely utilize it as a fishing lodge. Then seeing the ground was suitable he bought another 350 acres for a golf course. Subsequently, he bought four other farms and kept adding on, until

finally he had a compact property modeled very much on the style of an English country estate. Finally, he started farming on a large scale."

The aforementioned article mentions a Mr. T. McVittie, Pellatt's superintendent, who shows up on the 1917 King Land Ownership Map on the east half of Lot 12 in Concession IV. It is understood that as the superintendent he did reside on the property, though his name is not seen on the land registry documents. The *Toronto Star Weekly* also indicated that Pellatt was reconstructing all of the farm buildings that were in any way old or out of date, he employed twenty men and he had a retreat house for the single men and planned to build seven cottages for the married men.

When McVittie passed away on November 16, 1929, in King due to complications of pneumonia, an article in the *Toronto Daily Star* described him as the general manager of Sir Henry Pellatt's one-thousand-acre country estate at King and one of Canada's leading horticulturists. The article indicated that the funeral was held at McVittie's home, 334 Walmer Road; not coincidentally, this is the first residential address north of Sir Henry Mill Pellatt's Casa Loma Stables and greenhouse complex in Toronto. Speaking to McVittie's close ties to the King community, Reverend James Miller, pastor from St. Andrew's Presbyterian in Eversley, officiated the funeral. Sir Henry Mill Pellatt acted as honourary pallbearer. Lady Eaton, Sir Henry Pellatt and many of McVittie's affiliated associations provided wreaths, which numbered over fifty. A few of the local associations that provided a wreath included the Lake Marie Employees, the Lake Marie and King Athletic Association, the Lake Marie Hunt Club, the Laskey Hunt Club and the pastor and congregation of Eversley Church.

As mentioned in the previous chapter, not one of the buildings that was on the site pre-Pellatt is present today. However, there is an interesting history with respect to an original pioneer log cabin that Pellatt had moved to his land from another location in King. At best calculation, the log cabin is estimated to be more than two hundred years old today. This would make it one of the oldest standing and still actively used buildings in all of King Township. This early Ontarian/Upper Canada/Home-District log cabin is currently utilized as the gift shop for the Shrine at Marylake. Several sources speak to Pellatt having moved this cabin to his Concession IV property from land he owned on the neighbouring concession. It is rumoured to have once been utilized by William Lyon Mackenzie, the first mayor of Toronto and leader of the Upper Canada Rebellion of 1837. It is not known if he resided there at one point in time or if it was one of his hiding locations after the failed 1837 rebellion. Little by way of concrete information has been found

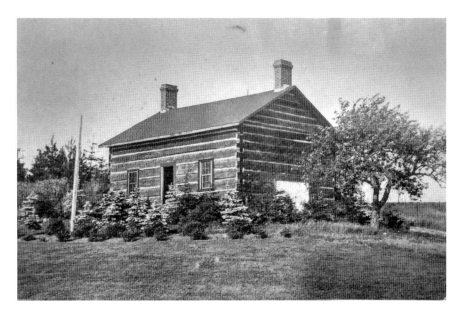

Pioneer Log Cabin at Lake Marie, circa 1920, earliest known image of log cabin. *Metro Toronto Reference Library.*

on this log cabin, most of it sourced from newspaper archives and magazine articles, and it is anecdotal at best. Given the exceptional age of the facility, its relevance to Ontario heritage and Pellatt's foresight in preserving it, several excerpts from the available sources are important.

The *Toronto Daily Star* made reference on several occasions to the log cabin at Lake Marie. As early as September 18, 1922, it says that "a surprise for the guests and the girl guides during an event at Lake Marie was a visit to Sir Henry's hundred year old log house." The article went on to say that "the log cabin had been transformed into an impromptu 'express office.'" On June 27, 1927, the *Star* wrote that it was "a humble log cabin to the rear of the house that attracted the most attention" and that "this architectural relic of Ontario pioneer life is not as humble as it was years ago as it has been fitted with electric light and wainscoting and turned into a museum and clubhouse for various societies from the nearby village of King."

Later, on November 25, 1929, the *Toronto Daily Star* reported, "Sir Henry Pellatt visited his country estate at King yesterday and received a number of friends in the old log cabin adjoining the house, where beside a great log fire, a delightful luncheon was held." In 1935, the last year that Pellatt resided at Lake Marie, a newspaper article showed a picture of the cabin accompanied by this description: "the old log cabin, transported by Sir

Henry to its present site near the main residence dates back to the days of William Lyon Mackenzie. It has been used as a club room by the villagers." A report conducted on the Lake Marie property in 1935 stated that the log cabin "contains a living room with fire place, kitchen with sink and running water. This log house is 100 years old." This would date the house back to 1835 and certainly place it during the lifetime of William Lyon Mackenzie, who lived from 1795 to 1861.

A special feature on Lake Marie in *Canadian Homes and Gardens* from May 1929 reads, "A landmark on Sir Henry Pellatt's estate is a 200 year old log cabin, unaltered as to its exterior, but modernized within and outfitted for the comfort and conveniences of men guests. A huge fireplace is flanked by a collection of ancient fire-arms. Here too, is Sir Henry's military collection." If the cabin was 200 years old in 1929, that would mean it was built in 1729, making it closer to 290 years old today. A final note from the *Toronto Daily Star* on June 27, 1932, stated that "a favourite spot was the old log house, over 150 years old whose timbers were hewn with the adze, before the axe came into use in these parts." If the cabin was 150 years old in 1932, that would take its origins back to 1782 and closer to 235 years old. The very first land patents awarded in King Township were in 1797, and there were six awarded at that time. It wasn't until 1802 when five of sixty-four patents were awarded for land that would one day be part of the Lake Marie Estate, two of which were in Concession III (Lot 12 and 13). But there are no records of a Mackenzie owning the land. At the very least, contemporaries will likely agree that the facility is over 200 years old today.

A final point as to the provenance of the log cabin is that perhaps the earlier comment about the cabin being "dated back to the days of William Lyon Mackenzie" has been confused with being connected to William Lyon Mackenzie and was merely meant to provide a reference to a period of time, not the individual, and actually had nothing to do with William Lyon Mackenzie himself.

The *Era Banner* newspaper often mentioned the log cabin. On December 4, 1968, the *Era* indicated that "a log cabin moved intact by Sir Henry from Lady Eaton Lake, still stands on the grounds as a storage room." For reference purposes, the former Lady Eaton Lake (now Lake Seneca) is situated on the east half of Lot 12 and 13 in the neighbouring Concession III. On October 10, 2000, the *Era Banner* noted that "an ancient pioneer log cabin was moved from the Third Concession to the estate" but does not reference a particular lot. A 1927 article also for the *Toronto Daily Star* read, "In the ancient log cabin that flanks one of the spacious lawns outside the

Left: Stockbrokers enjoying a day out at Lake Marie. *From the* Toronto Daily Star *(1900–1971), July 12, 1913, ProQuest Historical Newspapers.*

Below: William Lyon Mackenzie King with Sir Henry and Lady Pellatt at Lake Marie, 1911. *City of Toronto Archives.*

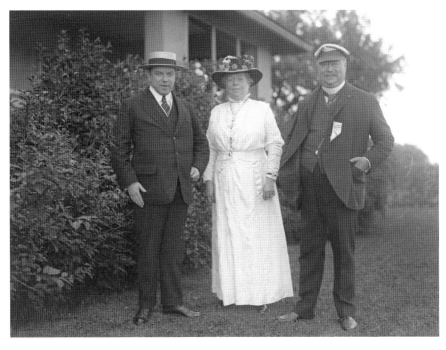

house, Sir Henry has stored a collection of small arms of every make and description and also a unique collection of coloured prints showing the uniforms and accoutrements of the various regiments." The article went on to include that "Sir Henry's own trophies as a soldier and one of the world's greatest distance runners are also prominently displayed." Many of these items were among the treasures that Pellatt kept until his death.

Notwithstanding the exceptional age of the log cabin, the connection to William Lyon Mackenzie makes the story and historical significance of the log cabin all the more interesting. Mackenzie was born in 1795 in Scotland and didn't immigrate to Canada until he was twenty-five years old. On July 1, 1822, Mackenzie married Isabel Baxter. They had fourteen children, including a daughter named Isabel Grace Mackenzie, who was the mother of William Lyon Mackenzie King. William Lyon Mackenzie King went on to serve as prime minister of Canada, from 1921 to 1926; 1926 to 1930; and 1935 to 1948. Mackenzie King visited Lake Marie on more than one occasion.

The story of William Lyon Mackenzie and his possible hideout in King after the Upper Canada Rebellion has always been a fascination to locals and historians. In fact, in January 1932, the *Newmarket Banner* had a call out to its readers looking for any morsel of information regarding William Lyon Mackenzie and the King/Aurora community. In an article titled "What's the Story about Mackenzie," the paper called on locals for information on William Lyon Mackenzie hiding out somewhere near Aurora after the failure of the 1837 rebellion. An unidentified gentleman who was writing a book on North York tales and traditions was pleading for anything, no matter how small, that might help him prove this story. The author noted, "I have lately heard in more than one quarter, that when he [Mackenzie] was escaping after his fight at Montgomery's Tavern at Eglinton, William Lyon Mackenzie hid for a while in a cave about 3 miles southwest of Aurora." Three miles southwest of the core of Aurora would put you roughly at Eversley in King, which makes the story of the log cabin on Concession III land in Eversley all the more believable. Regardless of whether or not the cabin is connected to Mackenzie in any way, it is exceptional in and of itself.

Pellatt was ambitious and made quick work of establishing his country estate, which seems contradictory to earlier indications that the estate was originally being planned as nothing more than a remote hunting and fishing lodge. If we look to a few of the earliest articles written about Lake Marie, we get a sense for what he built first, and more importantly, we discover that he was building on land that he did not yet personally own according

to land registry documents. This is an interesting discovery. The earliest article found describing Lake Marie was a special feature for *The Canadian* magazine in the May–October issue of 1912. If we only consider land in Henry Pellatt's name as of October 1912, the total estate should be only 590 acres. However, this special feature titled "Henry Mill Pellatt: A Study in Achievement" states that "one of Sir Henry's farms is located at Lake Marie, about twenty miles north of Toronto" and references the size as "consisting of 1,000 acres, and is divided into four portions, each with its own distinctive buildings, management and stock." This particular article also mentioned his two other large farms in both Picking and Port Credit "conducted in an equally systematic manner." This mention of 1,000 acres is such a gross overstatement for 1912, almost doubling what the land records indicate for that time, that it forces closer examination.

If, in 1912, the 144 acres of land owned by the Standard Cement Company in Concession IV (which had been purchased in 1903) was factored in, we get a total of 814 acres, which is the full segment that Pellatt owned in Concession IV. This all but suggests confirmation of that fact that he was buying land for personal use through companies he managed, for it is not likely that a non-Pellatt company would allow him to build on its land. It also demonstrates how Pellatt came into so much land at such an exceptional price, as the expense was hidden as a company expense with Pellatt paying nothing when it was transferred to Pellatt personally between 1914 and 1915. Having made this discovery, *The Canadian*'s statement of the estate being 1,000 acres still overestimates the size of the estate at that time by 186 acres.

This variance, of course, forced the examination of other players who may have been purchasing land for Pellatt. If we look to the Third Concession, the land registry documents indicate that Pellatt didn't own any land here until after the article in 1913. But if we look at the parcels of land owned by Pellatt's comrade in the Queen's Own Rifles and his associate with the Home Bank (among many other affiliations), we see that Colonel James Mason owned 115 acres as early as February 1912, which would bring the total Pellatt estate to 929 total acres—assuming it was purchased through some backhanded dealing for Pellatt—bringing the total acreage closer to the referenced 1,000-acre mark. It should not be surprising that Pellatt personally paid nothing for the 115 acres from Colonel Mason but worth noting that Mason paid $10,000 for this land in 1912. Lastly, given the 71-acre shortfall, it can be noted that although Pellatt did not purchase 85 acres from John Cairns for $5,000 until 1913, he did have an agreement with

Cairns noted in the land records as early as August 1912. This takes the total estate to 1,014 acres, a variance most can accept.

Why is this important? It's important for one main reason. It has always been said that Pellatt started purchasing land, thus showing interest in King Township, in 1911. But in truth, that statement needs to be revised. Pellatt was purchasing land in his own name in King Township as early as 1911, but through the Standard Cement Company he purchased land in King as early as 1903 and through Daniel Urquhart as early as 1902, which places Pellatt's interest, and perhaps his person, in King Township eight to nine years earlier than previously understood.

In addition to forcing the reader to look closer at the land records, the other benefit of this 1912 article in *The Canadian* is that it tells us a bit about what Lake Marie looked like in its very earliest days of operation. The article describes the estate thusly: "There one does not see only green grass and growing roots and grain; for there are thoroughbred horses and cattle and sheep, turkeys, pheasants, pigeons, chickens, peacocks, guinea fowl, partridges, deer, squirrels. The lake is stocked with bass, and there are runs for the partridges. One sees thoroughbred Percherons and belted cattle. There are tennis courts and golf links."

There have been many articles alluding to the tennis court and golf at Lake Marie. A 1919 *Toronto Daily Star* article mentions that "Sir Henry and Lady Pellatt received their guests on the verandah with its wonderful view and high tea was served at small tables on the tennis court." However, pictures have not been found to support the existence of tennis courts or golf links on the property.

Other items of particular interest on the property were the cannons. Of course, no one can argue that Pellatt wasn't a military enthusiast and collector. Not only was his log cabin home to several military-related medals, guns of every sort and mementos, but he also had several cannons on his Lake Marie property. The *Toronto Daily Star* of June 21, 1934, described these as "cannons, dating back to the war of 1812." How Pellatt acquired these is unknown. Nor is it known when they came to Lake Marie and where they went when they left. In a July 1927 article, a reporter noted that "at sundown the gun on Sir Henry's pacht [farm] boomed twice simultaneously." And later, on July 2, 1935, the *Toronto Daily Star* references the cannons with "one of the many cannon located on the property." An interesting way of describing the presence of the cannons came from the newspaper in June 1926, as thousands were making their way to Lake Marie for the fiftieth anniversary celebration of the Queen's Own Rifles: "The military shrine to

which this Toronto multitude made pilgrimage, despite the cannon guarding its lawns, is consecrated in agriculture." Many pictures of the estate clearly show two cannons on the west side of Pellatt's bungalow with their aim facing across the lake, but other references indicate there were more.

In the May–October 1912 issue of *The Canadian* magazine there was a feature on Pellatt titled "Henry Mill Pellatt: A Study in Achievement." Of course, the feature spoke in great lengths about Casa Loma and his role with the QOR, but it also celebrated his achievements and pleasure in farming. Excitingly, this publication provides us with a first glimpse of Pellatt's bungalow estate at Lake Marie and shows Pellatt's personal barn for his horses in the background; neither building stands today. It also shows the location of the log cabin in 1912; it has since been relocated. In speaking of Pellatt's farming enterprise, the piece confirms that Pellatt had three farms: Lake Marie and large farms in Pickering and Port Credit. The story goes on to say that Sir Henry took pleasure and personal interest in all of them and that "nothing pleases him more than to spend one or more days looking them over, and that in these things Lady Pellatt naturally has a keen interest."

A *Toronto Daily Star* article on the sale of Lake Marie to the Basilians that featured many images of buildings on the property as well as the much-talked-about cannons. *From the* Toronto Daily Star *(1900–1971), July 2, 1935, ProQuest Historical Newspapers.*

Having been pieced together through the purchase of many individual parcels of land, most of which had been active farms prior to the Pellatt purchase, Lake Marie Estate was never just one farm. The 1,214-acre estate, sprawling across two concession blocks, included as many as four to ten working farms at any time. In Pellatt's time, the estate served many purposes for the community and acted in vital roles, such as employer, landlord, community/recreation and leisure centre, dance hall, meeting space, hunting grounds, fishing site, vacation retreat and more.

Unfortunately, none of the buildings on the estate prior to Pellatt's ownership remains, with the exception of the relocated log cabin. Every building standing on the property today was built during Pellatt's occupation, with a few added during Augustinian occupation (1942–today). Lake Marie estate sits virtually frozen in time, aside from the fact that several of Pellatt's buildings are no longer standing.

Like most estate farms of the time, providing accommodations for the working staff was essential. Working hours were unregulated and long in those days. The average person did not have a vehicle to commute to work. In addition to having a multi-room boardinghouse for the single men, Pellatt also provided accommodations to his workers in the West Farm House, the Northwest Farm House, the Northeast Farm House, the lodge/gatehouse, the Dairy/Herdsman's House and several other worker cottages. There was also a home on the neighbouring Concession III known as the West Farm House. At its peak, the estate had no fewer than ten barns and farm-related buildings, including the West Barn (Concession IV), West Barn (Concession III), the large red horse barn (Concession III), Northwest Barn, Northeast Barn, main brick horse barn, main brick cow barn, turkey barn, Pellatt's barn, the hen house, the dairy building, the sawmill, large implement shed, the log cabin, the main chicken house, four smaller chicken houses and Pellatt's garage.

At its peak, Lake Marie is believed to have housed more than twenty men with their families. Later, as the number of staff on the farm was reduced and with commuting to and from work having become more common, the boardinghouse became the residence of the farm manager at Lake Marie. This home was considered a modern building, suitable for a master of an estate in and of itself, and was the one time home of Thomas McVittie, esteemed horticulturalist, who served Sir Henry faithfully for twenty-two years at Casa Loma and then Lake Marie.

Without a doubt the most spectacular buildings Pellatt built on the property include the cut stone lodge/gatehouse with its stone entrance

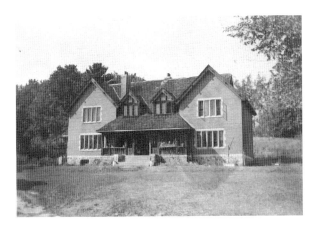

Pellatt's home for single farming men who worked at Lake Marie, later the farm manager's home. *City of Toronto Archives.*

arch, the large brick horse barn/granary and the cut stone dairy building/herdsman's house reminiscent of a medieval castle. Pellatt's original bungalow estate should also be on this list; however, all we are left with are pictures and drawings of his former country estate home, as it was demolished in the early 1960s to make way for the current Marylake Shrine. The order in which Pellatt began to build on Lake Marie is not clear, but we do know that he built quickly, with the majority erected between 1911 (when he returned from Aldershot) and 1913. Keep in mind, he was also feverishly developing Casa Loma at this time.

A previously mentioned 1913 *Toronto Daily Star Weekly* article read, "The farm is really several farms thrown into one. Many years ago Sir Henry bought the lake and some fifty acres, pulled down the old residence and built in its stead the present bungalow overlooking the lake." The article went on to say that "subsequently, he bought four other farms and kept adding on, until finally he had a compact properly modeled very much on the style of an English country estate." This lends one to believe that one of the first things he built on the site was his bungalow, and perhaps he had no intention of building more at that point. But as he started to expand his land and take on existing farms, the concept of gentleman farming may have taken hold.

Credit for the landscape that surrounds Lake Marie goes to God, or more specifically, the Wisconsin glacier that etched the landscape as it retreated over the land 2.5 billion years ago. This land is now part of the Oak Ridges Moraine, and we can thank the glacier for the stone, gravel, till and sand deposited in this area as it retreated. The glacier's withdrawal is also responsible for the creation of the kettle lake. A kettle lake usually has no surface drainage and is spring fed. They typically range in depth

Aerial image of Lake Marie, circa 1946. *National Air Photo Library.*

from ten to one hundred feet; Lake Marie's depth meets the deep end of that spectrum. There are many other kettle lakes along the Oak Ridges Moraine, Lake Seneca on the adjacent Seneca College land being its closest neighbouring lake.

There are no shortages of published descriptions of Pellatt's Lake Marie Estate, in contrast to the noted lack of published information on his supposed farm estates in Pickering and Port Credit. Most of what has been said about Lake Marie speaks to its romantic setting. A June 1926 article in the *Toronto Daily Star* mentions that "like a miniature Lake Louise, a serpentine of turquoise in the emerald setting of miniature-mountains, this jewel carved by the glaciers lies several miles to the west of the motor-polished highway of north Yonge street." The article continues, "You turn from the stream of Lake Simcoe traffic above Bond Lake where the weeds grow between the ties of the lamented Schomberg electric railway. After a few miles of the charm and farms of North York's agricultural paradise you come to the village of King which usually dozes at four cross roads." Perhaps the best description of the estate from the same article is that "it lived up to the postal service which at its birth christened it *King* City." An article on October 19 said of the estate, "It would be difficult to conceive a more delightful property of its kind—whether for agricultural, residential or sporting purposes—than Sir Henry Pellatt's farm at King, some twenty-five miles from Toronto."

A circa 1940 monograph created for the Kiwanis Club by Frederick Griffin says that "the fine country estate of 1,000 acres was at Lake Marie in King Township. The beautiful property with cut stone buildings, one of them reminiscent of a feudal manor house." The article went on to say that Pellatt had "spent much time there in the role of country squire and until late in life he was a crack-shot [skilled marksman] but enjoyed target shooting more than killing, for at base, in spite of his military preoccupation, he was a man of peaceful and benevolent instincts."

Later, in a June 27, 1927 article from the *Toronto Daily Star*, the lake is described as a "little lapis lazuli lake." In 1919, the paper referred to it as "the lovely blue lake with its canoes and small boats…a refreshing spot." In 1929, *Canadian Homes and Gardens* described the lake as "a crescent-shaped lake, half a mile of sparkling spring water, stocked with bass and perch." The magazine went on to explain that the lake itself was the reason for purchasing the property and that several years of negotiation were required before the other six adjacent farms could be purchased. The lake was and is spring fed and approximately one hundred feet at its deepest. The total acreage of the lake is approximately thirty-five acres, though some sources have gone so far as to almost triple its size up to ninety acres.

The *Daily Star*, writing about Lake Marie in 1927, described the estate property as having "a landscape of exceptional beauty, Lake Marie in its

setting of North York hills does not need to bow too low before Lake Louise and all its crown of mountains." The same paper said of the estate during a visit later in the same year that "Sir Henry Pellatt's beautiful summer home, overlooking the waters of Lake Marie, with its tall flagstaff and fluttering ensign and the many old pieces or ordnance did yeoman service for Canada's military units in a bygone age."

Canadian Homes and Gardens painted an enviable picture of Lake Marie as being composed of "sturdy Maples, stately Pines, slim white Birches—field, forest and water—cultivated farm and natural wilderness—such is Lake Marie Farm, the country place of Sir Henry Pellatt, north of the village of King, and twenty-five miles north of the City of Toronto." The article continued to describe "an imposing gray stone gateway and a gray stone lodge—both reminiscent of England—extend[ing] an invitation to turn in from the main road. A curving driveway nearly one mile long, its borders starred with cornflowers, runs between Evergreens and Elms."

An article for the *Toronto Daily Star* from July 2, 1935, just before Pellatt's tenure on the property ended, reads that the "property is a unique one, not only on account of the number and constructional excellence of the buildings thereon, but also because of its vistas of scenic beauty, a feature being some finely wooded areas of rolling countryside and a beautiful 90 acre lake, well-stocked with trout and bass, and known as Lake Marie." Here is one of the many references that grossly overestimates, in fact, almost triples the size of the lake.

One feature of the property that has never been lost on guests, regardless of the period, is the breathtaking approach. A June 28, 1926 article for the *Toronto Daily Star* revealed that upon arrival you would see "high iron, stone pillared gates and were in Sir Henry Pellatt's picturesque farm." It went on to say that "it is right to call it that [a farm] rather than an estate for the barns were larger than the house." Another article a year later reads that Pellatt's "stone lodge gate bears a constant invitation of welcome to his delightful country estate." The stones for the entrance arch and fence, the gatehouse and dairy were all quarried on the property. Evidence of at least three stone quarries exist on the property today.

It is perhaps astonishing to those who appreciate heritage architecture that only the gatehouse and stone arch are designated on the property (By-Law 84-107). The designation specifically covers "all of the main iron and stone entrance gates on the west side of the 4th Concession Road (Keele Road) and attached stone fences, the exterior only of the adjacent stone gatehouse and the immediate lands on which they stand under the Ontario

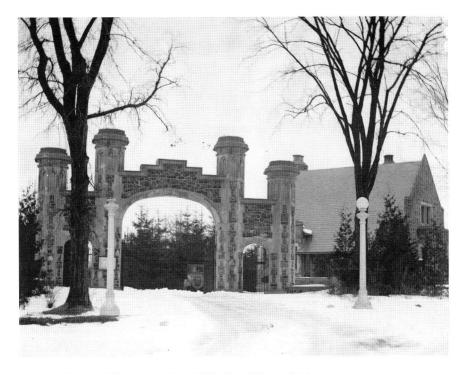

Entrance Gate and Gatehouse, circa 1922. *City of Toronto Archives.*

Heritage Act." The gatehouse and entrance gates were 73 years old at the time of designation, and as of this writing, they are 106.

Pellatt's Lake Marie was also famous for its deer and elk park to the north of the lake. In total, the enclosure consumed 170 acres of the estate. Pellatt had a specially designed fence that was used to encapsulate his deer and elk park, with posts that were ten to twelve feet above ground. The fence around the lake and deer park was said to be four miles in length. There has been much speculation surrounding how Pellatt acquired his beasts and when the enclosure for the deer and elk park was developed. Family pictures as early as 1914 include the well-stocked deer and elk park on the grounds, as does a June 23, 1919 article for the *Toronto Daily Star* that mentions that "an ideal day was spent visiting the dairy, the stables, the chickens, the herd of deer and the angora goats." In a 1935 report on the Lake Marie property, the enclosure is described as "an elk park consisting of swamps and timber lands." The report went on to say that "the elk park has to disappear, the swamps therein drained, stumps, dead wood, scrub woods cleared, timber thinned and after that is finished, seeded with a grass mixture with predominant Dutch clover."

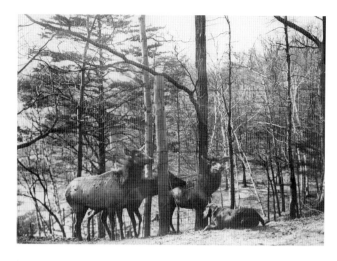

Deer and elk park. *City of Toronto Archives.*

There has always been a story circulating among the locals about Pellatt receiving the deer and/or elk from King George V and Queen Mary, supposedly as a thank-you for bringing the Queen's Own Rifles to Aldershot for six weeks of military manoeuvers in the fall of 1910. Indeed, there is evidence to support that some of the deer on the site came from Their Royal Highnesses, but the deer park was clearly there in advance of the gift. An article for the *Richmond Hill Liberal* on June 23, 1927, seventeen years after the Aldershot event, stated that "from authoritative sources it is reported that the deer which King George and Queen Mary presented to Sir Henry and Lady Pellatt will not arrive until the early fall at Lake Marie, [fall 1927] their summer residence." The article went on to say that "it was stated at the office of Sir Henry that no word has been received of the shipping of the deer, as it was explained that the deer are probably running wild and will have to be netted and shipped at a certain time of the year. At the present time there is quite a large heard of deer at Sir Henry's estate but none from the grounds of a king." King George V had bestowed the CVO on Pellatt for Aldershot. It does not seem likely that King George V would have waited seventeen years to provide Pellatt with deer promised to him back in the first year of his reign in 1910. Also, given that by June 1927 Pellatt had already been married for three months to his second Lady Pellatt, Catharine, who was responsible for founding the Queen Mary's Needlework Guild in Canada at Queen Mary's request, it seems more likely that the deer were bestowed upon the Pellatts as a wedding present.

Canadian Homes and Gardens wrote of the deer and elk park in 1929: "If you are lucky, when you visit Sir Henry Pellatt's country estate near King,

Ontario, you may catch a glimpse of the famous elk herd. Their number is estimated between forty and fifty. The entire lake and a goodly portion of forest to the north is heavily fenced, and within this enclosure the deer live free, happy and secure." An article for the *Toronto Daily Star* from July 2, 1935, just before Pellatt vacated the estate, said of the deer park that "the bush at present shelters the famous herd of deer that has been so long of interest to visitors to the estate" and went on to say that the "deer will likely be disposed of under the new ownership."

Speaking to the end of the deer and elk days at Lake Marie, in the 1970s, a woman named Marjorie Nazer wrote a twelve-page account of her time at Marylake. Nazer lived on the land between 1936 and 1939, during part of the period of Basilian ownership. In her journal, Nazer writes that they had used the hide of one of the elk that had died on the farm for the seat part of the primitive chairs they had made. The existence of this journal proves that the elk enclosure remained not only intact but also stocked after Pellatt had sold the land. Nazer discussed the elk's fate in her journal: "Sir Henry had a herd of them, and when Father Oliver first took over the estate there were still about a dozen roaming about. Unfortunately, they had to go because they had no respect for the farm crops." She went on to say that "there was a thrilling and exciting day when 'real' cowboys arrived at the lake, built a corral and the poor beasts were captured and shipped off to the O'Brien's estate in the Gatineau Hills."

Many of the original deer and elk enclosure fence posts and gates remain on the property today and can be found as you follow the white blazes that traverse the property via the efforts of the Oak Ridges Trail Association, which has had a land-use agreement with the current owners, the Augustinian Fathers (Ontario) Inc., since 1994.

The building on the estate that has garnered the most mention is Pellatt's modest country residence, the bungalow. And since the building has been demolished (over fifty years ago), the reader might enjoy some of the earlier descriptions of Pellatt's modest retreat. The May 1929 issue of *Canadian Homes and Gardens* magazine wrote that "beyond the fences are the evidences of a real farm—herds of Holsteins, flocks of sheep, well-tilled fields, substantial farm buildings—until a sudden turn in the road discloses a bungalow. The bungalow itself is unpretentious—a building of gray stucco, with wide verandahs and low-spreading roof. It is modelled after the old English hunting lodges—the central room extending the two stories." The article also repeated what many publications have noted, that the bungalow—located one thousand feet above sea level—remained cool even in the summer.

Remnants of the original Pellatt fence posts with white blazes/trail markings. *Author's photo.*

The same article later references Pellatt's residence as "the bungalow, which is the master's living quarters for the summer season"

Interestingly, an October 1913 issue of the *Toronto Daily Star* indicated that "next year [1914] a substantial residence is to be built to replace the bungalow, and in its present site....The bungalow residence itself is a pretty and comfortable little place—an ideal fishing-lodge in fact, but as mentioned, it will before long be replaced by a house more in consonance with the general magnitude of the estate and its operations." The article went on to say that Pellatt was considering keeping the bungalow and merely relocating it elsewhere on the lake as a cottage for guests or an additional home for farm staff. We of course know that Pellatt did not demolish or relocate his original bungalow (hunting/fishing lodge) but merely renovated it over the years to be more accommodating for larger events and guests.

Though most often referred to as the bungalow, Pellatt's Lake Marie residence has also been referenced as the lodge and the chalet. The earliest print reference found was from July 1913, when Pellatt had entertained the Toronto stockbrokers at Lake Marie. The article indicates that one of the photos was taken to show a "view of Lake Marie from the verandah of the [Pellatt's] residence." This article however, does not show any pictures of the buildings on the property, merely the gentlemen stockbrokers enjoying the day, the rolling landscape and the Holstein-Friesians already at pasture on the site. Later that year, in October 1913, Sir Henry's Lake Marie dominates the front page of the *Toronto Star Weekly* with not one but three different titles and subtitles splayed across the cover: "Millionaire Farming: Sir Henry Pellatt's Splendid Estate near Village of King," "Magnificent Country Home of Sir Henry Pellatt" and "Pellatt Farm at King: Like a Baron's Estate." The five images for this article included a headshot of Sir Henry, the boardinghouse, the horse barns, a Dutch

Pellatt's Bungalow west façade. *Marylake Archives.*

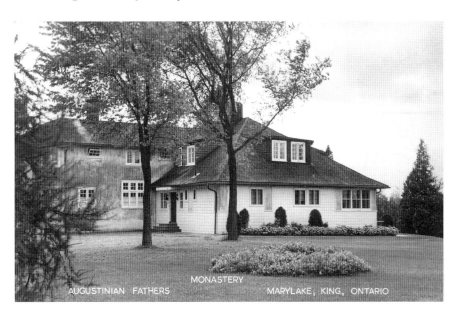

Pellatt's Bungalow north façade. *Marylake Archives.*

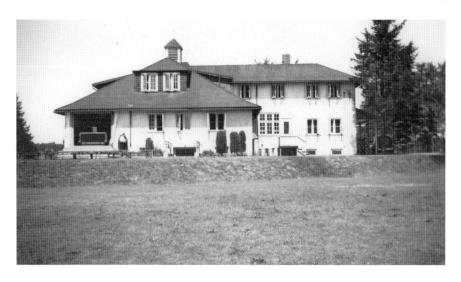

Pellatt's Bungalow south façade. *Marylake Archives.*

Belted bull outside of a barn (a species rare in Canada at the time) and a few of the calves on the grounds, with an inset image of Pellatt's bungalow.

In 1927, the *Toronto Daily Star* said of the home, "The chalet of Lake Marie is even more typical than that of Lake Louise of hospitality and sunny welcome." The bungalow, although originally built to be nothing more than a lodge for hunting guests, was a well-designed country estate home with excellent sight lines across the lake and property. It was situated at the heart of Pellatt's Concession IV property on the east half of Lot 12. The residence had a long lifespan, believed to have been built sometime between 1911 and 1913. Lake Marie was a weekend and summer residence for ten years until Sir Henry Pellatt and his first wife, Lady Mary, vacated Casa Loma in 1923 due to financial reverses. It was after the collapse of the bank in August 1923 that the Pellatts found their time at Lake Marie becoming more and more frequent, to the point where it was considered a primary residence during fair-weather seasons. After Mary died in 1924, Lake Marie at times served as Pellatt's primary residence between 1924 and 1935, but even during these periods, he often returned to a place in the city during the winter months. Pellatt's modest Lake Marie bungalow was demolished in 1963 to make way for the current Marylake Augustinian Monastery and Shrine. Over the bungalow's lifespan, it served as a summer or primary residence for Pellatt; it was the home of two prominent women during the Basilian occupation, with the basement serving as a primary

school; it was the main residence for an agricultural farm school and a chapel and monastery, its total lifespan being just shy of fifty-three years. This is remarkable when you consider that it was slated for demolition after only being in existence for a couple years back in 1914. The building went through several renovations over the decades to meet the needs of each successive owner.

Of course, from its inception, the home had to accommodate a team of house servants for the new knight in King and his Lady Mary. Pellatt's bungalow residence had two floors above ground and a basement. The servants had their own quarters to the rear (east side) of the home. Pellatt's bungalow was perched at the highest point around the lake on the eastern shore of Lake Marie, just fifty meters from the water's edge. The home was designed for ease and comfort. A lazy verandah surrounded the house on three sides to the south, west and north. The back (east) section of the home contained the kitchen and pantry on the main floor, and above the kitchen there were three servants' bedrooms, a servants' bathroom and originally a small upper verandah that was later enclosed and converted into another small room. The east/servants' side of the house on the upper level did not have access to the family quarters on this floor.

On the west/family side of the home, the main floor consisted of the great hall (large entrance foyer), a small office for Pellatt to conduct business while out of the city, a large dining room, the west bedroom, the east sitting room/bedroom, a full bathroom and a special feature of the home, the living room. The living room was the largest room in the home and most certainly the showpiece. It was situated at the center of the house and extended the two stories. It had a large, welcoming stone fireplace. In 1927, the living room was described in the *Toronto Daily Star* as having a wealth of flowers throughout from the garden, a unique collection of mounted wild fowl and other birds and Sir Henry's extensive collection of athletic medals and military souvenirs. The article went on to say that "the house itself is crammed full of those relics and trophies, treasured by every regiment as incentive to that most desirable of all regimental assets, esprit de corps [sense of unity]." A 1934 article for the *Aurora Era Banner* indicated that the home boasted "original prints of the crests of every regiment in England." Another 1927 article for the *Newmarket Era* said of the living room, "Sir Henry and Lady Pellatt received in the big gray stucco living-room which was done with pink peonies and unique decorations of birds and mounted water fowl." The living room hosted numerous events. In September 1922, the *Toronto Daily Star* wrote that the entire King City Girl

Guides troop of forty young ladies "enjoyed tea in the large living-room while their mothers and other guests were in the dining-room."

Canadian Homes and Gardens adds that "upon an oaken rail, high upon the wall are various stuffed birds, and above those, heads of deer, moose, a rocky mountain goat, well set off by the white walls and dark rafters." The article indicates that most of the birds were shot on the premises. The display of hunting prowess also included small animals, such as a red fox, minx, squirrels and two tiny bear cubs.

Certainly, Sir Henry's summer home was not just a place of refuge but also a place for personal reflection, having contained so many of those things precious from his past in athletics and military service. Many described his summer home as the beginning of a QOR regimental museum, if not a Canadian military museum.

The family/guest sleeping quarters on the second floor had a large balcony on the west side that overlooked the living room below and joined the two private bedrooms. It had a large upper verandah overlooking the lake on the west side of the house and two large bedrooms to the north and south, each with their own private bathroom. These bedrooms would have been used by the Pellatts as well as their family and special guests.

The basement was originally nothing more than a place for general storage, coal storage, the furnace and mechanical equipment. The walls in the basement were constructed of twelve-inch hard burned tile, and the flooring was concrete. There was a jacket heater for summer use and a Western Foundry Metal Company furnace for winter use with coal located on the north side of the home under the dining room. It wasn't until 1927 that Pellatt and his second wife, Lady Catharine, had the basement renovated to accommodate a tearoom and recreation hall and added an entrance to the basement from the exterior of the home with descending stairs that led to double doors on the south side of the building. Prior to that, the only way into the basement was via the stairs in the kitchen. To provide a sense of the size of the basement, in 1932, Sir Henry, by now a widower for a second time, hosted the nurses and doctors of Grace Hospital (for which he was a former governor and patron, having donated a fully equipped operating room/surgical wing to the hospital). The details of the event were recorded in the July 27, 1932 issue of the *Toronto Daily Star*, which reported that "movies were shown in the large downstairs hall of the residence where later there was dancing to the radio and Victrola and more fun and games for the 150 guests." This helps to give a sense for the size of the home, as the basement matched the footprint of the entire residence. In order for the basement to

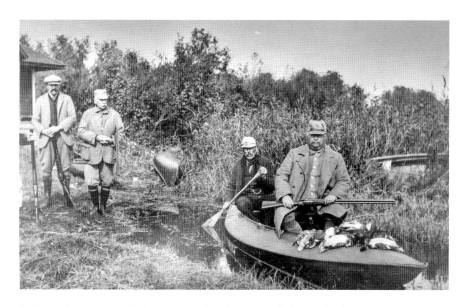

Pellatt and company enjoying a day of duck hunting at Lake Marie. *City of Toronto Archives.*

have space for 150 people to dance, it would have to have been quite large, although the square footage is not known. During the 1927 renovation, the basement also saw the addition of washrooms.

By all accounts it would appear that the official coming-out into society of the Lake Marie Farm and Estate happened between 1912 and 1913. Thankfully, the many articles on the estate provide a timeline for the property's earliest developments and indicate that construction of the original estate buildings would have started prior to 1912, circa 1910–11. As mentioned in the previous chapter, the research for this book endeavored to source original building permits with King Township, which would have helped to prove the exact dates, but none could be found from this period. The debut of Lake Marie would have been a topic of interest to the people of the day, as most were following the simultaneous development of Pellatt's Casa Loma estate in Toronto. By May 1912, *The Canadian* was already speaking of Pellatt's golf links, tennis courts and plethora of farm animals at Lake Marie as well as his guests to the property.

It has been intimated that Lake Marie was more than just a retreat house. First and foremost, Lake Marie was a farm, with its architectural developments considered the finest many had ever seen, certainly in King Township. As mentioned, Pellatt purchased existing farms, and as early as

1913, many papers noted that Pellatt was renovating any buildings on the property that were aging or inefficient. The eight farms managed on the property during Pellatt's time included the northwest farm on the fifth line of Concession IV (a small existing farmhouse, a pig barn and shed), the west farm on the fifth line (in addition to a brick residence built by Pellatt, a pig stable, barn and machine shed), the main Lake Marie farm buildings (including a cow barn, horse barn and granary, main chicken house, four small chicken houses, a large brick hen house and a dairy building—all built by Pellatt), the northeast farm (with an original farmhouse and small barn), an existing barn used for turkeys, Pellatt's private horse barn (to the east of his bungalow), the west farm on Concession III (including the existing farmhouse and two barns) and the large red horse barn, also on Concession III. The west farm complex and large red horse barns were included with the sale to the Eatons in 1922. For the remainder of this text, we will only speak to the developments on the Concession IV property. In addition, there was also a sawmill on the site with a large implement facility, both located about 250 meters northwest of the property entrance. The implement facility was built on the same grand scale as Pellatt's private barn and garage.

Of all the farm-related buildings mentioned above, only five remain standing. In Concession IV, the main cow barn, horse barn and granary, henhouse and dairy building remain, and in Concession III, although not a part of the Marylake property today, the large red horse barn still stands and is being managed and utilized by Seneca College. In short order, the Lake Marie Estate began to take on the glamour and luster of its romantic owner. It was known throughout the countryside as a rich man's farm—an extravagant folly, some called it.

When large complexes such as Lake Marie had multiple farms and barns as part of its operation, one of them would be identified as the home farm for the property. The large brick barn and granary are part of what is known as the home farm at Lake Marie. The main barn was reputable among agriculturists, not only because of its sheer size but also for its unbelievable modernity. It was constructed with over 300,000 red bricks at a cost of more than Sir Henry paid for the entire 1,214-acre estate. This barn is a magnificent structure and is as large as an armory. It was rumoured to have cost $60,000 (approximately $1.3 million today). The building is 220 feet long, 40 feet wide and 54 feet in height. The foundation was made of solid cut stone. The two gigantic silos are 18 feet across by 42 feet around. Built as sturdily as Casa Loma, the building, apart from the roof, was entirely fireproof. The original roof was made

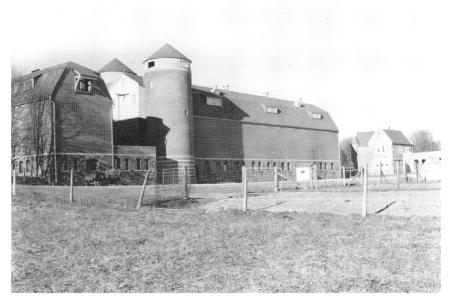

Above: Horse barn and granary. *Marylake Archives.*

Right: Ayrshire herd at Lake Marie. *Author's collection.*

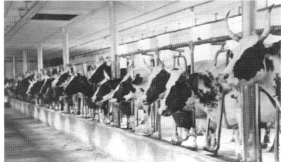

of flat stone (slate) that Pellatt imported from England. The roof of the main barn succumbed to fire in 1948 that destroyed the roofs of both silos, leaving the rest intact. The current roof was rebuilt and is two inches lower than the original and covered with aluminum siding.

The entire barn has a concrete floor except for the stalls, which have cork brick flooring for the comfort of the animals. To the south of the main barn is the cow barn that forms part of the large farm complex. This barn had separate pens for bulls and calves and eighty stalls for cattle. The stalls had automatic drinking bowls. There were also automatic carriers for the hay, feed and litter. The main barn also included the pumping station and the granary. The adjacent henhouses (which could easily accommodate three

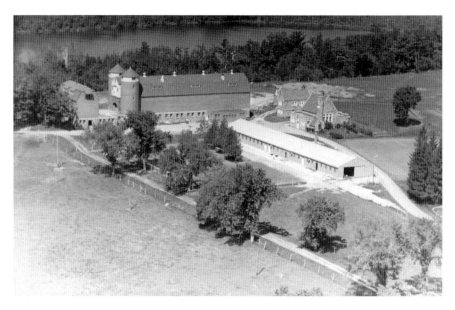

Aerial showing the cow barn, horse barn and granary, hen house and dairy building. *Marylake Archives.*

Dairy building. *Author's collection.*

Left: Pellatt's private barn. *Marylake Archives.*

Below: Large red horse barn (Concession III) under construction. *Ontario Archives.*

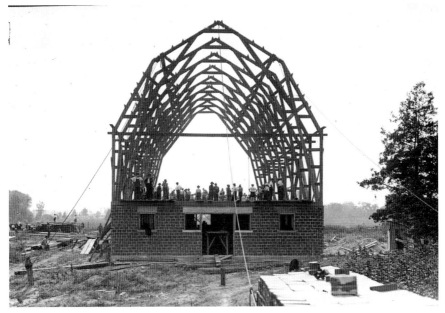

thousand chickens), and garages were built equally substantially and were also considered part of the home farm. There was also a dairy of cut stone north of the barn, complete with the herdsman's home on the west side and a dairy and refrigerated icehouse to the east of the building. The entire farm complex was outfitted with electricity, electrical equipment and hot and cold running water. It was a farming marvel. Throughout its early history, the main farming complex functioned as a dairy and bred cattle. This tradition continued for eighty-five years, from 1913 to 1998, when the Augustinian brothers sold the entire stock at auction for reasons that will be discussed in

Farming at Lake Marie. *Winnifred Smith and Tammie Buckler.*

chapter 6. In a 1935 inventory of the property, the livestock were listed at sixty-one head of cattle; twelve horses, including nine Percherons, one pony and two light horses; one boar, nine sows and thirty-four pigs; and one ram, twenty-two ewes and twenty lambs.

When the estate's farming was in its heyday, Lake Marie had many orchards with a variety of different apple trees. The acreage under active cultivation was about 530 acres of the 814 acres (or 65 percent), broken down roughly as 250 acres of oats, 40 acres of barley, 20 acres of winter wheat, 15 acres of root crops such as turnips and mangels (a beet with a large root, cultivated as food for livestock), 15 acres of corn, 35 acres of summer fallow, 130 acres of pasture and 25 acres of alfalfa.

The property was also home to a variety of farm equipment and machinery, including but not limited to tractors, wagons, trucks, drills, plows, discs, cultivators, binders, threshing outfits, harrows, chains, graders, grinders, hay press, hay racks, hay rakes, cream separators, manure spreaders, mangel and corn drills, a concrete mixer and a wide variety of hand tools.

By 1935, there were only eight men running the entire operation. The staff and their monthly wages included: one manager ($100/month), one herdsman ($50/month), one man of all trades ($50/month) and five men for fieldwork (ranging from $20 to $50/month). The total wages spent on Lake

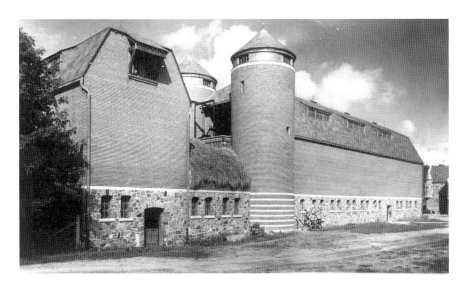

Home barn at Lake Marie. *Author's collection.*

Marie for that year was $4,620, approximately $85,000 today. Keep in mind that while by today's standards their salaries may seem low, the men also received free accommodation (most in their own homes), free utilities and, in most instances, their own vegetable garden, a cow, a horse, pigs and free, if not significantly reduced, fees for milk, butter and eggs.

According to an article for the *Toronto Daily Star* in July 1935, "At one time or another some of the finest cattle in the Dominion were pastured at Lake Marie. There were herds of Holsteins and herds of Belted Dutch cattle. There were many teams of fine horses, thousands of chickens, flocks of famous Shropshire sheep, white turkeys, guinea fowl and pen after pen of Yorkshire hogs included in the stock. There were also rabbits and hares and Norwegian partridges, wild geese and deer peopled the game preserve."

The maps provided in this book show the location of the residences and farm buildings that definitively existed during Pellatt, Basilian and Augustinian times. It is possible that other buildings existed on the property that this research was not able to ascertain.

A feature also of interest and part of King Township's railway history was the installation of the Pellatt Spur Line, which branched off the former Schomberg and Aurora Railway (S&AR). The S&AR was a short-lived and short run line. It was incorporated in 1896, with construction commencing in present-day Oak Ridge near Bond Lake in July 1899. The development of the line continued northwesterly to its terminus in Schomberg. It officially

Unidentified men at work at Lake Marie. *Marylake Archives.*

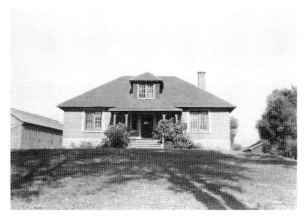

Left: West Farm House showing barn to the north (Concession IV). *Marylake Archives.*

Below: Farmer at Marylake in front of original turkey Barn. *Winnifred Smith and Tammie Buckler.*

opened in August 1902 as a steam railway and operated independently until it was acquired in 1904 by the Toronto & York Radial Railway Company (T&YRR). The line was the site of a trial operation by gasoline-electric car in October and November 1912. It was electrified in 1916 and operated as a subsidiary of the T&YRR throughout its existence. The total length of the S&AR was a mere 23 kilometers (14.36 miles). In total, there were fourteen stops along the entire S&AR line. Four of the fourteen stops were actual train stations, including Eversley Station, Aurora Station, Kettleby Station and Schomberg Station. Unfortunately, the last train ran along the S&AR in 1927, having operated for only twenty-five years.

Left: Staff cottage. *Winnifred Smith and Tammie Buckle.*

Middle: Former Northwest Farm House. *Marylake Archives.*

Bottom: Central staff cottage / farmhouse. *Marylake Archives.*

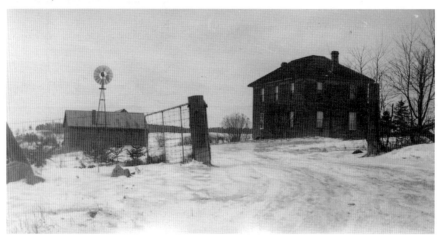

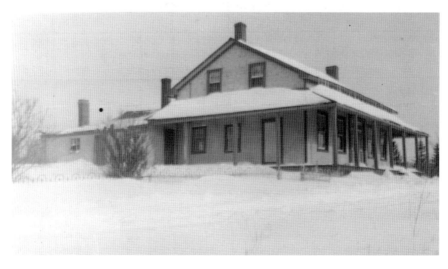

St. Thomas Cottage at Lake Marie. *Marylake Archives.*

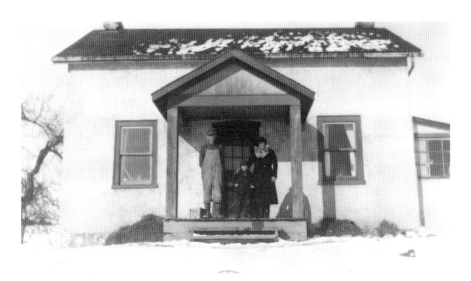

West Farm House (Concession III). *Marylake Archives.*

Pellatt looking out at Lake Marie. *City of Toronto Archives.*

The Pellatt Spur line ran west from the Eversley Third Concession Station (Stop 160) to Pellatt's property, traversing along the Lot 11 and 12 boundary line. Henry Pellatt purchased the east and west halves of Lot 11, Concession III, on April 1, 1913, from Walter Scott, a King Township farmer. Two years after the purchase, Sir Henry wrote to the reeve of King Township, William James Wells, regarding "routing and construction of a private spur line leading from the tracks of the Schomberg & Aurora Railway to the farm of Sir Henry M. Pellatt." The spur line was used to move equipment to the Pellatt farm as well as guests when a car could not make the short trip due to weather.

Some of the events hosted at Lake Marie were the biggest that King Township has ever seen, even to this day. Though it would be impossible to go into detail about all of them, a couple stand out as being rather extraordinary. In the summer of 1922, the B Squadron of the Royal Canadian Dragoons (RCD) Circus performed at Lake Marie before the prime minister of the time, Sir Robert Laird Borden. It was Robert Borden's cousin Frederick Borden who had put forward the recommendation for Pellatt's knighthood ten years prior. The event took place on the lake side lawn in front of hundreds of guests.

Another event in 1926 provides us with one of the only known early twentieth-century panoramic pictures taken in King Township found in

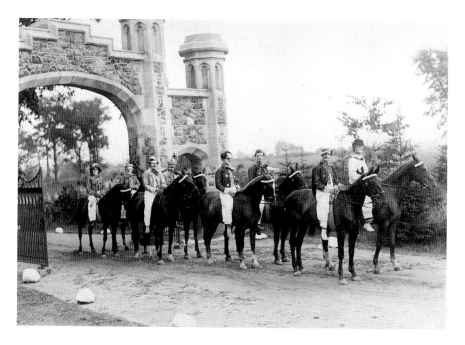

This page: Royal Canadian Dragoons Circus at Lake Marie performing before the prime minister, 1922. *Toronto Reference Library.*

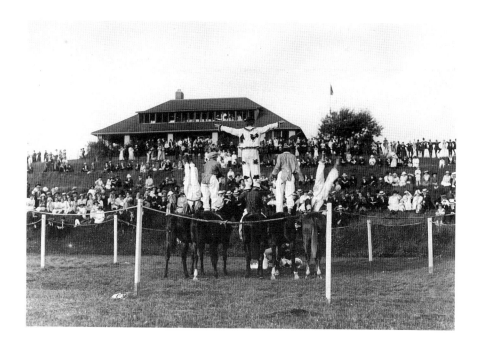

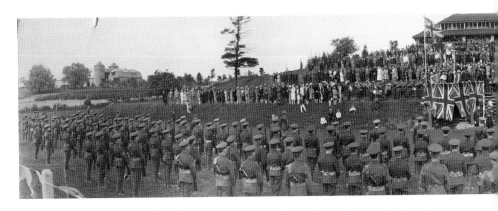

Above: Early and rare panoramic image take at Lake Marie in 1926 on the celebration of Brigadier General Sir Henry Mill Pellatt's fiftieth anniversary with the Queen's Own Rifles of Canada. *City of Toronto Archives.*

Opposite: Pellatt looking at a portrait of himself at Casa Loma as a visitor in 1938. *City of Toronto Archives.*

the City of Toronto Archives, and that event was the celebration of Sir Henry's fiftieth year with the Queen's Own Rifles of Canada. This event captured not just the interest of Torontonians but the entire country. The scope and magnitude of this event and the thousands of guests are conveyed in the image.

Two rather famous local institutions had their earliest developments at Lake Marie: the Lake Marie & King Athletic Association (LM&KAA), which received its letters patent on March 3, 1921, and the Lake Marie Hunt Club (LMHC). The LM&KAA was founded by Pellatt, but he was not listed on the letters patent as a member; the list included James Patton (drover), Kenneth Robertson Montizambert (bank manager), Andrew Warnock Crawford (manager), Victor Alphonso Hall (merchant) and Ellsworth Milton Legge (gentleman), all of the village of King. Legge at the time was a councillor and went on to be the reeve of King Township in 1928. The main headquarters of the LM&KAA was the main brick barn at Lake Marie.

For twenty-five years, Lake Marie was the home of the LM&KAA, until 1946, when the association developed a new home, later called King Memorial Park. From 1921 to 1935, Pellatt kindly permitted the use of the barn for community events, dances, fundraisers and sporting activities. It was the centre for young people, agricultural fairs, tradeshows and auctions. In fact, for all intents and purposes, Marylake could, in fact, be considered the first community and recreation centre in King Township.

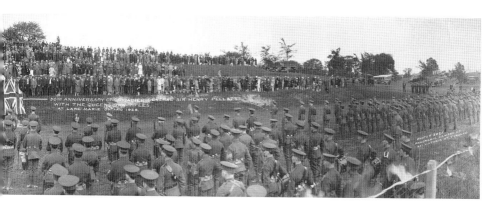

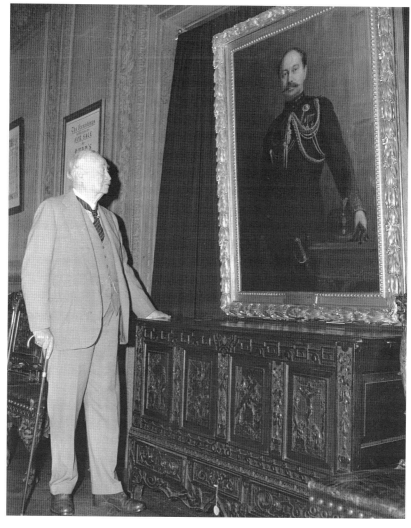

Official programme—Veterans of the Official Riding of North York Field Day at Lake Marie, 1929. *King Township Archives.*

How appropriate and what a coincidence that the first community centre in King Township is planned to be erected in 2021 on land that was once a part of the Lake Marie Estate, specifically on the east half of Lot 11, Concession III, in the former hamlet of Eversley, which was purchased by the Eaton family in 1922. All of this could be seen as the reawakening of one of the most active hamlets in King. One only hopes that when naming the new facility, the town consider the extraordinary and complimentary history that preceded it.

And now we come to the end of the knight's tale in King. Lake Marie represented the last stronghold of this one-time financial emperor of York. Losing Lake Marie, in a way, represented the end of an era. Pellatt would die three years and six months after vacating Lake Marie. It is not known if he ever returned during this time. In Carlie Oreskovich's book *Sir Henry Pellatt: The King of Casa Loma*, Gordon Sinclair writes in the foreword, "I read that the sale of his irreplaceable furnishings [at Casa Loma] brought no tear to his eyes, but the sale of his farm [Lake Marie] to the north of Toronto hurt him deeply."

4
BACK TO THE LAND

For there is no one who does not live on what the land brings forth.
—*Pope Leo XIII,* Rerum Novarum *(1891)*

When Pellatt bid his final farewell to Lake Marie in the fall of 1935, he left it in the care and custodianship of a group of Catholic laymen who formed a company, without share capital or shareholders, called the Marylake Agricultural School and Farm Settlement Association, incorporated on October 23, 1935. Many have questioned why a Catholic organization would take over such a large and expensive property when Canada was in the throes of the Great Depression, a time that saw a disproportionally large number of Catholics unemployed and on relief, placing an enormous burden on not only the individual parishes within the city but also Catholic support organizations and the Diocese of Toronto as a whole.

In order to understand why this was contemplated, how it came to pass and why it ultimately did not thrive, it is imperative that the reader have some understanding of the following: the economic climate in Canada between 1929 and 1939, some knowledge about the government's attempts to reverse the effects of the depression and alleviate unemployment, a bit about the history of Catholic social action in the Diocese of Toronto and the national back-to-the-land settlement scheme, which at one point was heralded as the measure to release Toronto, if not Canada, from the grips of the Great Depression. While this chapter does not discuss the Basilian purchase of Lake Marie in 1935, its purpose is to help the reader understand

why this purchase came about and examine some of the precursors within King Township to the Marylake Agricultural School and Farm Settlement Association purchase.

Between 1871 and 1911, Toronto's population jumped from 56,000 to 350,000, with the majority of the newfound masses being newly arrived immigrants. They came to Canada and then to the city in hopes of finding work and making a better life for themselves and their families. Most settled in the poorest areas of the city, where rent was cheapest and conditions deplorable. Toronto seemed unable to absorb its population. A factor hurting the everyday family at this time was that the cost of living rose an astronomical 64 percent in 1913. Then, in August 1914, World War I became a painful reality. The war gave the Canadian economy an unexpected boost. Unemployed Canadians flocked to enlist, and the war created many jobs. Thousands found work in war factories building Allied weapons and military machines. However, there was such an overwhelming surplus of workers for these wartime endeavours that employers were able to keep wages low—far lower, in fact, than the skyrocketing cost of living. The owners of these factories became millionaires overnight and did so on the backs of their employees. The working day was long, working conditions in many cases were unsafe and unhealthy and the rights of the worker moot. If you complained, there were hundreds of people who would scramble to take your place for the opportunity to earn a penny.

War has always been adept at creating opportunities for employment, far better than the government ever could. But like the war, the work didn't last. When World War I was over, those soldiers returning thought they were coming home to a better life. What they returned to was a rude awakening. No longer required, many of those wartime factories closed, triggering waves of bankruptcies across the country. Veterans returned to desperate poverty, and a pall of discontent fell over the country. While the majority of Canadians suffered, they watched the super-rich, men like Sir Henry Mill Pellatt—who was living at Casa Loma and retiring on weekends to Lake Marie—get richer. They watched their government support and stand by the employers. And in Ontario, they saw how resistant the government was to lending a hand to its citizens. The next decade was one of Canada's most active in terms of the fighting for the rights of the worker. The General Winnipeg Strike of 1919, also known as Bloody Saturday, gave the government a sense of the level of anger brewing among its working class. The climate for revolt and the season of discontent had arrived.

The decade following World War I was tough on Canadians. Many thought it couldn't get worse. They were wrong. Canada was hit hard by the Great Depression, which started in the United States in late 1929 and quickly reached Canada. Between 1929 and 1939, the gross domestic product dropped by 40 percent. Urban unemployment nationwide was 19 percent and Toronto's rate was 17 percent, according to the census of 1931. Just two years later, 30 percent of the labour force was out of work in Toronto, and one-fifth of the Canadian population became dependent on government assistance to cover the basic necessities of life. Interestingly, Catholics formed a disproportionately high percentage of unemployed people applying for aid from the Civic Unemployment Relief Committee (CURC). During the early 1930s, Catholics accounted for only 13 percent of Toronto's population and just 20 percent of the province's population. Brian Francis Hogan's 1986 thesis, titled "Salted with Fire: Studies in Catholic Social Thought and Action in Ontario 1931–1961," states that in 1933, the minister of labour for Ontario noted that unemployment had bottomed out and stated that "financial reserves are depleted, credit is exhausted and the cumulative effect of the long period of idleness and dependence on the State is breaking down the morale and health of many of these people."

At the onset of the Great Depression, the provincial and municipal governments were already in debt. The 1920s were a time of expansion for both infrastructure and education, so the federal government was called upon to try and improve the economy, but little had been done on the relief and unemployment fronts. When the Depression began, William Lyon Mackenzie King was prime minister of Canada. He believed the economic crisis would be short-lived. He was wrong. Mackenzie King refused to provide federal aid to the provinces and only introduced moderate relief efforts. In the 1930 election, the Conservative Bennett Government defeated Mackenzie King, but Bennett also initially refused to offer large-scale aid or relief to the provinces.

Conservative prime minister Richard Bedford Bennett (R.B. Bennett) held the post from 1930 to 1935, the worst of the Great Depression years. At the time of Bennett's appointment, government relief to the unemployed was widely considered a disincentive to individual initiative and was therefore only granted in the most minimal amounts and attached more frequently to work programs (called work relief) versus a direct handout (called direct relief). An additional concern of the federal government was that large numbers of disaffected unemployed men were now concentrating in urban centers and created the potential for a volatile

situation. They weren't wrong, and they needed only to look at Winnipeg to see how far unrest could go. As an alternative to what they believed would be bloodshed on the streets, the solution for unemployment chosen by the Bennett government was to establish military-run relief camps in remote areas throughout the country, where mostly single unemployed men toiled for pennies a day working on provincial and national infrastructure projects. At this time, any relief beyond this was left to provincial and municipal governments to manage, many of which were either insolvent or on the brink of bankruptcy and protested against the inaction of the federal government. Bennett countered by telling the provinces that they were "wasteful and extravagant" and even told Quebec and Ontario that they were wealthy enough to manage their own problems. He began to lose popularity quickly.

Municipalities were often so stretched for money that some leaders resorted to some pretty sinister tactics to alleviate the number of people on relief in their domains. For example, in a 2011 online article for the Heritage Ontario website titled "Rebellion in York Township," journalist David Wencer tells the story of Marsh Magwood, a former mayor of York Township who in 1937 accused the City of Toronto of offering to pay the first month's rent of any Toronto man receiving relief who was willing to move to York Township, which, if true, would have increased the financial burden to the already near-bankrupt York.

In the seat of Ontario premier during the Depression was another Conservative, George Stewart Henry (1930–34). Henry went to Upper Canada College and then the University of Toronto as well as the Ontario Agricultural College; he later became a farmer in East York. Coincidentally, Henry was not only born in King Township but was also a descendant of the George Stewart, who purchased Lot 11, Concession IV, in 1836, land that is now part of Marylake. He was succeeded by Liberal Mitchell Hepburn (1934–42). These two men could not have had more contrasting views, except when it came to relief. Like most Conservatives, Stewart was opposed to government intervention with the economy. Stewart, like Prime Minister Bennett, focused his relief efforts on creating jobs, mostly the building of roads and infrastructure. They built work camps, which in turn took men away from their homes and families for about twenty cents a day. These work camps were considered by many to be nothing more than a form of social control versus a system of relief. The aim seemed to be more about removing jobless men from the city and preventing unrest than providing relief.

The concept of social assistance at the turn of and well into the twentieth century was not popular—the main concern being a general belief that providing any measure of economic security would, in turn, diminish a person's incentive to work altogether. The concept of social assistance was a real challenge for the political and economic elite. They struggled to determine what measure of relief would encourage work ethic versus destroy it.

In a 1932 *Maclean's* article titled "Spent on Unemployment," reporter Grant Dexter took an incredible investigative look at what the Unemployment Relief Branch of the Federal Department of Labour had spent between 1930 and 1932 on relief for Canadians. The number is staggering when you consider that the concept of relief was not popular at the federal level. Between 1930 and 1931, $80 million was spent on relief, and between 1931 and 1932, $96 million was spent, for a total of $176 million (approximately $2.5 billion today) over two years.

Prior to an emergency session of Parliament in September 1930, little to nothing had been done to provide relief or create jobs to tackle the unemployment issue at the federal level. This session saw the creation of the Relief Policy of 1930. This Bennett policy, which had a lifespan of only two years and was widely criticized, was based on the following principles: first, the primary responsibility for unemployment rested with the municipalities; second, secondary responsibility for unemployment rested with the provinces; and finally, the federal government would only get involved with the problem of unemployment when it was a national problem. In the emergency September session, the Bennett government conceded that unemployment was, in fact, a national problem and was prepared to come to the assistance of the weaker municipal and provincial governments. These funds had two sources: some came through the taxation of citizens, but most of it was raised by loans, which became the lion's share of federal, provincial and municipal government debt.

Bennett's plan was not geared toward a direct handout. The plan was clearly a make-work project, although direct support was also included in this policy. The federal relief seemed doomed from the beginning. It cost the government far more to provide temporary relief work programs than it would have had it simply just provided direct relief. According to the aforementioned *Maclean's* article, approximately sixty-six thousand people were on relief in Canada between 1930 and 1931. The cost of maintaining the average family for one year at that time was around $600, across Canada this would have been a $39 million payout. Instead,

the government's program spent almost double, just over $70 million on infrastructure projects providing an average of only twenty-two days' work for twenty-six thousand men. This math did not make sense to the majority of Canadians. When *Maclean's* broke down the total spent (and still planned to be spent) on relief between 1930 and 1932, $151,993,789 was spent on relief work projects and only $23,651,389 on direct relief. Because the funds spent on infrastructure projects were so great during these two years, there was little to no work that needed to be done after 1932, thus it appeared as though the future of relief would have to either focus solely on direct relief or on other ventures and schemes.

By 1934, the Bennett Relief Policy had run its course. Bennett's star was descending, and with the election looming, he began to change his tune to please the masses. In a series of radio speeches to the nation in January 1934, Bennett rolled out unprecedented public spending and federal intervention in the economy, including progressive income taxation, a minimum wage, a maximum number of working hours per week, unemployment insurance, health insurance, an expanded pension program and grants to farmers. In one of Bennett's addresses toward the end of his term, he said, "In the last five years great changes have taken place in the world but the old order is gone.…We are living in conditions that are new and strange to us. Canada on the dole is like a young and vigorous man in the poorhouse.…If you believe that things should be left as they are, you and I hold contrary and irreconcilable views. I am for reform. And in my mind, reform means government intervention. It means government control and regulation. It means the end of laissez-faire." His change in attitude came too late, and William Lyon Mackenzie King returned to the post of prime minister.

Conservative Ontario premier George Henry Stewart was also out of favour, and Liberal premier Mitchell Hepburn took the reins with drastically different policies than Stewart. Between 1934 and 1942, Premier Hepburn undertook a number of measures that enhanced his reputation as someone who "cut the gravy train," to use a modern-day adage. In an austere public show of solidarity, he closed Chorley Park, the residence of the lieutenant governor of Ontario; he auctioned off the chauffeur-driven limousines used by the previous Conservative cabinet; and he fired many civil servants, all in an effort to improve the province's welfare. He felt that the province stood no chance of improving life for its people while those in senior government were living "high on the hog."

It cannot be said of the government that it did nothing to support its citizens in the earliest days of the Great Depression. And although the

Conservative government at the federal and provincial level was not credited for having solved the unemployment problem, it did much to alleviate the suffering of those affected by it. In a 1936 article for *Maclean's* titled "Unemployment a Permanent Problem," the unknown writer reminds us that the Depression was not the cause of unemployment, writing that "even in our most prosperous years there wasn't work for all who wanted it." The reasons cited were threefold. First, there was the massive influx of immigration. When you consider immigration numbers from 1867 to 1933, a staggering 6,450,000 immigrants came to make a new life for themselves in Canada. Between 1921 and 1931, over one million Canadians went south to the United States to look for work, as jobs had been scarce in Canada long before the Depression started. Secondly, the number of employable persons was increasing faster than the number of jobs could be created. Third, farming, which had for decades been one of the most abundant employers in the country, was becoming so mechanized that it was resulting in a decrease in the number of workers required; additionally, there was a decrease in export demand. These are some of the reasons that sent a great number of single men into the cities to look for work. And why were our farmers fairing so poorly? Our greatest trading partners, Britain and the United States, were licking their wounds as well.

So what alternatives were considered to the traditional relief system in Canada? One answer is the back-to-the-land movement. Simply put, this movement was sponsored by the federal government and the province and was promised to be pressed forward vigorously by 1933. When describing the movement, *Maclean's* indicates that the unemployed were to be placed on small farms and given a cash stake equal to the sum that would be spent on them if they remained in the cities and drew direct relief. The total outlay in each case would not exceeded $600. The hope was that after one year on a settlement, relief would no longer be required. But there were major concerns with this model as well. It seemed like a great idea if you were responsible for a municipality in an urban center, as there was now a way for you to move the masses of unemployed out of your city, off your relief budget and into the purse of rural municipalities. The concept was met with agitation. But those in favour of the concept of rural resettlement sang its virtues and insisted that this was one option that had lasting potential.

The municipal, provincial and federal governments were not left to deal with the burden of the depression and unemployment alone. The Catholic Church played a huge role in assisting its parishioners during these difficult economic times. Brian Hogan's aforementioned thesis discusses the

difficulties encountered by the Catholic Welfare Bureau (CWB) in attempting to carry on an enormously expanded caseload without a proportionate increase in either staff or funding. He notes that "in November 1932 all of the private family agencies concluded that they could no longer cope with the increased demands without greater help from the Public Department, and that by November 1932 the CWB reluctantly approached the City of Toronto's social service agency concerning the transfer of Catholic families to the Public roll." By the spring of 1933, the Welfare Department agreed to the transfer of approximately 500 Catholic families, leaving the CWB to care for about 2,500 families.

Concurrent with the early establishment of Catholics in Toronto, leading up to and after World War I, there was a developing change in social thought. Many would suggest this change in social thought was a product of Pope Leo XIII's encyclical *Rerum Novarum*, which translated from Latin means "revolutionary change." This 1891 Catholic doctrine focused on the condition of the working class, taking a close look at the evolution of society to a more urban and industrial civilization and the problems that resulted from this shift. These problems would rear a much uglier head in the years following the war, specifically the Depression years. This encyclical called on the state to intervene in items we take for granted today, such as worker rights, working conditions and a just wage. This doctrine also encouraged the forming of worker unions under the umbrella of worker rights. *Rerum Novarum* basically outlined the role of the church in social affairs with the end goal of achieving social order. This quest for social order was not just for Catholic men, but all men, and the quest was being led in Toronto by the Archdiocese of Toronto. The Archdiocese of Toronto spans a vast area of Ontario from Lake Ontario in the south, Georgian Bay to the north, Welland to the west and Oshawa to the east. Today, there are over 1.6 million Catholics in the Archdiocese of Toronto worshipping in over 223 parishes.

Father Henry Carr, CSB, was superior general of the congregation of St. Michael's College between 1930 and 1942. Spurred by Pope Leo's *Rerum Novarum* and Pope Pius XI's 1931 encyclical *Quadragesimo Anno* (so named to denote reference to the forty years that had passed since the Leo's papal missive) on the reconstruction of social order, Carr believed that the church could and ought to amend some of the social conditions of the Depression. One such amendment included the back-to-the-land experiment. Carr believed that people had become slaves to the concept of the standard of living. As mentioned before, the back-to-the-land concept was not just a Catholic theme; municipal, provincial and federal politicians looked to

agricultural resettlement to relieve unemployment in urban centers, albeit for different reasons. The Conservative government of the time continued to avoid any national obligation to the problem of unemployment and saw the back-to-the-land concept as a vehicle to do just that, preferring anything to providing direct relief.

Although a tremendous proponent of the subsistence farming scheme, Carr believed that there were three ways in which a farm resettlement scheme would fail. First, Carr asserted that farming had become such a complex mechanized activity that a man could make a success of it only if he had apprenticed himself since his earliest years. Secondly, Carr explained that even if one had the skills learned during a period of prolonged preparation, farming had become a big business. The normal farm of one hundred acres required a capitalization of at least $10,000, and it was inconceivable that the average person could finance such an operation. Finally, Carr believed that farm life sentenced individuals to an unnatural existence of lonely isolation. He believed that this final reason, in great part, accounted for the flight to the city, for it appeared that people would rather starve on little in the city than return to a farm that might offer them subsistence but also isolation.

A priest named Francis J. McGoey, who later became the fourth pastor at St. Clare's Church in Toronto between 1957 and 1972, saw firsthand the impact that the Depression had on his parishioners, with a great majority being unemployed and impoverished. Prior to becoming ordained, McGoey worked at a packinghouse in Toronto and was in the trenches with the disadvantaged. Thousands of newly unemployed workers were in desperate need of public assistance, yet a mounting national debt and shrinking income left the government with little money to spend on relief. It became evident to religious leaders like Carr and McGoey that the role of the church was going to have to expand in order to protect its flock. Father McGoey was one of the first to come up with a settlement scheme to support Catholics that were on relief in the city, and he was literally planning to shepherd his flock. McGoey was bolstered not only by Carr but also by Archbishop of Toronto Neil McNeil (1912–34). McNeil was an ardent supporter of the Catholic social movement.

McNeil founded the Federation of Catholic Charities in 1927, when the City of Toronto's Federation for Community Service refused to continue to fund Roman Catholic charitable institutions. In the spring of 1933, McNeil brought together a group of priests to discuss Canadian social problems. McGoey was one of those priests. One of the main messages from McNeil at this conference was that the field of social work was for every priest,

rural and urban alike. McGoey took on the role of secretary and later director for this group, known as the Rural Life Committee, and invited clergy from all over the diocese to participate. McGoey would write regular updates on Catholic action in rural districts from all over the diocese for the archbishop.

In the summer of 1934, just a year after the first conference, McGoey was ready to put the theory of back-to-the-land resettlement to the test. McGoey approached John Joseph McCabe (of King Township) with the hope of leasing or receiving free land to create a community of self-supporting Catholics. The land of interest was in King City, specifically at the intersection of Jane Street (formerly Fifth) and 16 Side Road

Father Francis J. McGoey. *Archives of the Roman Catholic Archdiocese of Toronto, Item PH 24MC/27P.*

(formerly Green Lane), just one hundred meters northwest of Lake Marie. McGoey intended to bring to life his own colony, and his goal, which he used as the title of a later pamphlet, was to "turn an ancient slogan from a bit of counsel to a remarkable reality." McGoey writes later of his project in a 1937 pamphlet that the first step in the founding of this rural community was realized when "a kind friend loaned me ten acres of land at King, Ontario. Supplemented by donations of $200 each by five well-wishers to build five very modest houses, a start was realized."

It began with a total of five families, thirty-eight individuals. Three of the original families were from McGoey's St. Clare's Parish; the other two families were from the nearby St. Basil's Parish under the leadership of Father Michael J. Oliver, who was also a member of the Catholic Action Committee with McGoey, a former teacher at St. Michael's College with Carr and the director of the St. Michael's Social Guild. A publication called the *Basilian* sponsored one of the first five homes in the colony. The goal of this colony was to provide families with an opportunity to build a new life in a rural setting and get themselves off relief. McCabe donated ten acres to McGoey for this project. This settlement was known to its members as the Mount St. Francis Colony; officially, it was the Catholic Land Settlement Corporation, established in 1934. The community was also referred to as the Catholic

Settlement and the King Ridge Community, given the height of land in King that it is situated on. Interestingly and maybe not so coincidentally, the pastor at St. Clare's Church between 1913 and 1930 was a Father Edward McCabe, and it is believed, although not proven in this text, that there was a connection between the McCabe father at St. Clare's Church and the land donated by the McCabe family in King Township.

The religious community affiliated today with this intersection is associated with Sacred Heart Parish Centre in King City, Ontario (now served by the Augustinians). Sacred Heart Parish began in 1929 as a mission church of St. Patrick's Parish in nearby Schomberg. The land on which the church was built had also been donated by John Joseph McCabe. The church was built by local farmers during a worker bee and was constructed out of wood from other projects. It was dedicated to the Sacred Heart. On Christmas Eve 1930, Father Ralph J. Egan officially opened the chapel, located on the northwest corner of Jane and 16 Sideroad. It was originally known as the Roman Catholic Church on the Fifth Line of King Township. Prior to the church being built, mass was celebrated at the McCabe home under the leadership of Father David Joseph Sheehan of nearby St. Patrick's Parish in Schomberg. Sheehan would also visit the sick and elderly of this region. This church would become the heart of the Mount St. Francis colony.

In a report for the Catholic Action in Rural Districts, McGoey writes of his project that he placed families who were on relief in the city of Toronto on land in King Township as part of a back-to-the-land project with the hope that they will become self-sustaining. McGoey's project, which started in May 1934, is widely considered the precursor of the somewhat similar Basilian project at Marylake, which started the year after. The concept of subsistence farming had taken hold in King Township. Just a couple months after McGoey landed in King Ridge, to the north in the Holland Marsh, a Dutch colony developed under a same structure.

In an article for *Maclean's* magazine from February 1937 titled "The Dutch Did It Here," reporter Erland Echlin asks Canadians, "If the Dutch can do it, why can't we? If destitute Hollanders can pull themselves up by their bootstraps right here in Canada, why can't Canadians?" The group of twenty Dutch families on relief in 1934 were all headed toward independence at half the cost of living on relief, and Echlin wanted to know how this had been possible. The answer was via a unique settlement scheme, the brainchild of Hollander Jan Snor. The Hollanders had a similar plight as those in McGoey's parish. They came to Canada looking for a better life. As the Depression swelled, farmers were driven into the city to look

for work and ended up on relief. A deeply religious people, the first thing they worked on after their small homes were completed was the church. Their church followed the Christian Reformed Church of Holland, and all services were in Dutch. They had a reputation for having the best one-room schoolhouse in all of King. The Dutch settlement was so popular that it drew in other settlement schemes around it. It should be noted that the presence of this Dutch colony in the Holland Marsh in 1934 and the name Holland Marsh is merely a coincidence, for the river was originally named after an English soldier and trader of early times, Major Holland. In 1937, there were already a number of individuals and separate groups settled in the area. There were groups of Italians, Yugoslavians, Asians and even a small settlement of communists all thriving on the Holland Marsh. The difference between the Hollanders' back-to-the-land settlement and Father McGoey's is that the former approached the Canadian and Holland governments for funding at the onset and McGoey was determined to go at it alone.

The Mount St. Francis Catholic families built homes, lived, worked and farmed. Communal life was very important to Father McGoey. There would soon come to be a store, a bakery, a church and a school; the families were living comfortably. According to a transcription by Doris Carson for the King Ridge Women's Institute, three of the initial five families had quite a lot of children and the other two initial families were young married couples without children. According to Carson, there were four small houses, and one of the young couples lived in a big barn on Mr. Bertrand's land. It was here, apparently, that the first baby of the Mount St. Francis Community was born, though no record could be found to substantiate this claim.

Mount St. Francis was not a secret society or secluded colony. In fact, the settlement was often written about, as was Reverend Father McGoey, in the *Toronto Daily Star*, most especially between 1936 and 1937, when there were no fewer than fourteen articles printed about the colony—all of which shined a positive light on the work being done by McGoey; the second chance at life for the participating families; the improved quality of health; the excellent school and library; the massive waiting list to get in; the high birth rate at the colony (three times higher than in Toronto); and, on several occasions, the connection with the Veterans Association, which had planned to set up shop in King City and run a program very similar to that of McGoey. Of course, a great majority of these articles spoke of the need for ongoing financial support.

A sixteen-page pamphlet created by McGoey in 1937 promoted the merits of his scheme: "Back to the Land: Turning an Ancient Slogan from a Bit of Counsel to a Remarkable Reality." McGoey stated that 150 families

Left: *Maclean's* cover: *The Dutch Did It Here*. Article by Erland L. Echlin, February 1, 1937. *From* Maclean's *Archives*.

Below: Full-page article on the success of the Mount St. Francis Colony in King Township. *From the* Toronto Daily Star *(1900–1971), March 13, 1937, ProQuest Historical Newspapers*.

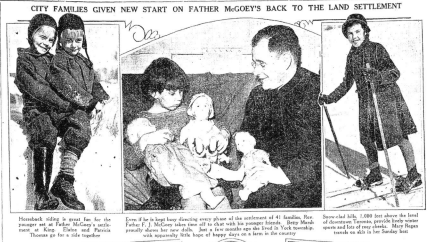

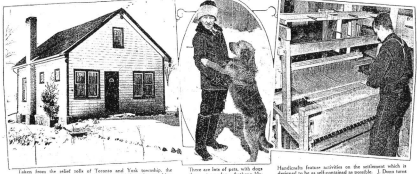

THE ROAD TO MARYLAKE

from his St. Clare Parish in Toronto were on the relief rolls (welfare), and the impossibility of gaining employment was destroying what little was left of their morale. The inability of the parish to help its parishioners was taking its toll. McGoey felt that his resettlement plan "would be the foundation of a definite and lasting answer for men of all creeds to today's and tomorrow's charge that unemployment and relief must be considered a permanent fixture in Canada's problems." He felt he had found the answer to the woes of his flock through the creation of what he called "Catholic Social Action in Rural Districts."

The following spring (1935), an additional fifty acres were purchased from McCabe. Fifteen more families were selected from the parish in Toronto to move to the colony. These men built five two-story homes for the first five families, and they each received a ten-acre share of the fifty acres. These five families also received a horse, a cow, chickens, pigs and implements. While the larger houses were being built, the other fourteen men were also building small one-story houses so they could bring their families.

According to the *Mail and Empire* newspaper, Father McGoey expanded the project rapidly, and by the spring of 1936, there were "112 souls composed of 20 amazingly happy families that were on relief in Toronto not long ago that were now living self-sufficiently at the community." Some forty Catholic families arrived during the mid- and late 1930s, leaving the depressed economic conditions in the city for a new start as farmers in King Township. Over the next five years, this colony grew in size to over 240 people, with at least a dozen families making a permanent home there. A *Mail and Empire* (1936) headline declared, "End of Year Finds Cellars Well Stocked with Food and Fuel" and also reported on the ways in which the community was interdependent, "each family contributed 25 cents a week to a contingency fund. For this it received insurance against small losses, and small loans when in need. A physician called every Monday. A dentist called twice a year and was available in emergencies. Five nights a week were devoted to scheduled activities: senior boys' night, senior girls' night, men's discussion night, the weekly dance and euchre."

Father McGoey acknowledged one of Carr's concerns regarding the potential for isolation in a rural an interview for the *Toronto Star* in 1937:

> We realize, in transferring city people to the land that they must have a social life and I don't think they are ever lonesome—in fact they have greater social activities here than many city residents. All these activities are carefully planned and the effect is noticed on the families soon after their

THE ROAD TO MARYLAKE

arrival. The boys change for the better in a few weeks after leaving city streets; they get a new interest in life. In fact, the biggest value we have here can't be measured in dollars and cents, but only in changed lives—in new hopes—in greater outlook and in far better health. The whole settlement might be called a club. We are taking people who had nearly lost hope and making them into valuable citizens in the best possible atmosphere.

By 1937, McGoey had hundreds of applications on file from other families in his parish who wished to be relocated to the thriving colony. McGoey included not only the exaltation of the families who prospered on the site in his pamphlet but also the pleas of the destitute families in Toronto who were literally beseeching McGoey for a place for their families at Mount St. Francis. McGoey also included praise from folks he described under the subtitle "Prominent People Endorse the Work" as influencers. Under this heading, McGoey included leaders such as Archbishop of Toronto James Charles McGuigan (1934–71), who wrote, "I am glad to commend the self-sacrifice and devotedness of Reverend Francis McGoey in his work of trying to rehabilitate Catholic people on the land. It is a difficult though meritorious work and is worthy of any help or encouragement that can be given to it. I gladly bless this endeavour and those who help to make it a success."

McGoey's scheme was doing so well in fact that on October 15, 1936, he found himself, his colony and his people in the national *Maclean's* magazine, featured in an article titled "Good-by Relief." Journalist R.E. Knowles includes images of the original temporary homes; the settlers at work on their own houses; and, as Knowles refers to them, "chubby, smiling, cherry-cheeked children." In his own words for the *Maclean's* interview, McGoey shares how the concept started:

Back in the winter of 1933–34, I was an assistant priest at St. Clare's Parish in Toronto. That's not such a poor district but by no means is it a rich one. I was struck by the utter hopelessness of families on relief. The continued idleness and the continued dependence seemed to be sapping their morale. People were talking a lot about back-to-the-land schemes. But nothing was done. I decided I'll do something. I didn't have a nickel to myself, so I borrowed $1,000 and ten acres of land and on May 21, 1934, I came up here with one family and seven single men, all of them unemployed. We built five, small, tar-paper-covered frame-houses, and the $1,000 just sufficed to buy the materials and pay wages to the single men.

Maclean's Magazine, October 15, 1936

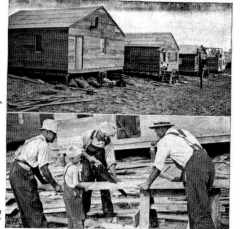

Good-by Relief

By R. E. KNOWLES, Jr.

For a year, a temporary home.

The settlers build their own houses.

From relief in the city to communal independence on the land — such is the story of the settlers of King Ridges

SOME twenty-five miles north of Toronto, on a settlement known as King Ridges, people formerly on relief are plowing, sowing and reaping to earn their own living from the land. They number 228 men, women and children, consisting of forty-one families. The land they are settled on amounts to about 218 acres. The cost of establishing them on it has been slightly more than $20,000.

Twenty of these families have successfully completed a year's probationary period, and each of them is now settled in a two-story frame house on ten acres of garden land, with a horse, a cow, a brood sow, fifty chickens and all the necessary farm implements. A short time ago every one of these twenty families was on relief; today they are not only supporting themselves but are paying interest charges and part of the principal on the money spent in establishing them there.

No one is more satisfied than they are that this should be the case. They are glad to be active, not idle. They are glad to be able to earn their own living, not to have to depend on the bounty of the Government.

"Are you happier here than drawing relief in the city?" the writer asked a number of these people. Some typical replies were:

"I never want to see the city or a relief voucher again."

"It's great. Just like starting life all over."

"My kids used to be sick half the time. Look at them now," pointing to three cherry-cheeked, chubby, smiling youngsters.

"I feel as if I can hold my head high now for the first time in four years."

idealist and the square jaw of the practical man. The corners of his mouth are covered with smile wrinkles. Sitting on his verandah in a rocking chair and puffing at his well-worn pipe, he began his story.

"Back in the winter of 1933-34," he said, "I was an assistant priest at St. Clare's Parish in Toronto. That's not such a poor district, yet it's by no means a rich one. Anyway, I was struck by the utter hopelessness of families on relief. Not that they didn't get enough to eat, clothes to wear and fuel to heat their houses, mind you. But the continued idleness and the continued dependence seemed to be sapping their morale.

"People were talking a lot about back-to-the-land schemes. But nothing was done. I decided I'd do something. I didn't have a nickel myself, so I borrowed $1,000 and fifty acres of land and on May 21, 1934, came up here with one family and seven single men, all of them unemployed. We built five small tarpaper-covered frame houses, and the $1,000 just sufficed to buy the materials and pay wages to the single men. Then the latter went

In that way they were able to eat until the first year's crop was harvested.

"We planted just potatoes and carrots that year. In the fall there was enough to stock each cellar for the winter and sell what was left over for $970. This money was divided among the five families, so that when they came off relief in September they had enough vegetables and cash to see them through the winter.

"Next spring I brought fifteen more families out. I had to raise more money by private subscription in order to buy more land and build more houses. This spring (1936) another fifteen families came out and six more came along later in the summer. That's meant more land and houses, which can only be obtained by more money. But I've been able to raise it—probably because I've proved that it's a sound investment."

It costs about $1,000, Father McGoey estimates, to settle each family on ten acres, with its two-story home, livestock and implements, whereas it costs more than $500 a year to keep the average family on relief. The families which have been at King Ridges for two years are paying 2 per cent interest on the investment and have started a sinking fund for the repayment of the principal.

Probationary Period

THE SUCCESS of the King Ridges venture, in contrast with the failure of many similar schemes, is due, in the writer's opinion, to two factors—the careful selection of prospective settlers and the year's probationary period that each family must undergo.

Father McGoey, himself, has chosen the settlers from hundreds of applicants—not on any basis of agricultural experience, but solely on that of moral character and physical fitness. He prefers middle-aged couples, partly because they are more likely to be content with a modest living than is ambitious youth, and partly because they have less chance of being reabsorbed by urban industry than have younger people.

The year's probation gives each family a chance to learn the elementals of farming, and shows whether they are made of the right stuff. Not until they have completed this period is the $1,000 invested in them. They start to work under the eye of an experienced farmer; he shows them what to do and how to do it. If, at the end of the year, all the members of a family have shown that they possess the proper qualities, then they get their ten acres, their house, stock and implements. So far, not one of the families that have received these things has proved unworthy of them and only three families have withdrawn during the probationary period.

During probation the settlers work part time on a communal plot in order that they may have vegetables for the ensuing winter. They also build their permanent homes.

During this period they live in one of the fifteen $200-houses erected by the first group of settlers. At the end of the year they move to a permanent home. This is two stories high, contains seven rooms, measures 25 by 27, has brick foundations, and costs $500. It would cost twice as much, were it not for the fact that their free labor is available in building it.

A near-by woodlot has been bought, and the men fell the trees, cutting them into boards with the help of a portable planing mill that is hired by the day. It costs them only $6 per thousand board feet, as compared with $20 to $30 per thousand that a dealer would charge.

When one set of families has completed its permanent homes and moved into them, the temporary dwellings then become available for others from the city. The system "goes round and round."

Exchange of Labor

THE OBJECT of the community is to produce for its own

The children are cherry-cheeked, chubby, smiling.

Maclean's cover: *Good-bye Relief.* Article by R.E. Knowles Jr., October 15, 1936. *From* Maclean's *Archives.*

The latter then moved back to the city and four families moved in, joining the family that was already up there, each of them moving into one of the little houses just built.

The point of back-to-the-land schemes was to unburden the government of having to pay relief to these individuals. In almost all cases, individuals

were removed from a location in a city to a rural one. In the McGoey instance, one would think that the financial burden of these people was now transferred from the City of Toronto to King Township. This is something that was managed very carefully. In the instance of the McGoey scheme, the Toronto Relief Department agreed to let each of the five original families stay on the Toronto relief rolls for another six months once they arrived in King Township. This is an extraordinary circumstance, as technically, they should have become a burden to King Township. It was also arranged that they could redeem their Toronto food store vouchers at a store in the King village, providing food until the first year's crop was harvested. In a letter written on October 26, 1935, McGoey writes to MPP Morgan Baker, Esquire, of North York that the five families he brought to Mount St. Francis in 1934 had only remained on relief for three months after they left Toronto and that this was for food vouchers only and all other expenses—moving, clothing and medical attention—had been taken care of by the Catholic Land Settlement Corporation before they left the city. As Toronto was paying each of these five families $500 per year on relief, McGoey notes a $2,500 savings to the City of Toronto for the following year and indicates that he has a letter from the City Relief Office to support this claim. At the time this letter was written, McGoey had already brought another fifteen more families to the settlement, which meant that within the first two years, the City of Toronto would recognize $13,000 in savings. McGoey was proud to share that at no time had his corporation received any support whatsoever from any level of government. His pride in this matter may have contributed to the eventual downfall of the colony.

McGoey's success was not enough to alleviate the concerns of the citizens of King. An article for the *Newmarket Era* in April 1937 titled "Council Wants Guarantee Settlers Won't Be Charges" deems the McGoey plan commendable, but locals feared the additional potential liability should the scheme fail. Council and community members were worried that if the project went south, all of these families would, in essence, become public charges of King Township. At the March 1937 King Township Council meeting, Councillors E. Milton Legge and Cameron E. Walkington put a motion forward to "prepare an agreement with Father McGoey and his principles and this municipality guaranteeing that all residents of that settlement [Mount St. Francis] that have been or may be brought there shall not now or for all times to come, be a charge [dependent] upon this municipality." The residents who attended the meeting indicated that they already had such a letter from McGoey, but it was determined the letter

they had was not enforceable. Council also indicated that this was not just to apply to McGoey's settlement but all future settlement schemes. Council was aware that the concept of land resettlement had become popular in all levels of government, and King, being just twenty-five miles out of the city, was a prime destination and location.

For all the good it did, the concept of being self-sufficient and living within a self-sustaining community was not without criticism. Many disapproved of the colony's way of living as reverting back to a barbaric and medieval economy. McGoey was proud to agree that was exactly what he was doing and questioned whether or not the medieval community might not be better than the modern industrial system, which had been failing humanity for years. Unfortunately, the Mount St. Francis colony did not last. Hogan's aforementioned thesis cited a couple reasons why this was. First, the land was not as fertile as the land the Hollanders were on in the Marsh, making farming conditions difficult. Second, McGoey was not able to realize his objective of providing ten-acre farms to each family after their probationary year as he had planned and hoped. Third, the living conditions were extremely harsh, with no modern amenities and not a single luxury available. Fourth, Hogan says that it was never clear why these families did not qualify for relief farm settlement through the government or why better arrangements for government relief were not coordinated for those who required it. Perhaps a final reason was the most significant impetus for the colony's demise: war loomed again for Canada. The city that only four years prior was only too happy to see the masses flee to rural settlements beckoned them back with the promise of wartime work in factories or encouraged them to enlist, deeming it their responsibility to do so.

Having said that, the colony cannot be considered a failure, for it did provide relief for many. It improved the physical health, mental health and morale of its members. It provided social opportunities, quality education, employment, food and shelter and unburdened the state. A dozen families, in fact, made the colony their permanent homes once they were settled on their ten acres. The Mount St. Francis colony continued as a structured entity from 1934 to 1939, at which point the intake of new families ceased. McGoey went on to other projects, and in 1943, he published a small book titled *Rural Sociology* that looks at the problems of rural life from a variety of perspectives.

Father Michael J. Oliver, CSB, of St. Basil's Parish was watching the success of McGoey's Mount St. Francis settlement in its early days. Oliver was the pastor of St. Basil's Parish (1934–37), which was located on the

Father Henry Carr (*left*) and Father Michael J. Oliver. *Marylake Archives.*

grounds of the University of St. Michael's College. Father Oliver and McGoey knew each other very well, and two of the original families who settled on the land from Oliver's parish stayed on to be permanent residents of the community. Father Oliver had back-to-the-land plans of his own and, using examples like the Mount St. Francis colony in King Ridge and the Hollanders model in the Marsh, conceived his plan. Although Oliver's plan would differ from others in that it would focus on a truly Basilian principle—the importance of education—to that end, he planned to not only provide a way out for many Catholic families living on relief in his parish but also hoped to establish an academic center focused on agriculture and subsistence farming for the clergy. Oliver, like Carr, McNeil, McGoey and many others, believed that priests should participate in the economic lives of their people.

Oliver's plan, however, unlike the other two settlement schemes in King, would require a huge capital investment. Sir Henry Mill Pellatt had land to sell in King, and it wasn't going cheap, especially considering the times. Oliver lit the embers that flamed the conversion of Lake Marie Farm and Estate into the Marylake Agricultural School and Farm Settlement Association.

BASILIAN OCCUPATION

Bonitatem et disciplinam et scientiam doce me.
(Teach me goodness, discipline and knowledge.)
—*motto of the Basilian Order*

ather Michael J. Oliver understood and supported government relief efforts and regarded relief as an absolute necessity and responsibility of the state. He also believed that short-term work projects and direct handouts could not solve the problem of unemployment but only provide a temporary patch. He worried that citizens had now become dependent on government relief and had lost either the morale or ability to become self-sustaining. Oliver and his contemporaries were concerned that the government's system of relief, designed to be a temporary measure, had now become an absolute necessity to the majority of those utilizing it and was missing a necessary second phase. This placed a tremendous financial burden on the state as well as the church and would continue to do so unless addressed. Thus, encouraged by projects like Father McGoey's Mount St. Francis and Jan Snor's settlement in the Holland Marsh, Oliver hoped to address the issue of perpetual single-phase relief programs.

Oliver believed that given current social disorder and distress, there were now two types of support needed: immediate and permanent. Immediate help was required for those who were hungry, had lost their jobs and needed clothes or shelter. Work relief and direct relief were both considered immediate support, as neither had the ability to be offered indefinitely.

Permanent help was meant to assist an individual in achieving self-sufficiency once their immediate needs were being met. Unlike the government, Oliver did not believe that the continuation of direct or work relief was a form of permanent help. To this end, Oliver returned to a Basilian fundamental for his permanent support plan: education.

To understand this chapter, it is import to understand some of the terminology and history of the Basilians. First of all, the term Basilian means of the Congregation of St. Basil (CSB). Basilians are an order within the Catholic faith. Also known as the Basilian Fathers, it is a Clerical Religious Congregation. The CSB was founded in France in the early nineteenth century (1822) in the aftermath of the French Revolution. By 1837, the CSB had received an *decretum laudis*, which is Latin for "decree of praise." A decretum laudis is the official measure with which the Holy See grants the recognition of an ecclesiastical institution of pontifical right. The Basilian educational and pastoral work brought them first to North America. The original priests of St. Basil arrived in Toronto from France in 1850 at the invitation of Bishop Armand-François-Marie de Charbonnel. This is the same Charbonnel who spearheaded the Toronto Savings Bank in 1854, as discussed in the first chapter. As a teaching and learning order, the Basilians came to Toronto with two main aims: educate young men who would become priests and support the 100,000-plus (mostly immigrant) Catholics in the Diocese of Toronto. This remarkable group of priests, only four in total, managed to have both St. Michael's College and St. Basil's Parish in operation by 1856. In the year 1867, the same year as Canadian Confederation, the CSB received its approbation, which is an act of approval by which a bishop or other legitimate superior grants to an ecclesiastic the actual exercise of his ministry. This means that the Basilians, like Canada itself, are celebrating a 150-year anniversary in 2017.

The Basilian motto is derived from Psalm 119 (originally Psalm 118). In the late nineteenth century, Charles Vincent, a Basilian priest who was one of the founders of what would later become St. Michael's College, brought the Latin motto to the Congregation of St. Basil, *Bonitatem et disciplinam et scientiam doce me*, which translated means "Teach me goodness, discipline, and knowledge." The motto is a biblical reminder of the Basilian role as a teaching community and the simple, foundational importance of ongoing learning, goodness and discipline. Today, the Congregation of St. Basil (or the Basilian Fathers) is defined as a community of priests and students for the priesthood with an active, apostolic community of simple vows, seeking the

glory of God in every form of priestly activity compatible with the common life, especially in the works of education and evangelization.

In adherence to Basilian principles, Oliver was a firm believer that any rural social action endeavor must be rooted in training and skill development. Oliver said on many occasions that "education must be the root of rural life if there is to be any sustainability," and in early 1935, just a year after Father McGoey had started his back-to-the-land settlement, Oliver went to work. It would seem, however, that Oliver would have a more difficult time getting the required approvals and support for his endeavor. Although timely, Oliver's plan required more capital—much more. Oliver suggested that St. Michael's College take on another farm at a time when the concept was running out of favour. Oliver intended to start his project on land known as Lake Marie. At the time Oliver was interested in the property, Sir Henry Mill Pellatt was still residing on the estate in the main lodge house (bungalow). Oliver learned that Pellatt was looking to sell what was now an 814-acre farm. The asking price was originally suggested around $125,000, which in today's dollar would be the equivalent to just over $2.3 million. This would have been an exceptional price at any time, least of all for St. Michael's College or St. Basil's Church, in the throes of the Depression.

In an early letter, Oliver indicated that the Mount St. Francis settlement had a somewhat similar objective, though each has its own method and management. Though not meant as a criticism, Oliver meant to do better where he felt the McGoey project had fallen short, and that was with respect to the provision of training and education from knowledgeable and learned persons in the field of agriculture.

Many believe and have written that the story of Basilian interest in Lake Marie began in 1935 with Father Oliver, but that is not the case. In fact, Oliver was rather late to the game. As early as 1933, records indicate that St. Michael's College was already considering the purchase of Lake Marie, but not for the same reason as Oliver. A look into the history of farm purchases on behalf of Henry Carr, Henry Bellisle and St. Michael's College is required here.

In 1930, Henry Carr, CSB, had been elected to the position of superior general of St. Michael's College, a position he held until 1942. A year later, in 1931, Father Henry Stanislaus (H.S.) Bellisle was appointed by the general council as superior and president, a position Carr held between 1915 and 1925. Bellisle was apparently one of Carr's favourite former students and an exceptional athlete. Both found themselves holding important roles with St. Michael's College at a difficult time in history.

The Great Depression saw the crash of the stock market and the plunge of listed securities as well as government bonds, not to mention the Canadian dollar was at an all-time low.

Father Edmund Joseph McCorkell, the superior general at St. Michael's College succeeding Carr (1942–54), wrote a biography of Henry Carr titled *Henry Carr, Revolutionary* in 1969. McCorkell writes that that in the early 1930s, Carr began to worry about some of the college's substantial endowment funds given the very fragile state of the economy and stated that "a Toronto broker and a good friend of the Basilians, strongly advised the purchase of farms." Carr was told that "the best investment in Canada, which provided the most stability in 1931 was farm land, though not because its yield was attractive, but because it was independent of the currency and carrying charges were low." The money that St. Michael's College had to invest was the result of a previous farmland transaction led by Carr, so he already had an encouraging model to work from.

Back in 1881, fifty acres of farmland were purchased by a Father Lawrence Brennan on the north side of St. Clair Avenue east of Bathurst. These fifty acres were always referred to as the "college farm." The land remaining from this 1881 purchase is the site of St. Michael's College School today. Due to the selling of some twenty acres of this parcel to a future residential subdivision after World War I, Carr realized a considerable sum that he could now invest on behalf of the college. Carr wanted to ensure these funds were managed securely, as he did not have a great deal of confidence in many traditional investments. It was no small piece of change either. The sale of the twenty acres yielded an incredible $100,000 ($1.5 million today). Carr considered a variety of investment options from liquor stocks and government bonds to farmland.

In the spring of 1932, Carr and Bellisle embarked on what would be the second college farm project with the purchase of a 300-acre Jersey farm about twenty-five miles north of Toronto's city hall, a mile east of Yonge (price unknown). The Jersey farm acted as the epicenter of this new farming-cum-investment initiative. Carr named it Annesi after the first monastery established by Saint Basil. By the spring of 1933, St. Michael's College was considering the purchase of several other farms, all that would act as satellites in support of Annesi, including the DeLaPlant Farm (387 acres, price unknown), the Rae Farm (320 acres, $65,000), the Hodgson Farm (also spelled Hodgins) (108 acres, $12,000), the Marshal Farm (288 acres, $15,000), the Watson Farm (acreage unknown, $18,000) and Lake Marie (814 acres, $125,000), with Lake

Marie being the farthest from Toronto City Hall at thirty miles. Had St. Michael's College purchased all seven farms, it would have had over 2,500 acres of farmland. In the end, according to McCorkell, the total acreage owned by St. Michael's was around 1,000 acres, and Carr spent over $200,000 (approximately $3.5 million today). This sum is astronomical when you consider the times and economic pressures. But again, Carr wasn't looking to the purchase of farmland for farming's sake, although he was a supporter of back-to-the-land schemes from many perspectives. He saw this as an investment opportunity, believing that the value of farmland would rise once Canada was out of the Depression. Although this text will not go into detail about Carr's college farm endeavor, it will discuss the Basilian interest in Lake Marie.

Leading this program was St. Michael's College Superior Father H.S. Bellisle. Bellisle wrote to Carr for permission to move ahead on the above projects, and in a letter dated April 6, 1933, Bellisle writes of the Lake Marie opportunity, "I am directed by St. Michael's College Council to ask permission to bid $100,000 for the Pellatt Farm. We are not sure that the property can be purchased for this amount." An earlier letter from the college's real estate agent, Frank McLaughlin, indicated that the cost would be closer to $125,000, but there was a sense that it might go for less. Bellisle goes on to say that "this property at $100,000 looks to us here as the best purchase of all the farms visited by our committee. We feel it is the safest place we know for St. Michael's College money." Bellisle mentions some potential concern over the fertility of the soil, the thought being that the hills might be too much of an obstacle, but a local farmer (Mr. McCabe, father of Noel McCabe a recent graduate of the college from King Township) assured them that the land was fertile and could grow anything and that the hills are not so steep as to be a real obstacle.

On April 20, 1933, Bellisle received his reply: "At a meeting held yesterday, the General Council expressed itself as opposed to further extension of farm operations on the part of St. Michael's College until there was some evidence that the experiment was a success. A committee was appointed to interview the Superior of St. Michael's. The committee reported that the approval of the Pellatt farm purchase with the condition that the farm would not be managed directly by St. Michael's College would be considered by St. Michael's as equivalent to rejection of the proposal. In view of this the General Council expressed itself as unfavorable to the purchase." The next day, Bellisle received another letter indicating which of the aforementioned farm purchases were considered acceptable in addition to the Jersey farm

that they were already committed to. Lake Marie, being the most expensive and farthest from Toronto, was not one of them.

Later in Carr's biography, McCorkell wrote that Carr and St. Michael's College "regretted that they had not purchased the Pellatt farm at the beginning rather than their own [the Jersey farm]." Carr was noted to have had particular regret that he had not seen the Pellatt farm until after the large purchase of the Jersey farm. McCorkell cites the advantages of the Lake Marie farm as being more compact, of sufficient size, located near the soon-to-be Highway 400, excellent buildings and a beautiful lake. It wasn't meant to be.

On August 2, 1934, Carr received a letter from his lawyers with information on how to "obviate [remove] the ever-recurring difficulties which arise where property is held in the name of the Trustees for the Order, it appears to us that the formation of a corporation without share capital would be desirable for the purpose, chiefly, of holding the various parcels of real estate which the College now owns." Clearly, Arthur Kelly with Day, Wilson, Ferguson & Kelly was encouraging St. Michael's College to move away from the college-owned and managed model. McGoey had also gone this route when he created the Catholic Land Settlement Corporation for his Mount St. Francis colony.

Fast-forward one year to February 5, 1935, and we now see, on St. Basil's Church letterhead, that Pastor M.J. Oliver had begun his quest for the approval of his new scheme, and he started this quest with the Very Reverend Henry Carr, CSB. In a two-page letter, Oliver gets right to the point: "I wish to submit for your approval a scheme for establishing a number of families in the country." At this time, Oliver felt that the "present social condition is far from Christian" and did not feel it necessary in the letter to dwell upon this point further or elaborate on how the scheme could work, as Carr had sketched out how back-to-the-land schemes could work in an earlier publication. What Oliver had envisioned was the development of about fifty families on one thousand acres of land with the homes arranged in a group and a church, school and community hall located centrally. Oliver felt this scheme could be "financed without cutting into parish revenue to any great extent." This interest in farmland was different from that of Carr and Bellisle. Oliver did not want to commit himself to any definite plan at this time but was hoping for simply "permission to make preliminary investigations with a view to establishing ten families this year [1935]." Oliver closed the letter with this: "If, however, you tell me it is no affair of mine, I can drop the matter with an easy conscience." Later,

this statement proves to be untrue, as Oliver does not give up the matter after several rejections. In this letter, Oliver was seeking approval to begin looking into the idea of purchasing Lake Marie.

Just a month later, in March 1935, Oliver wrote an article for the brand-new Basilian publication, *The Basilian*, titled "Flee to the Country." Oliver stated that the purpose of his paper was to "outline a case for a group of families living in the country on a self-supporting basis" and he had in mind "families on public relief." He focused on a few concepts in his article, one being a form of distributism, a method for creating a permanent way of living, not temporary relief viewed as subsistence farming, which places an emphasis on the material side. Instead, his idea was Christian farming, which places an emphasis on God, neighbours and self. To support his case, he makes reference to *Rerum Novarum* and *Quadragesimo Anno*, two encyclicals mentioned several times in earlier chapters. At times, Oliver's language leans to the extremist, but in the end, he comes around to an important fact supporting his case for relocating people to the country: "We are living in a country where there is plenty of good land that is not being worked. When we consider the large numbers of people on the public relief, in Toronto, nearly 30,000 families totaling about 130,000 souls, we must realize that there is something very wrong with the present system." In his conclusion he writes that "to continue as we are makes it more and more difficult for people to serve God properly."

Through the writing of letters and articles and speaking at rural life conferences, Oliver worked fervently to gain support for his project. It was clear that permission to investigate Lake Marie as an option had been granted, for on June 10, 1935, Oliver presented a complete report on the state of Lake Marie Farm to Superior General Carr. Written again on St. Basil's Church letterhead is a detailed, seven-page account on the state of the estate and farm. The report didn't depict a happy state of affairs, but it did forecast a blessed future. Oliver opens with, "I submit for your consideration the purchase, by the Basilian Fathers, of Lake Marie Farm, near King." The letter indicated that his proposal included a report on the current state of the farm, considerations for future use and plans for how to finance the project. In his plea for support, Oliver reminds Carr that the depression was not clearing but deepening and spreading, the state was not curing the wounds of its people and cannot because of its heretical views, the Basilian Order is a teaching order and action is the best form of teaching. Oliver also reminds Carr that Archbishop of Toronto James Charles McGuigan asked Oliver to convey to the Basilians his request that "they lead in a practical way to better

the economic and social conditions of the people." Oliver also stated that McGuigan had expressed his support for the project and had his approval but indicated that he was not able to support it in a financial way. Oliver ended with these words: "To do something of this sort, I believe, is not only our opportunity but our duty."

The Lake Marie report was broken up into twelve sections and included details such as the land, buildings, machinery, fences, livestock, employees, a summary on why the estate does not pay and, finally, a discussion on whether or not the estate could cover all of its expenses. As for financing the project, Oliver was looking to the Basilians to finance the entire scheme with operating revenue coming from the sale of milk, butter, hogs, chickens, mares and steers. The operating expenses included taxes, interest, insurance, wages (twenty men) and sundry (miscellaneous) expenses. Oliver was banking on a net profit of $25,100 per year once fully operational and at max capacity—almost $500,000 today. Oliver indicated that this was based on "conservative maximums of production for the farm when it reached full development." His report also came with much criticism as to why the estate at present did not pay, indicating that farm management had been very lax and no records whatsoever had been kept as to accounting, stock, harvesting and so forth. Oliver was confident that with better management and some changes to the quality and quantity of certain livestock that the venture would, in five years, be in solid financial shape. Oliver also adds a note that was not factored into revenues: "There is also the prospect of getting revenue from leasing summer cottages and there is also the prospect of getting revenue from leasing or selling small farms to the workers who have been trained on the estate to learn how to make a living from a small acreage." Oliver closed confidentially, "In my opinion, this estate provides a good and solid investment and sure returns if it is properly stocked, and managed."

The general council wasn't convinced. Just four days later, on June 14, 1935, Oliver received word in writing. The letter included two lines of response. "Your proposal to purchase the Pellatt farm was considered at a recent meeting of the General Council. The Council was not inclined to favour the proposal." This would have been a blow to Oliver for certain. It is possible that Oliver was unaware that St. Michael's College had been advised by its lawyers a year prior why and how to move away from the ownership and management of farms. Oliver must have also been confused, as men like himself and Father McGoey had been encouraged to move toward social action largely based on the writings of McNeil, McGuigan and Carr, who published a series of pamphlets on Christian economics in 1933.

Undaunted by the initial rejection, and perhaps advised by Carr on the way in which he might have some luck to proceed, Oliver reaches out to Carr again two months later in a letter dated and signed August 29, 1935. This time, Oliver approached Carr with a different strategy seemingly in line with Arthur Kelly's recommendation. For the benefit of the reader and the history, the following is a direct excerpt of the letter:

Dear Father Carr,

I submit for your consideration the following petition re: Lake Marie Farm at King. Some weeks ago your Council considered another proposal about this farm. The present plan, as you will see is quite a different one from the proposal made last June that the Basilian Fathers purchase this property.

Let me review the situation briefly. My interest in some plan for social reconstruction goes back over two years to one of your own pamphlets on the subject. I have helped Father Kelly and Father McGoey, of St. Clare's Parish, to establish poor families in the country. Two families from St. Basil's are members of the colony at King Ridge [Mt. St. Francis]. Since last spring, I have felt that the project needed more support and the members more training before it could function as it should. I was convinced that several years' experience on a well conducted farm and some years of teaching and training under suitable religious and social influences were necessary before it would be self-sustaining.

At this time, Sir Henry Pellatt's Farm came to my attention. It seemed to afford a splendid medium for the project. My first efforts were to interest St. Michael's College or the Basilian Fathers in the ownership and management. For good reasons, as you know, this plan was rejected. Now I humbly submit a new arrangement which would I expect serve the same purpose.

If this project is not considered favorably, I would appreciate your advice as to whether I should attempt any other plan for social betterment. I have thought that a Basilian pastor in such close contact with one of our colleges as we are here, is in a particularly favorable position to direct some such Catholic activity. Accordingly, in view of the present social conditions, I am prompted to suggest that something of this nature be undertaken.

Enclosed you will find a draft for a petition for incorporation of a company without share capital. The members and their elected executive have the responsibility of owning and managing the farm. The members are appointed (by invitation) by the Spiritual Director. The Spiritual Director is appointed by the Basilian Fathers. Residence at the farm is not

necessary; I should say better otherwise. When the development required it, the resident Chaplain would be appointed by the Basilian Fathers and approved by the Archbishop.

The Basilian community accepts no financial responsibility. The reading of the enclosed petition and memorandum of agreement will give you a more complete understanding of the nature of the company. I should be glad to have your suggestions if there are any points that you think should be changed.

I consider that there are a sufficient number of good, reliable men interested in this project to make a success of it, with the religious guidance which the Basilian Order can furnish.

P. [Percy] R. Gardiner has assured me that he will give $15,000 as soon as required. Others will give smaller amounts. Just at present it is difficult to find suitable prospects, because I would not wish to interfere with a possible donation to the new St. Michael's College Building.

The newly incorporated company buys the farm on an agreement of sale plan. The sale price is $95,000 [reduced from the original $125,000 asking price in 1933]. *The down payment is $10,000, which secures full title to the stock, implements and chattels, but not the land. At the end of the first, second, third, fourth years there is a cash payment of $5,000; the balance, $65,000 is paid. The interest rate is 5½%; the taxes about $900 per year. Up to the end of the fifth year the stock, implements and chattels could be sold and the deal closed without further responsibility.*

Please pray for me and for the whole parish.
Yours sincerely in Christ,
M.J. Oliver, Pastor

It is clear that Oliver was no longer proposing the involvement of St. Michael's College, the Basilian Fathers or the superior general in the financial or managerial side of his scheme. What can also be taken away from this letter is that although Oliver was open to and asked for guidance and advice, it seems fairly evident that he intended to move ahead with his plan. Evidence that the wheel was already in motion is confirmed by the date on this letter to Carr. The letter is dated August 29, 1935, but Carr was likely already aware that Oliver was not looking for permission per se thanks to a rather large article in the *Toronto Daily Star*.

The *Toronto Daily Star* ran a full-page article on page four on July 2, 1935, announcing the purchase of the farm as "Catholic Group Purchase Pellatt Estate at King"—almost two months prior to Oliver's letter to Carr. The article goes into explicit details on the sale, price, change of ownership and association proper. What it also mentioned was that there was a forty-day option on the sale, allowing Oliver time to do his due diligence on the farm. To this end, he brought in a reputable farmer from Holland to assess the land, crop and potential. This forty-day option would run until mid-August if in effect as of July 1, 1935. This is somewhat confusing, since the letters patent for the Marylake Agricultural School and Farm Settlement Association were signed on October 23, 1935, about two months after the option would have expired. Another interesting piece of information from the article was that "arrangements in the deed of the sale have been made whereby Sir. Henry Pellatt will occupy the main home [bungalow] till the end of September this year [September 30, 1935], after which the property will pass completely into the hands of its new owners." This is interesting in that it provides a date that that can be confidently used as the end of the Pellatt era in King Township.

The *Toronto Daily Star* article includes seven pictures of buildings on the Lake Marie property and reports the following on the purchase, "As part of a plan to rehabilitate Roman Catholic unemployed in Ontario, a company sponsored by and representing prominent Roman Catholic organizations in Toronto, has purchased Sir Henry Pellatt's 1,000 acre estate [actual acreage was 814] at King Ont., the transaction being the largest deal in country real estate to be closed for many years. The purchase price is not disclosed, but is understood to be something over $100,000." We know today that the value of the purchase and sale agreement was $95,000. The article also indicates that the new company, philanthropic in its motives, intends "to promote and establish rural communities by obtaining, holding, improving, leasing and selling land." This is not listed as a primary activity in the letters patent, which includes only the second part of this article, "to establish and train families in such a way as to enable them to keep themselves on farms." No profits were to accrue to any members of the company and no salaries paid to any of its directors. The plan, according to the *Toronto Daily Star*, was to utilize Pellatt's estate as a training centre to teach families to become self-supporting and to educate them in farming. Father Oliver said for the article, "Today, following years of depression, the farm is only a shadow of its former glory from an agricultural standpoint. But the land and the buildings, all

of the best are there, and labor and industry will bring it up to its former pitch of perfection once more."

About two and a half months after the article went to print, and two weeks after Oliver's second plea for support to Carr, Oliver received his reply on September 14, 1935, from the general council. "Dear Father Oliver, after giving a great deal of consideration to your plan for the purchase of Lake Marie Farm, as set forth in your letters of August 29 and September 13, the General Council feels that it cannot give its approval." There were further negotiations and further refusals from the general council.

This result prompts the question, how did Oliver move forward without the support of the Basilian Fathers or St. Michael's College? The answer can be found in the name of one of the men who signed the letters patent on behalf of the newly formed company. On October 23, 1935, the letters patent were created for the Marylake Agricultural School and Farm Settlement Association. The following five individuals were listed in the request for a patent as the first members of the association and the first directors and officers of the association: the Most Reverend James Charles McGuigan (archbishop of Toronto), Reverend Michael Joseph Oliver (priest in Holy Orders), Percy R. Gardiner (financier), James E. O'Farrell (company president) and Charles Zeigman (produce merchant). The detailed statement of real estate owned in Ontario includes Lots 11, 12, 13, 14 and 15, Concession IV, Township of King. The most notable name above most certainly was the Archbishop McGuigan.

Oliver must have felt much buoyed by the support of the archbishop. Although not in the form of cash, McGuigan's involvement would add much credibility to Oliver's project. It was the archbishop's name at the top of the petition to His Honour Herbert Alexander Bruce, the lieutenant governor of the province of Ontario. And with the letters patent and the deal arranged for the purchase of the land, this is how Father Oliver started the conversion of Lake Marie Estate into the Marylake Agricultural School and Farm Settlement Association (MASFSA). The entire project was placed under the patronage of the Mother of God, and one of the first things Oliver did was change the name from Lake Marie to Mary Lake, soon merged into one word, Marylake, making Our Lady of Grace the official patroness while paying homage to the name given to the property by Pellatt.

In the beginning, Oliver focused on his original plan to move persons living on relief to the property, though none during the years of Basilian operation went on to own any land at Marylake, in contrast to Father McGoey's concept at Mount St. Francis. It is for this reason that even

after both projects eventually came to an end, McGoey's plan resulted in permanent resettlement in the area when Oliver's did not. Regardless, between 1935 and 1939, Marylake became the new home for no fewer than ten families and some fifty-eight persons, more when you factor in the single gentlemen who were hired to work the farm but have not been accounted for in any records found.

One of the best ways to tell the story of Marylake's earliest days is through the voice of one of its earliest inhabitants—and a very unlikely one at that. Marjorie Isobel Nazer, niece of Lady Edith Mary Windle, was astute enough to write a record of her account of Michael J. Oliver's work at Marylake. In a twelve-page typed document, located in the Marylake Archives, Marjorie recounts how it all came to be and preserves for us the names of some of the project's earliest inhabitants. One of the items that requires immediate consideration is why Miss Nazer and Lady Windle came to live at Marylake in the first place. Certainly with the prefixes one would not think that these women were in need of financial support. It was Father Oliver who requested that Lady Windle and her niece Marjorie take up residence at the farm in Pellatt's former bungalow and act, according to Brian Hogan's thesis, as the "centering presence for the community."

Lady Windle was the second wife and widow of Sir Bertram Coghill Alan Windle. Bertram was a professor at St. Michael's College with so many letters after his name it would take a couple lines to cover them all. Bertram was a British anatomist, administrator, archaeologist, scientist, educator and writer. It was on the insistence and foresight of Carr that Bertram came to Canada in 1919 in order to elevate the quality of educators at St. Michael's College. In 1909, Bertram was made a knight of St. Gregory the Great by Pius X. Bertram was the son of a reverend with the Church of England, and his conversion to Catholicism is said to have affected many people.

Father McCorkell writes of Bertram's beginnings in Canada that Father Henry Carr, president of St. Michael's College, "was on the search for professors with the prestige of scholarship." Windle's recently published book *The Church and Science* caught his eye, so he wrote and asked the author to come. An exchange of letters resulted in Sir Bertram's decision to accept the invitation for a year at least. He came on an experimental basis, but it was an experiment that did not disappoint him. Bertram was an important man and huge asset for the college, and he died in 1929, leaving Lady Windle a widow.

According to Marjorie, in the spring of 1936, Father Oliver, who knew Bertram very well, said that he knew that her aunt, Lady Windle, always

Marjorie Nazer and Lady Mary Edith Windle in front of St. Thomas Cottage at Marylake. *Marylake Archives.*

wanted to live in the country. Oliver asked Marjorie to come to the farm and see what he planned to make of it and offered Pellatt's bungalow as the residence for Marjorie and her aunt, who was visiting in England at the time. Marjorie says that she came up in the spring of 1936 and mentions in her memoirs that Henry Pellatt was still living on the estate. This note is confusing as the agreement indicated that Pellatt would only stay on the property until the end of September 1935. Marjorie tells the story of how she drove to Pellatt's bungalow and sat in the drawing room and had tea. She mentions that Pellatt was old, ill and barely able to walk at that time but "very gracious." Pellatt told her that "he loved the place and thought that a lot of people could be happy there and he hoped that Father Oliver would be able to finance the estate." Marjorie was so taken with the place that she said that she decided then and there that she would move to Marylake, even if her aunt said no. That was not an issue. When Lady Windle returned from England, she went to see the farm with Father Oliver and Marjorie, and she, too, decided to call it home. Marjorie said that Lady Windle moved to Marylake in May 1936 and that she visited most weekends that summer. That fall, Father Oliver asked Marjorie if she too would move up there and teach handicrafts, which she did.

Marjorie and Lady Windle, residing in Pellatt's bungalow, used the large basement as their schoolroom for the first year they were in operation and had approximately twenty children in first through eighth grades. An unlikely trio, Lady Windle was sixty-seven, Father Oliver forty-eight and Marjorie just thirty-one years old when they all came together at Lake Marie. Perhaps

Oliver felt that Lady Windle would add and act as a motherly figurehead at the farm given her age and title. It is rumoured that many in her life called her "Ma Edith." She didn't have any children of her own, which lent to her having such a close relationship with her niece Marjorie.

Lady Windle's presence was no small thing. In fact, on March 20, 1937, the *Toronto Daily Star* ran an article titled "Lady Windle Helps Train Children to Brighter Life" with the subheading "Are Given Vocational and Academic Instruction at King School." This article indicates that Lady Windle came to Marylake because "she felt she could help a worthy cause." Later, she went on to say, "[B]ut I am not the person to see. I have only come here to help in any way I can because I love this country." The article goes on to say that Lady Windle provided assistance with the children at the school, which was set up in Pellatt's former bungalow basement, and that she dealt with all minor ailments on the farm that did not require a doctor. When Lady Windle was not attending to studies or illnesses, she worked on her famous oil landscape paintings in a former Pellatt bedroom that she converted into a studio. These landscapes, presumably of Marylake, were exhibited at the J. Merritt Malloney Galleries.

One of the first challenges that Oliver faced at Marylake in its earliest days was with King Township Council over taxes. As this property had been owned as a private residence, it was subject to property tax. Oliver, as lead appellant on behalf of the MASFSA, challenged the town to reverse its decision to continue assessing the property. Oliver was successful and didn't have to work too hard for the win. On July 23, 1936, Judge T.H. Barton determined that the MASFSA was an "industrial farm and a charitable institution conducted on philanthropic principles and cannot be questioned. And as the lands and buildings are being used to further the objects of the Corporation, they are exempt from assessment under the provision of Subsection 9 of Section 4 of the Assessment Act." A July 30, 1936 article in *The Liberal* reported that King Council, under general accounts, paid fifty dollars to the "Marylake Appeal." The loss of Marylake as a taxpaying property was a big financial loss for the small township at the time. The judge who oversaw this case said that he was merely "influenced by the strict wording of the assessment act exempting all philanthropic institutions from local taxes."

A list of the first families Father Oliver brought to the farm, according to Marjorie, is provided here, and was found within her accounts of her time at Marylake from 1936 to 1939:

1. *The Smith Family. They were living in a tent near Meaford Ontario with five children. At first, they lived in the back of the main lodge/bungalow with Lady Windle and Marjorie until a home had been fitted properly for them. The children were Eileen, Winnifred (known as Winnie), Stephen (known as Bud or Buddy), Shirley and Kathleen. Shirley had a lovely voice. The parents were Elva and Stephen Smith.*

2. *The Fitzgerald Family. They were on relief in Toronto with seven children. The father was an "excellent carpenter." One daughter was named Margaret. Eldest son was named Gerald.*

3. *The Allison Family. John Allison was a general handyman and played the fiddle; they had three children (one daughter named June).*

4. *The Flanagan Family. He ran the dairy and had four children. They were from a small village where they ran the general store, which collapsed during the Depression. There was a Louise and a Helen Flanagan.*

5. *The McGeeans. An Irish family with three boys with another son born at Marylake two years after they arrived. They arrived at Marylake with virtually nothing except hope, which they found. A gay family, delightful and full of humour.*

6. *The Urbanavitch Family. They came from Hungary and had one daughter named Annie.*

7. *The Whalen Family. They had seven half-clad children, the mother almost driven to insanity because she had nothing to offer her children.*

8. *Mr. and Mrs. Mullen. They had no children and were both good with horses. They came because there was nothing for them in the city.*

9. *The Lanthier Family. They had two boys and two girls. Mr. Lanthier was the farm manager. He worked for Pellatt. He was a graduate of MacDonald's Agricultural College. Mrs. Lanthier made the most amazing rhubarb pies. Joan, their second daughter, went on to be the Dean of Women in the Toronto College.*

10. *Mr. and Mrs. Copping. Mr. Copping was the chicken and egg man, and Mrs. Copping cooked, cleaned and looked after the needs of Lady Windle and Miss Nazer. Mr. Copping was a great musician, and his banjo playing added to all their dances.*

11. *Lady Edith Mary Windle and her niece Marjorie Isabel Nazer.*

12. *Miss Kavanagh. Joined the farm in the earliest days as a teacher.*

13. *Mr. Sidney Berthelot. Herdsman.*

In addition to these families, there were several young unattached men who resided on the property in the single men's residence. As you can

see from above, there were approximately thirty-five children living on the farm at any given time. Marjorie talks about the lively dances they all enjoyed in the large barn before retiring to the schoolroom in their basement for some hot cocoa before everyone returned to their homes on the farm under the light of the moon and stars and the quiet of the lake. Marjorie speaks about how these strangers who were existing in almost isolation and poverty came together to form a unique and prosperous community contributing to the Canadian economy after only three years of working together. In 1939, when everyone went their separate ways, Marjorie says that many went on to own their own homes and businesses, most achieving a life of contentment, fulfillment and happiness.

During a fortuitous interview with Winnifred Rosaline Smith (Winnie), now in her early nineties but just a girl of thirteen years old when her family moved to Marylake, she spoke of her time at Marylake between 1938 and 1942. Winnie indicated that her most vivid memory as a girl of that time was "running up and down the seven terraces from Pellatt's bungalow down

Left Helen Flanagan, M. Berthalot and Winnie Smith at Marylake. *Winnifred Smith and Tammie Buckler.*

Right: Unidentified men on the grounds of Marylake in winter. *Marylake Archives.*

to the lake." She also recalled that a table in Pellatt's former bungalow had "a cut out in it where his abdomen would fit as he was of such a large girth." Winnie recalled that Pellatt "was a very kind man," which means that Pellatt did visit Marylake after the property was taken over by the Basilians. Winnie also said of Father Oliver that "he loved music and he loved the chapel in the bungalow" and that it was Oliver who "encouraged her and her mother to start singing."

For the children, every school day started with fifteen minutes of choir practice, and after three years, the children developed a solid repertoire and were quite good. Lady Windle would play the small organ—music played an important role in their little community. Marjorie shared that on Christmas Eve, all of the children would pile onto the sleigh drawn by two grey horses while Mr. Mullen would drive them around the farm and then out to the surrounding farming neighbours, all the while singing carols. They would always end at Mr. and Mrs. Claude Elmsley's house for hot chocolate and buns. On the cold winter nights, the adults would get together and play euchre, and the children would perform a play or concert. "In winter, ice blocks were cut from the lake and stored in the huge ice house, enough for all of us, no Frigidaires necessary." The life they created for themselves out of nothing may have seemed idyllic, but it was also very hard.

By all accounts, Christmas was a particularity joyous occasion. One year, Father Joseph Edward McGahey, CSB, was to say the midnight mass. The children had made a rough crib and figures for the nativity scene. Father McGahey suggested that all of the presents for the children go under the tree so as to show that they were for the Christ child. At the end of the mass, the children were informed that the gifts were for them, and Marjorie recalled how happy a time it was to see the children with their parents, trudging back in the deep snow to their homes with their presents in hand. Marjorie said that they never went a winter without a Christmas tree in the schoolroom; the children would make decorations for it. Every year, donations would come of new and used toys for the children from their friends in Toronto. The used toys would be cleaned up and polished with a fresh coat of paint, "as if they had come straight from the Eaton's store." Marjorie also recalled a night before Christmas when two priests and two laymen knocked on the door late at night with a special surprise for the children. "In no time they had set up a complete modern railway with a clockwork policeman on point duty." These four good Samaritans were none other than Cardinal George Bernard Flahiff, Monsignor Phelan, Mr. Lavanoux (editor of *Liturgical Arts*, New York) and Dr. J. O'Brien, a St. Michael's College student who went on to be a pediatrician.

Left: Two cars in the snow after a large storm at the gates of Marylake. *Marylake Archives*.

Right: Marian Grotto at Marylake. *Author's collection*.

Marjorie's memoirs are a real treasure. Through them, she has been able to re-create a time that until now could only be imaged. Although it is still the imagination that brings it to life today, the reader can do so with far greater accuracy. Marjorie said, "Many Basilians came to Marylake and I think they all felt a peace with the place." Many possessions at Marylake were homemade, and one item that brought much pleasure and peace to the visitors was a small shrine to Our Lady that stood at the end of the long driveway. Today, a small Marian Grotto stands in the same place.

Oliver notably did not live at Marylake, and although a visitor, he was ultimately responsible for and made most of the decisions for the people living at the farm. Mr. Lanthier, farm manager, was responsible for the day-to-day operations. It would seem, however, that the two men had a different managerial style and different ideas about what their roles entailed. In a letter to Lanthier from Oliver in February 1937, Oliver appears to be gently reminding Lanthier that any major decision should

come to Oliver first for consideration. In this instance, it seems the issue pertained to staffing on the farm. With money being as tight as it was, Oliver did not appreciate Lanthier taking on extra hands (workers) without first consulting Oliver. And on the other side of the spectrum, Oliver did not want Lanthier dismissing any families who were settled on the farm without prior consultation.

After one full year of operation, on January 1, 1937, Marylake had in terms of livestock: 64 registered purebred Ayrshire cattle (valued at $3,775) and 22 grade cows (valued at $1,056); 10 heavy horses and 1 light horse (valued $1,000); 34 sows, 235 market pigs and 2 boars (valued $2,435); 28 ewes and 1 ram (valued $211); 45 laying hens (valued $337.50); and 10 turkeys (valued $30). The total value of the livestock was $8,853.50 (or $151,000 today). This was an increase in stock value by 30 percent ($2,686) over the year prior on January 1, 1936. The full list of Marylake Farm machinery and implements as of January 1, 1937, can be seen in Appendix B. The full list of inventoried furniture at Pellatt's Lake Marie Bungalow as of 1935 can be seen in Appendix C.

As for the medical needs of the folks living at Marylake, Father Oliver contacted a doctor in nearby Aurora named Doctor Clifford John (CJ) Devins and explained his situation at Marylake. Dr. Devins agreed to support the group by providing very low fees for his services and would visit every fortnight, at which time he would hold a clinic and visit any bed patients, conduct any minor surgical cases at the farm and perform any major surgical cases in the hospital at Newmarket. For this regular service, a fee of $300 per year would be charged to the corporation. His visits became social, and everyone enjoyed his company. Marjorie indicates that between herself and Lady Windle, they were able to deal with most of the minor ailments and had a stocked infirmary in their house for such occasions. A telephone was also scheduled to be installed in the bungalow to allow for consultation with the doctor. Oliver stated that maternity cases would go to the hospital at Newmarket and not likely exceed $30. A one-week stay at the hospital would be around $12.50. Oliver indicated that the farm treasurer (himself) would pay the doctor monthly and that the fee would be deducted from the monthly cheques of all employees. This arrangement was to go into effect on March 31, 1937. There is a street (Devins Drive) and a public school (Devins School) named after Dr. Devins in Aurora. Dr. Magner and his family from King City were also constant visitors to the farm and, at times, treated persons at Marylake, as did Mrs. Grace Field from nearby Mount St. Francis.

A major project undertaken by the children of Marylake was reforestation. Credit is owed to their efforts, as hundreds of trees were planted on the slopes beyond the lake that were of no use for pasture land. Marjorie explained the process: "Mr. Mullen and Mr. McGeean ploughed furrows and we ran an assembly line of boys and girls, dropping in the trees, stamping them firmly, followed by the men and boys with buckets of water. We had [received] the trees from the re-foresting estate near Midland, all free, courtesy of the Ontario Government."

The biggest event of the year was the Sunday nearest to Corpus Christi. "The choir from Holy Rosary Church would come to Marylake for the day. An altar was erected on one of the terraces overlooking the lake and a procession was formed from our Log Cabin Chapel to the altar of repose on the terrace." It's interesting to note here that the pioneer log cabin that Pellatt moved to the estate was now acting as the chapel. "The children gathered flowers from all of our gardens, enough to strew along the path of the Blessed Sacrament."

Marjorie ends her account of life at Marylake saying that by 1939 her Aunt Edith felt that they had done all that they could do there. They had been there with these families for three years (1936–39). Lady Windle moved to Thornhill, and many of the original families mentioned began to move on. "It was obvious that the world was on the brink of war again and so unemployment was no longer the boguey it had been after the 1929 depression." Marjorie aptly ends this thought with these word: "Such is the tragedy that a country's economy thrives on war, whereas life could be so much more meaningful in peace, if there could be more Marylakes everywhere."

Marjorie ends her memoir with a description of what happened to Marylake when she and the others had left, indicating the house became home for seminarians but could say no more but that only "Father Oliver must write the rest of Marylake's history as far as the Marylake Agricultural School & Farm Settlement Association was concerned." And since Father Oliver did not continue the story and is no longer with us today to do so, the remainder of this text will attempt to fill in the blanks.

As early as February 1939, the directors of the MASFSA began a fundraising campaign to reduce the remaining $70,000 debt left of the original $95,000. There were many factors contributing to the project's demise. For one, Oliver had thought that by the fifth year of operation, gross revenues would be around a conservative $25,000 per year. In the three years leading up to 1939, the gross revenues were $9,600 (1936),

This page: Outdoor service by the lake next to Pellatt's former bungalow, now chapel. *Marylake Archives.*

$13,400 (1937) and $16,023 (1938). Oliver and his partners were expecting 1939 to be a prosperous year, but in fact, gross revenue was down to $14,404 that year. While they were able to manage the interest payments on the property, they were not able to pay the principal payment. The men responsible for MASFSA at this time, including Bernard W. Hughes (president), Gerald M. Kavanagh (vice president), J.F. Murphy (secretary) and Reverend M.J. Oliver (treasurer), all knew that something had to be done if the project was to be salvaged. Competing pressures included the creation of jobs with war on the horizon and the loss of their stabilizing figurehead, Lady Windle, on the farm.

The corporation had missed its $5,000 principal payment, which was due on May 1, 1939, and then again when it was extended to October 1, 1939. By 1940, it looked as if it was about to default on another payment. Attempts had been made to convert the property—or part of it anyway—into other revenue-generating opportunities. One such scheme initiated in 1938 was the establishment of the Marylake Health Centre, also referred to as the Marylake Rest Home, with the hope that it would open in the spring of 1939. On August 25, 1938, Oliver was corresponding with the Department of Health, which had its office in the Parliament Building in Toronto. In this letter, it is clear that there had been earlier correspondence. Oliver had been charged with the responsibility of providing the plans for the main lodge house/bungalow. He submitted the plans of the bungalow's main and upper floors as well as the large basement, which at this time was still the home of Lady Windle and Marjorie Nazer. He provided two letters of reference upon request: one from a Dr. D'Arcy Frawley and another (promised at a later date) from a Dr. Knowlton. He also provided a detailed and informative note about the corporation. Oliver had been doing his homework, for without prompting he informed the Health Department of the provisions he planned to make as to the management of the proposed rest home, and to that end he included an excerpt from a letter from the superior general of the Grey Sisters at Pembroke:

> *Our two sisters have returned to Pembroke after their visit to Toronto and Marylake, and are very much pleased with their trip. They have given glowing reports of conditions at the Marylake Rural Health Centre, and, after examining the blue prints very closely, we consider it a wise move on our part to accept this new opening. Accordingly, in my plans for placing the Sisters for September* [one month later], *I am reserving at least three sisters for this work. If I can secure a fourth I will do so, as it is always*

more convenient for the Sisters themselves to have a fourth, who can fill in on various occasions. The staff will include A Superior, a Nurse and a Cook.

Oliver received his response from a Mr. M.E.J. Stalker on behalf of the Department of Health Office of the Deputy Minister on September 2, 1938, on the subject of a "Rest Home at Merry [*sic*] Lake Farm School-King." The letter started on a positive note: "I am advised that provided the applicant for a license for a rest home on the above property meets all of the requirements of the Department, the Department is prepared to recommend to the Honourable the Minister that such a license be issued." Those requirements were listed as "making the building safe from the standpoint of fire hazard; allowing adequate cubic space for each patient; and providing satisfactory sanitary arrangements. Evidence should be supplied that there is available at all times an adequate supply of pure water for drinking purposes and that sewage disposal is satisfactory." Unfortunately, Oliver did not submit a signed application with his letter of August 25, indicating that to get all the directors together to sign it would cause delay, and it is for this reason that the application was returned with a note that all the signatures were required. It is unknown what ever happened with this plan other than it did not come to fruition.

Later, in November 1939, Oliver wrote to *the* Albert E. LePage, realtor. His letter begins with what seems to be an almost endless trail of property or parcel sale opportunities between 1940 and 1942. The letter from LePage was a follow-up to a telephone call they had that morning. Clearly, Oliver was interested in land values and was inquiring as to the benefit of selling the Marylake estate as a single entity or breaking it up into several parcels. The first item that LePage confirmed for Oliver was the value of land in and around King Township in 1939 without any buildings. LePage was advised by a Mr. J.A. Willoughby that land could fetch about $80 to $100 per acre. That would price Marylake without any buildings at about $81,400. The next query was what price could the land fetch around the lake itself, sold in ten-acre lots. Willoughby was noncommittal but said he felt that an estimate provided by a Mr. Frank McLaughlin of $1,000 per acre was far too high. A Mr. Hopkins was an agent selling estate lands in the Bayview and Steeles area for $1,000 an acre but indicated that as soon as you went north, east or west the price dropped to a max of $500 per acre. He provides an example where Timothy Craig Eaton purchased one hundred acres at the northeast corner of Steeles Avenue and Third Concession, a beautiful wooded property with the Don River running

through it, for $28,000 ($280 per acre). One thing to consider is that Oliver did not own this land he was planning to sell. The land was owned by Caledon Securities Inc., and any plan to sell off any portion of land would have to be vetted and approved by that company.

LePage ends with two thoughts: "Under the circumstances, I doubt if you can expect more than $500 per acre for the 'estate' part of your property, and, in my opinion, you will have to use a great deal of care in dividing the lots in such a way as any sales made will not interfere with the farm part of the property." The postscript from LePage reads, "Should you ultimately decide to sell the property en bloc, or perhaps half or quarter it, I should be glad to take the matter up with some of my wealthy clients and see if I could dispose of the property for you." Happily, the property was not severed during these desperate times, but it wasn't for lack of offers.

The rest home scheme may have led to this next opportunity. On January 29, 1942, Oliver received a letter from the Department of Pensions and National Health (DPNH) in Ottawa via a Mr. W.S. Woods. Woods starts off by indicating that Colonel Baker had handed him a document from Oliver concerning the sale of Marylake Farm School. Woods acknowledges everything that was included in the report: an inspection report by Reed, Shaw & McNaught, insurance engineers; a plan of the property by the Ontario Forestry Branch; a photostat plan of the property; a general report of the woodland area; and a leaflet reporting the outline of the work of the school and its objectives. Woods confirms that "this material is being placed before the Sub-Committee of Land Settlement of the Government's General Advisory Committee on Demobilization and Rehabilitation, after which I shall forward it to the Director of Medical Services of this Department to examine it from the standpoint of its use for convalescent purposes." Woods ends with no assurance that the property would be useful for either land settlement or convalescent purposes and closed with "meanwhile, if you wish to make any proposal to sell or lease in whole or in part, I shall be so pleased to refer it to the authorities mentioned."

On February 4, 1942, Oliver received a reply from the DPNH. The letter starts by acknowledging Oliver's letter from January 29, 1942, and thanks him for providing the data on Marylake Farm School to the proper authorities. It then goes on to reference an opportunity presented to them by Oliver: "Concerning the sale or lease price [of Marylake], we would be prepared to accept $150,000 for the whole property [814 acres] or $100,000 for the East Half [414 acres]. You will see from a map of the property that the east half means 414 acres and practically all of the lake and all of the

buildings. From the insurance survey and pictures you will see that these buildings are not ordinary farm buildings—especially the main barn and granary. It is an exceptional estate on which the late Sir Henry Pellatt spent some $450,000, we would not be interested in leasing the property." At the same time, the adjacent estate to the east of Marylake, known as Eaton Hall Farm and Estate, had just signed a contract with the Wartime Convalescent Homes Inc. to turn over the newly completed Eaton Hall to the Royal Canadian Navy for use as a convalescent facility. The Marylake property did not go on to be involved with either the rehabilitation and training of servicemen or a convalescent facility, but clearly Oliver was considering every option to help finance his debts.

In the early 1940s, the financial situation of the MASFSA was rather dire. The capital debt was $70,000, and the MASFSA had paid off only $25,000—largely through support from private individuals. The current revenues were sufficient to take care of current expenses but neither capital nor interest. Oliver proposed three suggestions. The first suggestion was to simply raise $75,000 ($1.2 million today) to pay off all of the debt and interest completely. The second suggestion considered only the immediate need, which was $5,000 a year to cover the annual capital payment and $5,000 more for the interest. With suggestion two, Oliver explained that only $10,000 was needed to carry on the work further and notes that "the

Marylake Farm School bill.
Marylake Archives.

estate was taken over by a purchase and sale agreement so that it is not like an ordinary mortgage" and that "failure to pay means forfeiting all the money and energy we have put into it." Oliver's third suggestion came from a friend who was willing to make a donation of $10,000 to be paid out at $2,000 per year over five years and would require $40,000 to be paid by others over the next five years. Although not mentioned in his suggestions above, Oliver did get a bit down the road with several land sale and lease options to local farmers, but none came to fruition.

In September 1940, Oliver rolled out one of his more industrious schemes and opened the Marylake Farm School: A Rural Secondary School for Boys. This is

one of the most interesting concepts and perhaps had the potential to be the most sustaining concept at Marylake had it had a chance to succeed. But it was born at such a difficult time. Oliver was trying to plot a course, steer a ship and bail, all at the same time—a difficult task for anyone. Much of the information about the Marylake School comes from Oliver's six-page brochure. But other documents from the Marylake Archives have also been useful. The school only operated for two years: 1940–41 and 1941–42. The last session was summer 1942.

Of course, Marylake had been operating the Marylake School since its inception for grade school children. This school ran out of the basement of the Pellatt Bungalow and was considered a separate school. It was open to children of the farmers at Marylake and from the surrounding area. These children would do their ordinary primary studies but also be trained in the cultural and domestic arts. There was also an adult school where all of the men and women on the farm were instructed and trained according to their ability in farming and in rural arts and crafts. The Marylake Farm School for Boys was a different program altogether. First consideration was afforded to boys who had already completed two years of high school. A list of the sixteen courses and their descriptions can be found here.

MARYLAKE FARM SCHOOL

Outline of Courses in Agriculture
(As Indicated in the 1940 Registration Package)

1. SOILS, THEIR STRUCTURE AND COMPOSITION: What soils consists of; fertilizing constituents of soil; kinds of soil; characteristics of various soils; production capacity; reaction to moisture; temperature; air.
2. SOIL MANAGEMENT: Tillage systems for various soils; use of various tillage implements; crop rotations in maintaining fertility; control of weeds; care and application of farm manures; commercial fertilizers, their nature and use.
3. PRODUCTION OF COMMON FARM GRAINS: Wheat, oats, barley, peas, corn; choice of varieties and selection of seed; preparation of seed bed; fertilizer requirements, place in crop rotation; harvesting, cost of production, possible yields.

4. Forage Crop Production: Grasses, clovers, corn silage, roots; soil requirements, preparation of land, planting and care of growing crop; curing of hay, silage from clovers and hay; care and management of pastures; production of corn and root crops.

5. Principals of Feeding Live Stock: Principal constituents of feed; requirements for growth, production and reproduction; minerals and vitamins in the ration; balanced rations; home grown vs. purchased feeds.

6. Dairy Cattle and Milk Production: Breeds of dairy cattle, selection of breeding stock, pure breeds vs. grades; grading up a herd; cow testing; feeding for milk production, economical rations; care and management of the milking herd; calf raising; development of growing heifers, time to breed, care and maintenance of the sire, care of milk.

7. Beef Cattle Feeding: The feeding of beef cattle as a business; purchase of stockers and feeders; stall feeding; fattening on grass; maintaining a beef herd; raising one's own feeders; baby beef; dual purpose cattle; marketing beef cattle.

8. Bacon Hog Production: the pig as an economical producer of meat; place of the hog on the farm, selection of bacon type; management and feeding of the brood sow; care at farrowing; weaning pigs; growing and finishing pigs, housing requirements.

9. Sheep on the Farm: Value of the small farm flock; types and breeds of sheep, selection of breeding stock; winter feeding of ewes, care at lambing; castration and clocking; weaning; pastures for sheep; fattening for market; fall care; the sheep barn and equipment.

10. Horses, Their Care and Management: Horses as the source of farm power, principal breeds in Canada; selection of draft type; care and feeding of the brood mare, raising foals; feeding and care of work horses.

11. Poultry Husbandry: Opportunities in poultry raising; the small farm flock, the commercial poultry plant; types and breeds of poultry; feeding the laying flock; care and management of the layer; brooding and rearing chicks; fattening cockerels, killing and plucking; culling the laying flock, care of eggs, grading and marketing; poultry houses.

12. Orchards and Small Fruits: Laying out and planting and orchard, varieties to plant; training the young orchard, pruning, fertilizing and cultivating the orchard; sprays and spraying; planting and care of bush fruits.

13. The Farm Garden: Importance in relation to household expenses; selection of site; preparation of soil, classification of vegetable varieties; reason of growth, hardiness, maturity, etc.; layout of farm garden for efficient working; winter storage of vegetables; hot beds and cold frames.

14. BEE KEEPING: Returns from bees; methods of starting; equipment required; winter care, feeding; swarming; developing new colonies; handling honey, disease problems.

15. THE FARM HOME—PLANTING AND CARE OF GROUNDS: Importance of attractive home and surroundings; simple rules for landscaping; planting and care—trees, shrubs, lawns, perennial boarders.

16. FARM MANAGEMENT: Types of farming; location and size of farm in relation to the type of farming practiced; investment in land, buildings and equipment for various types of farming; farm selection; efficient farm layouts, planning a farm program; farm accounts and records; marketing farm products.

The object of all education at Marylake was to train people to make a living and be happy, rather than to make money and to avoid work. Oliver's pamphlet proclaimed, "The country is the nursery of the nation and if the rural life fails, the city fails too and the nation is doomed." The chief aim of the boys' school was to give young men the opportunity to achieve their high school education under Catholic conditions. The school opened on September 8 each year to coincide with the Feast of the Nativity and closed on June 21 to coincide with the Feast of Aloysius. The school closed for two weeks at Christmastime and one week at Easter. The boys would then work for two months during the summer on the farm.

In year one, the fee was $300 per year, which was broken out as a $150 payment and another $150 in equivalent manual labour completed by the boy at the farm. In today's dollar, this would be $5,000 per year but paying only $2,500 and expecting $2,500 in work hours on the part of the boy. In the second year, the fees went up to $400 per year with $200 in payment and $200 in equivalent manual work hours. These fees covered the tuition, a private bedroom with basic furniture, all meals, Catholic teaching, high school education, rural education, fresh air, exercise, health/medical needs and the manual labour/work experience, which was considered the same as a work placement today—a form of apprenticeship. The boys would pay extra for books and clothing through the school or could be provided with a list of what they needed to purchase in advance to bring with them.

In a one-page summary written by Oliver on the reason why this type of school was so crucial, he notes that "the number of farm boys who now proceed to the priesthood is remarkably low. In the Toronto diocese the percentage has almost reached the vanishing point." Oliver also points out

that "a boy who lived on a farm that goes on to higher education, even to high school, is generally lost to the farm for good and the farmer is paying the cost." Ahead of his time, Oliver recognized that the education system was designed to encourage and promote urban and industrialized life, not a rural one.

A boy from Marylake Farm School could expect to develop skills that would help him whether he intended to proceed to the priesthood, a professional life or a rural life. A regular eleven-and-a-half-hour day for a boy at the Marylake Boys School included Holy mass (approximately thirty minutes), four hours of class time, three hours of study time, two hours of manual labour and two hours of recreation/leisure time. Over the course of the school year, each boy was expected to contribute eight hundred hours of manual labour to offset half of the tuition fee. The concept never had the opportunity to gain traction. Although no records have been found that list the number of pupils, financial records show revenues from school fees for two years of operation as $650.69 and $929.75, respectively.

By 1942, the majority of families had left Marylake. Windle and Nazer were gone. The rural, bucolic, country life they created together was a distant memory. Only a skeletal farm operations staff remained on hand, not enough to harvest the crops that year. In a letter dated March 9, 1942, to a Mr. W.M. Cockburn, agricultural representative for York Country, Oliver bemoans that "we now have only four families and a total of twelve men and boys over twelve years of age." Still hampered by the war call, Oliver adds that "none of them are eligible for military service, the men too old, and the boys too young." Oliver indicated in this letter that there had been a far greater number of people at the farm at one point, as many as eleven families, but "lack of funds has compelled us to reduce our help." At the time, Marylake did not have the manpower to manage the 345 acres under cultivation. As for the state of the Marylake Boys School, by March 1942, there were only four pupils enrolled doing "junior high school work." Oliver closes with a plea: "We have a few good men but to see crops neglected is a heart breaker to them….If you have any information or advice bearing on our situation at Marylake will you give it, if you can, so as to be of some help to us during this coming season."

Oliver was not alone. In fact, the following year, Cockburn initiated a campaign to encourage citizens of the local community to become "farm commandos" and dedicate whatever hours they could to support their local farmers during this harvest. Without it, there would be much wasted yield and thus less food for the coming winter. The government also created a

program called Victory Holidays for professional and business men and women to take approved time off to support the harvest. Farmers were being asked to submit an application to the Federation of Agriculture and the Agriculture War Committee for their manpower needs. An article for the *Newmarket Era* on April 22, 1943, titled "Organize Commandos to Help Farmers, Is Urged" goes into further detail. But these efforts came too late. By the end of summer 1942, it was evident that the Basilian time at Marylake was coming to an end. Marylake would soon have a new master.

Oliver's last attempt to save Marylake returned him to the doorstep of the Basilian Fathers, but it was evident that Oliver simply didn't have the support of the community this time. In a letter dated July 17, 1942, Reverend John V. Harris, clergyman for the Archdiocese of Toronto, wrote to Archbishop McGuigan about the Marylake opportunity that Father Oliver "feels quite certain that it will be a very profitable investment." Harris indicated that he had spoken to Father McCorkell and had asked him, "Why, if it was such a good investment, the Basilian Fathers did not supply the money themselves?" Harris indicated that McCorkell replied, "It would take too long to dispose of it and they are tied up in a lot of property of a similar kind at the present moment." To quote Brian Hogan: "The Basilian Fathers were not able or willing to mortgage their future on such an uncertain endeavor." Of course, many Basilians supported Oliver's project in principle but were not willing to support its principal payments. What would become of Marylake?

All was not lost. Archbishop McGuigan, who had always been a strong supporter of Oliver's plan and was the figurehead on paper when the MASFSA petitioned for its original patent in 1935, had a new vision for the future of this blessed property. In the summer of 1942, negotiations began for the transfer of Marylake from the Agricultural Association to the Augustinians, sparking the beginning of what has now been seventy-five years of Augustinian life in King Township.

6

AUGUSTINIAN OCCUPATION

Anima una et cor unum in Deum. (One mind and one heart unto God.)
—motto of the Augustinian Order

The year 2017 represents not only the semi-sesquicentennial anniversary (seventy-five years) of Augustinian ownership of Marylake but also seventy-five years of stewardship, pilgrimage and respite for people of all races, religions and creeds. Marylake today may be synonymous with Catholic life, but one does not need to be a practicing Catholic to feel the many gifts and joys that are abundant on the property. The emblem of the Augustinian Order includes an open book, a flaming heart and an arrow; together they symbolize the basis of Augustinian spirituality. The open book symbolizes the Augustinian intellectual quest, the flaming heart represents a developing love that must be as passionate as it is profound and the arrow evokes the divine energy and stimulating grace. The Augustinian motto is *Anima una et cor unum in Deum*; translated to English, it means "One mind and one heart unto God."

To begin the history of the Augustinians, one must go back almost eight hundred years. Augustinians are men and women who follow God in the spiritual model of Saint Augustine. Augustine was a scholar born in AD 354. He established monastic communities and wrote a rule that serves as the guide for living in a religious community. The Order of Hermits of St. Augustine is a mendicant order established in the year 1244. In 1244, the church decided to bring together all the hermit communities under the

Augustinian emblem. *Author's collection.*

rule of St. Augustine to form the Hermits of St. Augustine. The name changed from the Order of Hermits of St. Augustine to the Order of St. Augustine (OSA) in 1968, how we know it today.

The history of the Augustinians in Canada began in 1938, but the history has roots that go back almost two hundred years to the community of Monastery, Nova Scotia. Monastery is about thirty-four kilometers east of Antigonish. The town of Monastery is named after the original Trappist monastery that today is home to the Contemplative Augustinian Nuns. The monastery originated in 1825 and was named Petit Clairvaux. Petit Clairvaux, which means "small clear-dale," was established by a Trappist monk from France, Father Jacques Merle. Another priest would join in the early years, Father Johann Baptist Kaiser. Kaiser assumed the administration of the monastery while Merle assumed parochial duties and missionary work. Merle named the monastery after a Cistercian monastery in France. It was the first Trappist foundation in North America. The monastery was occupied by Trappist monks until 1919, with the exception of the years 1900–1903, when the monastery was vacated after two significant fires. The monastery was seen as the heart of the community and played a significant role in community life. In 1919, the Trappists abandoned Petit Clairvaux forever. For the next nineteen years, the monastery remained vacant.

On May 4, 1938, a small group of German American Augustinians arrived in Monastery and quickly began the hard work of restoring the monastery. This was the foundation of the Augustinian Order in Canada. The Augustinians restored the buildings on the property and renamed the monastery for their patron saint. In addition to the various ministries they provided for the local community, the Augustinians established a model farm on the property, reestablishing many of the original farm buildings. The first Augustinians in Monastery included Brother Lucien Kammerer, Father Charles Schlereth, Brother Sturmius Nuszkowski, Father Forerius Schramm, Father Gelasius Kraus (prior) and Father Andrew Steinberger. The year 2018 will represent eighty years since the arrival of the first permanent Augustinians in Canada.

In the early 1940s, a highly successful Nova Scotia businessman and devout Catholic named Alexander G. Sampson (1900–1964) praised the work being done by the Augustinians in Monastery, Nova Scotia. Sampson was well known within important social spheres in Canada for his company, Château-Gai. Château-Gai originated in the late 1930s just after Prohibition and was one of the larger wineries in Ontario during the 1960s and '70s. In 1939, a group of investors bought out six wineries and combined them under the trademark Château, and in 1940, they changed the company name to Château-Gai. Alexander Sampson was the man behind Château-Gai. Sampson and Château-Gai were made famous/infamous after being sued by no fewer than fifteen French champagne houses for using the word *champagne* on its products, the argument being that only grapes grown in the district of Champagne, France, could use the term. Sampson later received a honourary degree from St. Francis Xavier University.

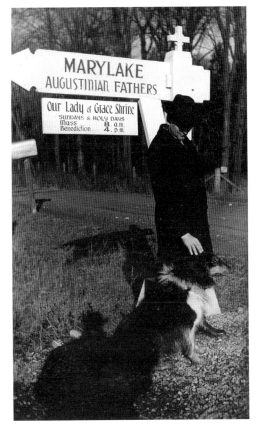

Alexander G. Sampson at the entrance to Marylake. *Marylake Archives.*

In several sources, Sampson is credited with being the man to have incited the purchase of Marylake. In a 1988 publication titled "Rooted in Hope: The Story of the Augustinian Province of St. Joseph in Canada," author Tarcisius A. Rattler, OSA (vicar provincial, 1947–53), credits Sampson's "business acumen and sociopolitical influence combined with a deep and abiding concern for the interests of the Catholic Church" as the catalyst for the Augustinian purchase in King Township. In early 1942, Sampson had a chance meeting with an Augustinian prior from the monastery. The friars at St. Augustine had just recently fled Nazi Germany due to their opposition to Hitler's policies. These friars had a very similar experience to the original French Trappists who fled France at the time of the French Revolution, leaving their home country first for the United States and then Canada.

Sampson also happened to be a close friend of Archbishop McGuigan in Toronto and told him of the great work that was being done by the Augustinians in Nova Scotia. Although it is believed that McGuigan had always wanted a pilgrimage site within his diocese and was well acquainted with Marylake, Sampson is credited with getting the process moving, though it is not known if Sampson's support was monetary.

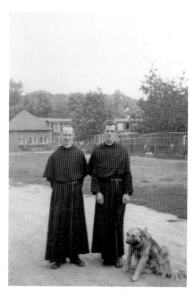

Father Pape (*left*) at Marylake with unidentified brother, circa 1942. Chicken house in the background. *Marylake Archives.*

On August 25, 1942, Archbishop McGuigan invited the vicar provincial, Father Anthansius Pape, OSA, from St. Rita's Monastery in Wisconsin to Toronto to discuss the possibility of opening a similar venue in his archdiocese. Pape held the position of superior for the German-American Commissariate from 1931 to 1936 and vicar provincial from 1936 to 1947. It was Pape who four years earlier had accompanied the first six Augustinians from New York to Monastery, Nova Scotia. McGuigan was considering a religious center and a place of pilgrimage for the Archdiocese of Toronto, similar to St. Augustine's, for the much larger Archdiocese of Toronto, and at the time, he had his eye and mind set on Marylake, a property he was intimately aware of through the

Basilian ownership. Pape, acting on behalf of the OSA, spearheaded the administrative process for the new acquisition. McGuigan, acting on behalf of the Archdiocese of Toronto, led the ecclesiastical approval process.

Perhaps not enough credit is given today to Archbishop McGuigan and the Archdiocese of Toronto for the development of Marylake, for it was certainly due to McGuigan's perseverance and support that buoyed the Basilian use of, and then the Augustinian purchase of, Marylake.

On August 31, 1942, Leonard W. Mitchell, barrister and solicitor, clearly connected to the Augustinians through Sampson, was now acting on behalf of Pape and the OSA and wrote to Reverend Father A. Pape, OSA, at St. Rita's Monastery in Racine, Wisconsin:

RE: Mary Lake Farm

Dear Father Pape:

Mr. A.G. Sampson has spoken to me with reference to the proposed purchase of Mary Lake Farm by your Order and has asked me to act for in connection therewith. I shall be very pleased to do this and will be glad to have an opportunity of discussing the matter further with you when you are in Toronto again.

In the meantime, the first thing to be done is to have an agreement prepared and signed by you and the vendors of the property setting out the terms of proposed sale so that there will be a definite contract of sale pending the completion of the formal transfer of the property to you. I understand from your letter to Mr. Sampson which he showed to me that this cannot be done until you obtain the necessary consent from the Apostolic Delegate. I shall proceed immediately with the preparation of the necessary agreement so that it may be signed on your return to Toronto.

With very best wishes for the success of your new venture,
I am faithfully yours,
L.W. Mitchell

Father Pape responded to the above letter on September 2, 1942, thanking Mitchell for his work and perhaps a little cynically asking Mitchell to see to it that "nothing of importance is taken away from Marylake," because "as you know, we intend to buy the farm with all of the implements, live-stock,

feed, harvest, etc." Pape trusted Father Oliver completely but had less faith in the farm employees. Pape closed the letter with the indication that he was merely waiting on approval from Rome, and as soon as he had it, he planned to send several fathers and brothers to Marylake from Wisconsin.

Meanwhile, on September 1, 1942, Archbishop McGuigan, also working on behalf of the Augustinian purchase, was doing the leg work for the necessary ecclesiastical approval. World War II meant that communication with His Holiness the Pope in Rome was impossible. This would make the approval process a bit more challenging. McGuigan hoped to attain approval via the mediation of the Apostolic Delegate, the Most Reverend Archbishop Ildebrando Antoniutti, and wrote to him in Ottawa: "The Augustinian Fathers of Our Mother of Consolation whose Provincial House is at Racine, Wisconsin in the Diocese of Milwaukee, are anxious to make a Foundation in the Archdiocese of Toronto." McGuigan went on to say that "an opportunity presents itself of a magnificent piece of property known as 'Marylake', very suitable for a Monastery about 25 miles from Toronto, which can be had at a very reasonable price." McGuigan indicated that he was "pleased to give the necessary permission for the 'Fundatio Canonica' [Monastery Foundation]. I now ask your Excellency to obtain the necessary permission from the Apostle Congregation of Religious or to give it to us in the name of the Sacred Congregation if perchance you have this faculty during the war period."

While McGuigan was working on the ecclesiastical approval, Mitchell replied to Pape on September 3, 1942, suggesting a rethink on the planned title on the ownership for the future monastery. Mitchell suggested that Pape reconsider the proposed name, which was "The Augustinian Fathers of Our Mother of Consolation, Riverdale N.Y. Inc." and asked him to consider incorporating an Ontario holding company without share capital and take the property in the name of that company. Mitchell noted that the cost would be the same as doing a license in mortmain and beneficial from a taxation standpoint. Mitchell also initiated the conversation around taxation of the property and posited that the land should be evaluated by parcel, as different parcels could be taxed differently, most especially given then aims of the newly created corporation. Mitchell also noted that the taxes were currently about $1,200 per year, which is "no small matter to them [King Township]" and would be equivalent to $17,780 today. This suggests that there might be a bit of a debate around the property's assessment at the municipal level.

On September 5, 1942, Pape replied, indicating that he had no concern with forming an Ontario holding company but reminding Mitchell that he

has "no Canadian citizens who could be members of this company." The Augustinians had only been in Canada for four years, having arrived in Nova Scotia in 1938, all of the Canadian men who joined the order were not yet full-fledged members and the priests are all U.S. or German born. Mitchell informed Pape that there were no concerns with the members or directors being U.S. citizens and that being German born was not an issue if they were indeed U.S. citizens. As for the name of the corporation, Mitchell suggested, "Augustinian Fathers of Our Mother of Consolation (Ontario) Limited or something similar."

The last tricky bit of the sale was less about the terms of the agreement and approval from Rome and more about who actually had the power to approve the sale. On September 10, 1942, Mitchell indicated to Pape that the vendor, that being Father Oliver, who was acting on behalf of the Marylake Agricultural School & Farm Settlement Association, must obtain consent from Caledon Securities Ltd., the registered owner of the property, not Father Oliver, St. Michael's College or the Congregation of St. Basil (CSB). A couple other important provisions in the agreement include the possession date of Marylake, which was earmarked for October 1, 1942; taking over all of the present farm staff for the period of one month, although Mitchell noted that "Mr. Sampson has asked me to mention that he thought this should be done and that perhaps a month isn't long enough"; and finally, Mitchell needed to know, in writing from Pape, exactly what he planned/intended to do with the land by parcel for assessment and taxation purposes. Mitchell enclosed a copy of the sale agreement with this letter. Pape replied two days later indicating that he was very pleased with the agreement and that he would "prefer to sign it on my [his] arrival in Toronto on Tuesday September 14th."

The agreement stated that the terms were to be accepted on the eighteenth day of September 1942 or otherwise void. The sale included "Marylake Farm, namely all of Lot 11, 12, 13, and 14 and 13.84 acres in Lot 15 all in the Fourth Concession of the Township of King, in the County of York, together with all buildings, plants, machinery, appliances, chattels, implements and tools, cattle, hogs, horses, poultry and any other livestock, growing crops, crops in barns and storage and all furniture and fixtures belonging to the Vendor" and required the purchaser to employ all present staff for a period of one month after closing. The vendor, being the Marylake Agricultural School and Farm Settlement Association, with Oliver as procurator, and the Augustinian Fathers of Our Mother of Consolation, Riverdale N.Y. Inc., with Pape as president, were both aware of the others'

approval requirements (those being ecclesiastical and Caledon Securities), failing which, the deal would be null.

As fate would have it, the day prior to the agreement needing to be signed on September 17, 1942, a "telegram from the Vatican informed the Apostolic Delegate that the requested approval had been granted and that he had been empowered to execute the rescript of the Sacred Congregation, a task which he performed the following day." Also, the first Augustinian monks arrived at Marylake that day, with Father Leo Ebert acting as the first prior. (See Appendix D for a list of all past officials for Marylake.) On the next day, September 18, 1942, McGuigan received the letter from the Apostolic Delegate (reference number No. 2662/42), which read:

> *Your Excellency,*
> *I beg to inform Your Excellency that the Sacred Congregation of Religious, favourably complying with the request presented by the Augustinian Fathers and approved by Your Excellency, has granted the "Beneplacitum Apostolicum" for a new foundation of their Order in your Archdiocese, in the place known as "Marylake." While making to Your Excellency this communications, with best regards and wishes, I remain,*
> *Yours Sincerely in Christ*

On September 19, 1942, Mitchell informed Pape that the agreement had been executed by Father Oliver, "subject of course to the consent of Caledon Securities, which has not yet been received." Mitchell indicated that he was requesting that the purchase price of $56,100 CDN be broken down to show how much was attributed to the land and buildings and the portion toward the chattels. He suggested this for two reasons: first, "to assist in getting the assessment reduced," and second, "to save on the transfer tax on registration of the deed." Mitchell indicated that taxes were "$2 per every $1000 of purchase price and is only payable on the price of the land and buildings and not chattels." Mitchell also informed Pape that the west half of Lot 13 was currently being leased at $300 per year for five years from January 1, 1942, to a relative of Father Oliver's. However, there was a ninety-day sale clause to give the tenant notice to vacate, and Mitchell asked if Pape would like to exercise this notice. Mitchell ended his letter by informing Pape that the "papers for incorporation of the company have been completed" but that he "will not file them until we hear that Caledon Securities has consented to the sale; otherwise you might have a charter incorporating a company but no property."

On September 23, 1942, Pape replied, wishing Mitchell luck with Caledon Securities, the assessment board of King and the lawyer of the archdiocese. Why the lawyer for the Archdiocese of Toronto was involved is unknown. Though it is true that the archbishop was working on obtaining the approvals from the Apostolic Delegate, it is not understood why the lawyers for the archdiocese were involved with the sale between the Augustinian Fathers and Caledon Securities (MASFSA)—this becomes clearer later on. Regarding the lease of the west half of Lot 13 to Father Oliver's relative, Pape asked to reduce the tenancy period from five years to one year and concluded that "we have received permission from the Holy See to open the monastery at Marylake. Consequently this no longer is an impediment on our part—we may complete the negotiations."

With what must have been heavy hearts, the trustees for the Marylake Agricultural School and Farm Settlement Association closed the doors on Father Oliver's project for good. The official sale price was $51,000 United States funds (USD). The conversation rate of the time made the price $56,100 Canadian funds (CDN). By comparison, today, $51,000 USD would be about $67,400 CDN. On closing, less the deposit and some minor adjustments, the total owing was $55,657.59 CDN (approximately $830,000 today). Financially, this was a major investment on part of the OSA.

And so it was official. Sir Henry Mill Pellatt's bungalow overlooking his Lake Marie became the new monastery. The shrine chapel stood in what had once been Pellatt's grand living room. The farm manager's home near the main barn was to become the new retreat house. The monastery opened October 1, 1942, and on the same day, Archbishop McGuigan selected its full title, Marylake—Our Lady of Grace, in recognition of a very ancient devotion of the Augustinians to the Mother of God. Work began on the new shrine at once.

On October 3, 1942, the letters patent were signed in the province of Ontario for the Augustinian Fathers (Ontario) Inc. (amended January 16, 1943). The first directors of the corporation are listed on the letters patent: Alexander Gardner Sampson (company manager), Leonard Wilson Mitchell (barrister) and Mary Camilla Maddigan (secretary). Little information on Mary Camilla Maddigan could be found aside from her date of birth being November 2, 1905, in Charlottetown, PEI, and that she died on January 2, 1960. She was Roman Catholic and is buried in Charlottetown, PEI. How she came to be associated with Marylake in Ontario is unknown. The newly formed corporation was described thusly:

Postcard showing Pellatt's living room converted into the Marylake Monastery Chapel. *Author's collection.*

> *The Augustinian Fathers (Ontario) Inc. is a non-profit charitable organization registered with Revenue Canada pursuant to the provisions of the Income Tax Act (No. 0200634-46-13). It is conducted on religious principles and not for the purpose of profit or gain. On a daily basis its activities are directed towards the offices of worship, preaching, teaching and parochial and retreat ministries in the Archdiocese of Toronto. As a member of the Roman Catholic Church and the world-wide Augustinian Order our roots are anchored in the age-old Christian faith. Our monasteries are peopled by men who make a life-long commitment to the Church and the Order, through the vows of Chastity, Poverty and Obedience and our daily schedule is centered around divine worship and the exercise of the ministries mentioned above.*

By all accounts, it would appear that the sale had closed on October 1 but for a letter dated October 23, 1942, to Pape from Mitchell. In this letter, it is revealed that there was a matter of taxes in arrears owed by the MASFSA to the Township of King, which with penalties and interest to date was now up to $1,625. This had caused a further hold-up in the closing of the sale. Mitchell was happy to announce in this letter that the matter of the outstanding taxes need not hold up the closing any longer, as

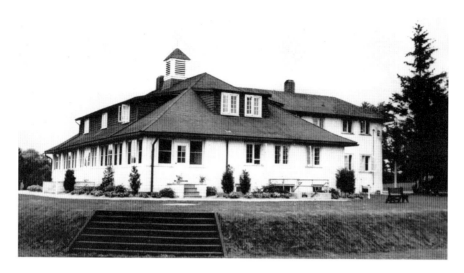

Pellatt's bungalow after monastery renovation. *Winnifred Smith and Tammie Buckler.*

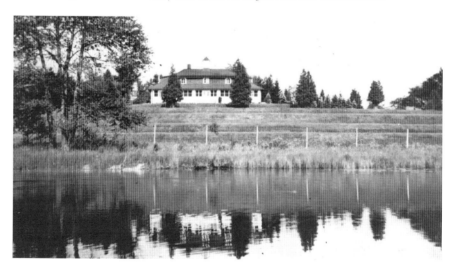

Looking across the lake at Pellatt's bungalow after monastery renovation. *Winnifred Smith and Tammie Buckler.*

he was able to arrange with the vendor's solicitors to withhold $1,625 from the purchase price. On Wednesday, October 28, 1942, Mitchell wrote to Pape again concerning the revised sale price with $1,625 withheld to cover the tax arrears and other adjustments, $54,032.59 CDN. According to the land registry documents, the instrument date for the purchase and sale was October 14, 1942, and the registration date was November 12, 1942.

On October 28, 1942, Pape writes to the Honourable American Consulate General in Toronto asking permission for the five American citizen members of Marylake to register at his office. The initial members were Father Leo Ebert, OSA; Father Suitbert Bernard Moors, OSA; Brother Ladislaus Ignatius Marcinek, OSA; Brother Pirmin Aloysius Haberkorn, OSA; and Brother Patrick William Bohmann, OSA. This request was granted, and Marylake became their new home.

On October 31, 1942, Archbishop McGuigan wrote to Pape of his hopes for Marylake: "I would like to see a public chapel and a shrine where people could go for afternoon and evening devotions on Sundays and Marian Feast days." He continued, "You may educate candidates for your Order, you may conduct lay retreats, you may do missionary work." McGuigan also began to discuss plans for the Archdiocese of Toronto having a permanent station or home at Marylake.

In a letter written on November 3, 1942, it becomes clear why the lawyers for the Archdiocese of Toronto had been in any way involved in the Augustinian purchase of Marylake. In this letter, Pape wrote to Archbishop McGuigan thanking him for his kind letter of October 31 and gushed, "That we should have the privilege of having Your Excellency situated at Marylake in a summer home, is an honour we could never have counted on." Pape goes on to say that "never did we realize when we hesitated making an agreement which would take in the lake frontage for the Archdiocese, that the lake frontage was intended to be used for Your Grace's own personal home....Our fear was that an institution might, in the future, be erected that would take away the privacy of our Monastery facing the lake."

This conversation is interesting for a few reasons. First, it's the first time we learn of how and why 200 of the 814 acres purchased by the Augustinians were sold to the Archdiocese of Toronto the same week the Augustinians purchased the land. Secondly, it explains why the lawyers for the Archdiocese of Toronto were involved with the discussion around the sale of the property when they were not the purchaser or vendor, because, as Pape said, "Never did we realize when we hesitated making an agreement which would take in the lake frontage for the Archdiocese, that the lake frontage was intended to be used for Your Grace's own personal home." This statement confirms that from the beginning the deal had three parties involved.

On November 9, 1942, the instrument was signed for the sale of 200 acres of land, specifically the west half of Lot 11 and 12 in the Fourth Concession, King from the "Augustinian Fathers (Ontario) Inc." to the "Roman Catholic

Episcopal Corporation for the Diocese of Toronto, in Canada" for $6,000 (approximately $90,000 today).

McGuigan replied to Pape's November 9 letter on November 12 thanking him for his kind words: "I appreciate very much your kindness in allowing me to have the property and I know that we will be an inspiring example of the 'good neighbor policy.'" One might think this ushered in an era of the Archdiocese of Toronto residing at Marylake, but that was not the case. In fact, the Archdiocese of Toronto has never held an official office or post at Marylake. Instead, the same week that the Archdiocese of Toronto purchased this land, it signed a ninety-nine-year lease agreement with the Augustinian Fathers, who have leased those two hundred acres for the past seventy-five years. No development has occurred on that acreage, and it is predominantly farmland leased to a local farmer. The initial agreed upon rental rate between the archdiocese and the Augustinians was of $180 per year. Joe Gennaro, the current executive director of Marylake (since 2011), confirmed that the rental fee has not been required or paid in years and that although it is the Augustinians who pay the property tax on this property, it is still technically owned by the Archdiocese of Toronto. This contract will be up in 2041, and Gennaro believes there is an option to continue for a consecutive ninety-nine years.

On November 23, 1942, the Superior Provincial of the Augustinians received a signed letter of support from the "Sacra Congregatio De Religiosis," or the Congregation of Religious Affairs from Rome, with permission to erect a canonical house, "erectio canonica domus." And the rest, as they say, is history.

For assessment purposes, the property is divided into three parcels: Roll No. 19 49 000 025 280 00 0000 comprises approximately 393 acres. It is owned by the Augustinian Fathers (Ontario) Inc. and contains the Marylake Monastery and Retreat House and the Shrine Church of Our Lady of Grace. It also includes a convent and farm buildings, including a cattle barn, machine shop, carpentry shop and implement sheds. There is also a gatehouse and dwelling house. This property is classed for assessment purposes as residential. Part of this parcel is tax exempt. The exempt portions comprise the Shrine of Our Lady of Grace, which is a part of the Marylake Monastery; the chapel, which is a part of the retreat house; and twenty acres of property that are used for the purpose of pilgrimages during weekends from June to September each year.

Roll No. 19 49 000 025 460 00 0000 comprises approximately two hundred acres and contains no buildings. Portions are used for agricultural purposes

as part of the Marylake Monastery and Retreat House, and it is assessed as farmland. This property is owned by the Roman Catholic Episcopal Corporation for the Diocese of Toronto, in Canada. The property is leased to the Augustinian Fathers (Ontario) Inc.

Roll No. 19 49 000 025 550 00 0000 comprises approximately 221 acres and contains no buildings. Portions are used for agricultural purposes as part of the Marylake Monastery and Retreat House, and it is assessed as farmland. This property is owned by the Augustinian Fathers (Ontario) Inc.

On August 15, 1943, on the Feast of the Assumption, among a sea of twelve thousand people, Archbishop McGuigan preached a sermon and dedicated the original chapel (the former Pellatt bungalow living room) and blessed the statue of Our Lady of Grace. Five years later, the major renovation of Pellatt's bungalow began as well as the conversion of his large barn and garage to become St. Joseph's Hall. The architect responsible for this transformation was John Gibb Morton. According to the online Biographical Dictionary of Architects in Canada, Morton was a talented and underrated architect who became a master of ecclesiastical design in Ontario. Morton freelanced, soliciting work from local Baptist, Presbyterian and United Church congregations but, most importantly, from the Roman Catholic Archdioceses in Toronto and in Ottawa, which provided him with the bulk of his commissions.

On April 26, 1947, Morton presented his sketches for the major renovation and a thorough, nine-page document to the Augustinian Fathers with a list of work to be completed, including but not limited to excavation, concrete work, masonry, carpentry, electric wiring, plumbing, painting, tile floor installation and so on. The total cost of the renovation was shown to be $14,405—the equivalent of $190,000 today. This work would see Pellatt's private barn become a large recreation Hall (St. Joseph's Hall) for pilgrimages and retreats and Pellatt's private garage become the public washrooms. St. Joseph's Hall would also have a service kitchen with dumbwaiters and an altar.

From the exterior, the renovations to Pellatt's bungalow to accommodate the new monastery may not appear too drastic, but when you compare the changes to the interior, they are quite astonishing. During Pellatt's occupation, over the two floors there were four bedrooms for guests and three bedrooms for servants. After the 1948 renovation, the number of bedrooms increased to sixteen without changing the footprint of the home. This gives you a sense for the size of the rooms initially. The sixteen bedrooms, now referred to as monastic cells, were each equipped with medicine cabinet over a washbasin

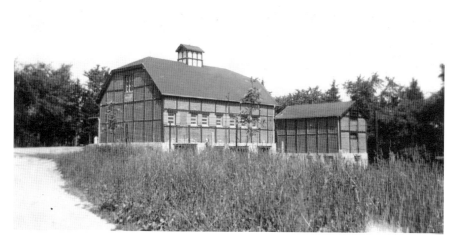

Pellatt's private barn before the conversion to St. Joseph Hall. *Marylake Archives.*

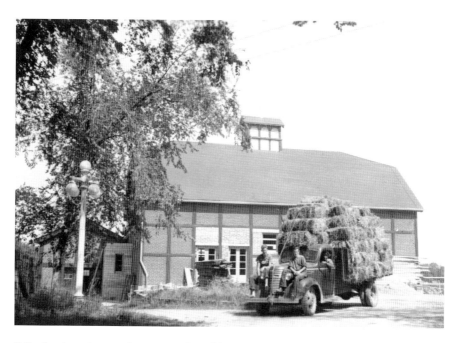

Pellatt's private barn under construction with unidentified workers prior to being converted to St. Joseph's Hall. *Marylake Archives.*

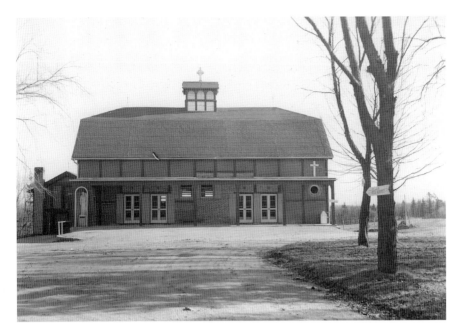

Pellatt's private barn after the conversion to St. Joseph Hall. *Marylake Archives.*

with a mirror on the outer door. The upper floor of the home was at one time not connected and had two distinct halves, one for servants and the other for guests. This was opened up in the new edition. The one-time main feature being the wraparound porch had now been enclosed and fitted with windows to create new rooms. The upper verandahs, one for the guests and the other for the servants, were also enclosed. The fireplaces were all enclosed, and radiated heat was installed.

The Retreat House at Marylake is the longest-serving same-use building on the property. Since the Augustinians moved onto the site, the intention of the one-time farm manager's home had always been as a retreat centre. The official title bestowed to the retreat house by the Augustinians was Father Clement Hall, named after the Venerable Father Clement Fuhl, OSA (1874–1935). Father Clement was a great spiritual priest and died in the odour of sanctity as a General of the Augustinian Order. Father Clement is now a "Blessed," which is a step toward being made a saint.

Father Clement Hall was built during Sir Henry Mill Pellatt's ownership around 1910. The retreat house could originally accommodate fourteen overnight-retreatants, and preparing the house for retreatants was one of the first priorities of the Augustinians. Less than one year after purchasing the

Lake Marie Estate Bungalow/Marylake Monastery

A comparison of the main estate lodge in Pellatt times (1913)
vs. after Monastery Renovation (1948)

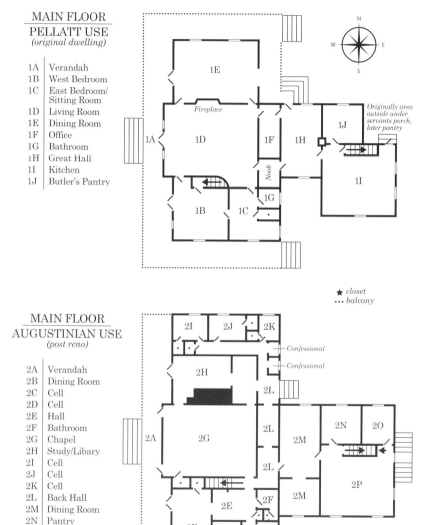

MAIN FLOOR
PELLATT USE
(original dwelling)

1A	Verandah
1B	West Bedroom
1C	East Bedroom/ Sitting Room
1D	Living Room
1E	Dining Room
1F	Office
1G	Bathroom
1H	Great Hall
1I	Kitchen
1J	Butler's Pantry

★ closet
... balcony

MAIN FLOOR
AUGUSTINIAN USE
(post reno)

2A	Verandah
2B	Dining Room
2C	Cell
2D	Cell
2E	Hall
2F	Bathroom
2G	Chapel
2H	Study/Libary
2I	Cell
2J	Cell
2K	Cell
2L	Back Hall
2M	Dining Room
2N	Pantry
2O	Storage
2P	Kitchen

Lake Marie Estate Bungalow/Marylake Monastery

A comparison of the main estate lodge in Pellatt times (1913)
vs. after Monastery Renovation (1948)

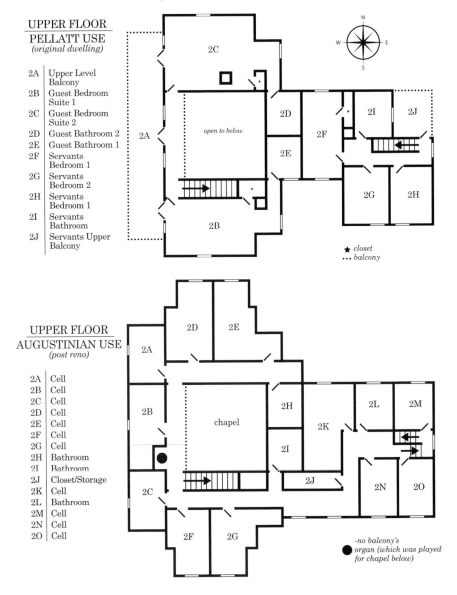

UPPER FLOOR
PELLATT USE
(original dwelling)

2A	Upper Level Balcony
2B	Guest Bedroom Suite 1
2C	Guest Bedroom Suite 2
2D	Guest Bathroom 2
2E	Guest Bathroom 1
2F	Servants Bedroom 1
2G	Servants Bedroom 2
2H	Servants Bedroom 1
2I	Servants Bathroom
2J	Servants Upper Balcony

★ *closet*
••• *balcony*

UPPER FLOOR
AUGUSTINIAN USE
(post reno)

2A	Cell
2B	Cell
2C	Cell
2D	Cell
2E	Cell
2F	Cell
2G	Cell
2H	Bathroom
2I	Bathroom
2J	Closet/Storage
2K	Cell
2L	Bathroom
2M	Cell
2N	Cell
2O	Cell

● *-no balcony's*
organ (which was played
for chapel below)

Right: Unidentified men in the Father Clement Hall Retreat House at Marylake. *Marylake Archives*.

Middle: Father Clement Hall, before expansion. *Marylake Archives*.

Bottom: Father Clement Hall, after expansion. *Marylake Archives*.

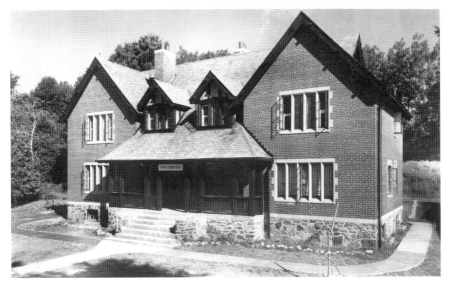

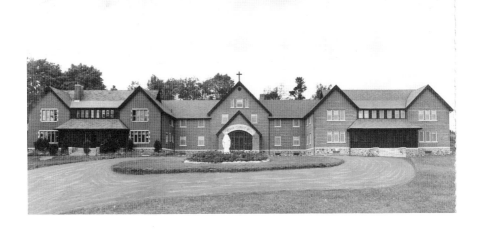

site, coinciding with the Feast of St. Augustine, the first group of retreatants arrived on August 27, 1943. The first retreat was appropriately preached by Father Anthansius Pape to fourteen retreatants. Alexander Sampson served as the retreat captain for this group and for many years presided as the group leader for the Pioneers of Our Lady of Grace. For the next nine years and two months, the original farm manager's house served as retreat house until it could no longer support the size or frequency of retreatants.

On October 19, 1952, the massive expansion and renovation of the original retreat house was completed. It was dedicated by McGuigan on that day with approximately seven hundred people in attendance. The architect for this renovation, although not confirmed, is believed to have been John Gibb Morton. The renovation added a duplicate and almost identical retreat house to the east side of the original home joined by a large hall. Speaking to Sampson's ongoing involvement with Marylake, as late as 1952 on a Marylake Retreat pamphlet, Mr. A.G. Sampson is the contact name as the "general retreat organizer" at Marylake, with his address being 330 Bay Street in Toronto (Northern Ontario Building). Not coincidentally, this is also the address for the lawyer, Leonard Mitchell, whom Sampson connected with the Augustinians to represent them for the purchase of Marylake in 1942. Retreats are held annually from the first weekend in September until the last weekend in June. After the renovation, the retreat house increased in size from fourteen to forty-eight private rooms. The retreat house also has a chapel, a library, a large dining room and a kitchen.

When Father Clement Hall opened in 1943 there was no set fee for retreatants. Each group was asked to make a free-will offering—tax deductible—that they see fit and could afford. Gennaro at Marylake confirmed that today,

> *like all events, a retreat has costs associated with it. A donation of $175 to $200 would help offset the costs of two-nights' accommodation and five meals. This would also allow a little money to be donated to the Augustinians so that they can continue their ministry and also for the Retreat House upkeep, housekeeping, renovations, etc. If this suggestion is a limiting factor, any donation will do. Marylake has never refused a retreatant for financial reasons, nor should it prevent a retreatant from returning to Marylake over and over again.*

In the early days of the Marylake Retreat program, it had its own newsletter called the *Marylake Retreat Circular* or MRC. This newsletter was

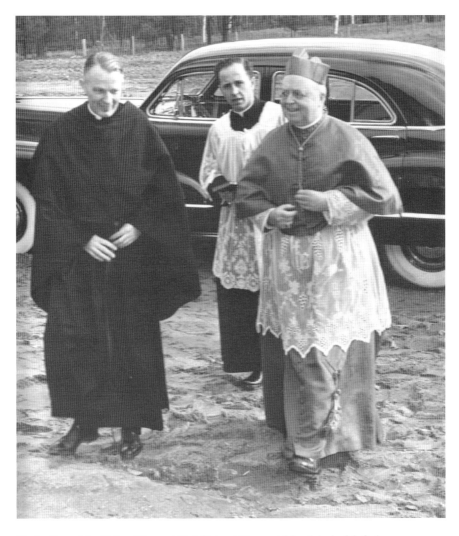

Dedication of the Father Clement Hall Retreat House at Marylake by McGuigan on October 19, 1952. *Marylake Archives.*

issued three to four times per year starting in 1944. When the circulation ceased is unknown. Each issue appears to have had three main aims: report on the joyous season that had passed, encourage existing retreatants to assist in getting new retreatants to sign up for retreats and to impart some of the positive benefits or stories from a past retreat or speak to a current event such as the ending of the war. The first prior at Marylake, Father Leo Ebert, wrote the content for the MRC.

Eight years after Marylake opened, and just two years before the expansion of the retreat house, the first sisters came to Marylake. There were four of them initially. They came from Würzburg, Germany, and on December 10, 1950, they landed in Halifax after a stormy sea voyage that lasted ten days. Once settled, the sisters travelled by train from Halifax to Toronto and then King City. They were called the Sisters of St. Rita. The number of retreats and retreatants were growing, and the brothers needed support. On September 15, 1949, Archbishop McGuigan wrote to Prime Minister Louis St. Laurent, a Catholic and a Liberal, to tell him about Marylake and the need for support:

> *The Augustinian Fathers, who have an Institute at Marylake, are anxious to secure the services of Sisters founded by their Order called the Sisters of St, Rita whose motherhouse is in Bavaria. I am not sure whether, according to present law, these Sisters can be admitted to Canada, or whether it would be impossible or embarrassing to have an Order-In-Council passed to allow them to come. The Augustinian Fathers tell me that in 1940 several of their Fathers and Brothers were admitted to their Monastery in Nova Scotia from Germany, although at that time there was open conflict between Canada and Germany.*

St. Thomas Cottage at Marylake, the first convent house at Marylake for the Sisters of St. Rita. *Marylake Archives.*

The nuns were granted admission into Canada. When they first arrived at Marylake, they moved into St. Thomas Cottage, which was just south of the log cabin. At this point, the name of the house changed from St. Thomas Cottage to St. Rita's Convent. St. Thomas Cottage was too small to include a chapel, so a little alcove was created in the monastery chapel to provide the sisters with privacy for their prayers and attendance at Holy Mass. Their main responsibility was to serve the domestic kitchen and kitchen apostolate, but they had other duties in addition to cooking, including cleaning, washing, mending, gardening and laundry.

Once the retreat house was enlarged, another sister joined the group for a

total of five. With five sisters, they had outgrown their tiny home. It was determined that they would move into Pellatt's former dairy and icehouse. Constructed of native fieldstone, it resembled a miniature castle. Thus, the dairy was converted into the new St. Rita's Convent and Laundry House. The new convent also served as a seminary for training for the postulants and novices. The convent included five private bedrooms, a chapel, a dining room, a kitchen and a common room. The sisters now had their own chapel within their residence. The name bestowed on this facility was Blessed Frederick Hall, named for the Augustinian Blessed Frederick of Regensburg, Germany, whom Pius X beatified on May 12, 1909. The Sisters of St. Rita dedicated themselves to the success of Marylake for twenty-five years, from 1950 until June 1975. Due to their age, they returned to their convent in Germany. The last two Sisters of St. Rita left on June 29, 1975.

Marylake had grown accustomed to the support of the sisters, so prior to their departure, work was being done to find a suitable replacement. The Mexican Augustinian sisters officially called the Working Sisters of Good Counsel answered the call, beginning a one-year trial period in June 1975. The convent that had been home to the St. Ritas was now home to the Sisters of Good Counsel, and the facility received a little facelift. The Sisters

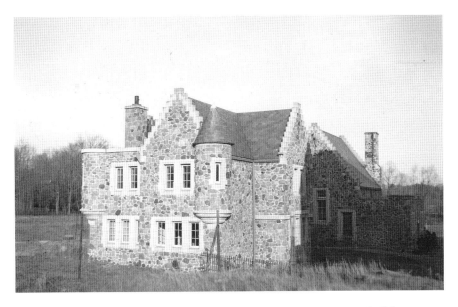

The second convent house for the Sisters of St. Rita at the Marylake Dairy Building. *Marylake Archives.*

Left: Unidentified Sisters at Marylake. *Marylake Archives.*

Below: Unidentified Sisters of Good Counsel. *Marylake Archives.*

of Good Counsel have been faithfully serving the needs of Marylake for the past forty-two years. Today, there are four sisters living on the property.

Farming had always been the fundamental enterprise at Marylake, long before Pellatt arrived. In Augustinian times, it was dairy farming, specifically for the production of milk, which was at the heart of the operation. Virtually all other farming activity on the site was in support of the dairy operation. Four hundred acres were under cultivation to support the feed for the herd. Crops of hay, corn, wheat, barley and oats were managed. In 1980, the herd was designated as a Master Breeder Herd. This herd filled an Ontario Milk Marketing Board quota of 1,700 litres (374 gallons) every two days. The Augustinians maintained a herd of approximately eighty to one hundred Holstein cattle for the better part of fifty-six years at Marylake. It wasn't until an article was written for *The Regional* in the early 1990s that we learn of the need for support to manage the farm: "For the first time the Augustinians have hired a professional herdsman. The brothers are getting older and fewer people are entering the religious service," according to Reverend Cyril Smetana, prior and spiritual leader.

It wasn't until the summer of 1998 that the Augustinians made the decision to sell their entire stock at auction. It has been nineteen years since Marylake ran the dairy operation. In its heyday, the dairy operation accounted for a

Image of the prized cattle at Marylake. *Marylake Archives.*

significant portion of Marylake's total gross revenue—25 percent, in fact. In the 1980s, retreat work was still the largest income generator for Marylake at about $135,000 per year. Farming/gardening was a close second, generating about $115,000 a year, with revenue from shrines and pilgrimages edging in at about $55,000 per year. Other sources of revenue included pensions, rebates, bequests, specials, teacher's salary, outside help and sacristy. These all together brought in another $310,000. From a net perspective, retreats were more profitable at 39 percent of revenues, with farming having higher operating costs, running at 57 percent of revenues. For all the work, Marylake was just covering its $450,000 on average of annual expenses, which as a not-for-profit association was acceptable.

One of the more memorable yet unfortunate events on the property during Augustinian occupation was the barn fire of 1948. This fire destroyed the entire roof of the main home barn, include both large silos. As the barn itself was fireproof, the walls were spared, but the roof was replaced by a new roof two inches lower than the original and covered with aluminum siding. Sir Henry Mill Pellatt's engineering ingenuity is to be credited, for had he not been so extravagant in his construction of the barn, it most certainly would have been lost to us.

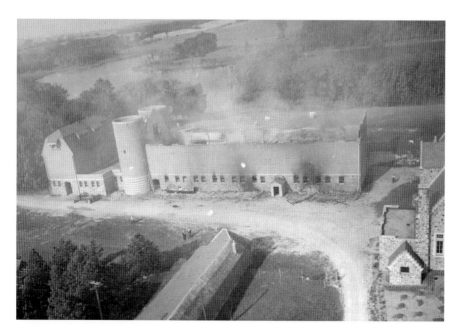

Picture showing the extent of the barn fire damage in 1948. *Marylake Archives.*

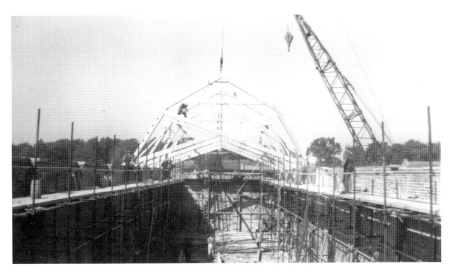

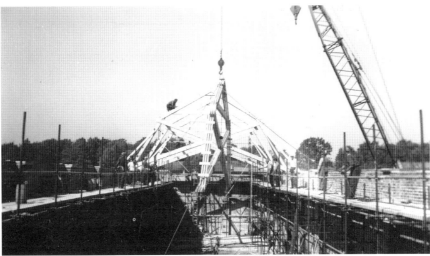

This page: Barn roof repairs. *Marylake Archives.*

Today, the shrine and monastery, housed in one facility, are the jewel and crown of Marylake. Originally, Pellatt's lodge served as the monastery, with his living room acting as the chapel. After a while, this facility became too out of date and too small to continue to be used in this capacity. With the growing number of retreatants and pilgrimages, Marylake desired a larger facility that could house larger groups.

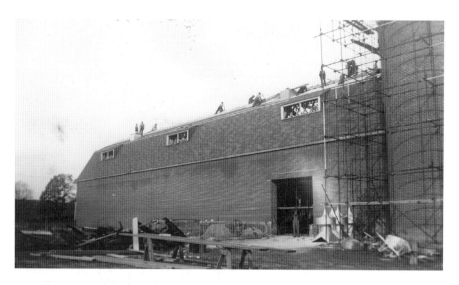

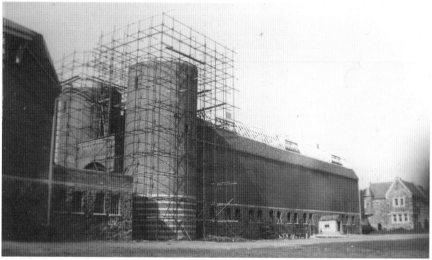

This page: Barn roof repairs. *Marylake Archives.*

As early as June 16, 1956, the *Toronto Daily Star* was reporting on the prospect of a new shrine in King. An article titled "See Proposed Shrine Comfort the World" read that "the proposed Our Lady of Grace Shrine at Marylake, near King City, was seen as a source of encouragement, responsibility and consolation for pilgrims from all over the world as the campaign for the shrine got underway at the Knights of Columbus Hall on Sherbourne Street this week." Clearly the funding for this project would

Right: Unidentified man on the roof of the barn during repairs. *Marylake Archives.*

Below: Barn roof repairs. *Marylake Archives.*

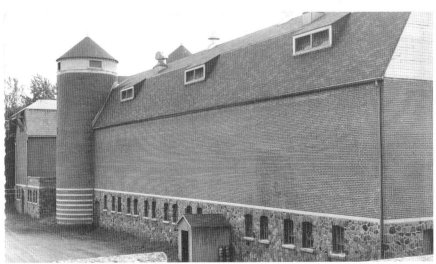

Man with dog in front of Home Barn after roof repair. *Winnifred Smith and Tammie Buckler.*

not be a local responsibility but would reach a larger audience. Senator Harold Connelly of Nova Scotia was present and said to the one hundred men in attendance that "in these materialistic days of strife and turmoil, it is most edifying to find such a representative group of men together on behalf of such a positive cause." The Very Reverend Suitbert A. Moors, prior of the Augustinian Retreat House at Marylake, indicated that "similar organizational meetings would be held soon in Barrie and St. Catharine's." Mr. A.G. Sampson was named as the general chairman of the campaign.

Almost twenty years after the Augustinians took over Marylake, architects were invited to bid on the design of the new monastery and shrine. Two design submissions were found while researching this book. The winning architect was John Stuart Cauley of Peterborough, Ontario. The selected builder/contractor was Vincent DeMarco. Cauley had served with the RCAF and had been an executive of the Architectural Society. Cauley became a fellow of the Royal Architectural Institute of Canada (FRAIC) in 1969, just a few years after designing the Marylake Shrine and Monastery. Cauley's original schematic of the Marylake Shrine and Monastery eloquently complemented the landscape around it. The design for the shrine

and chapel are described as being ellipsoidal in form and most certainly would be described as nontraditional.

A second bid concept for Marylake Shrine and Monastery came from an American named Henry R. Slaby. Most of Slaby's work is in the United States, including many ecclesiastical projects in Wisconsin. Not coincidentally, this state is where the headquarters of the Augustinians in North America was located. In 1939, Slaby designed the new St. Rita's Monastery in Racine, and his work was well known to the Augustinians.

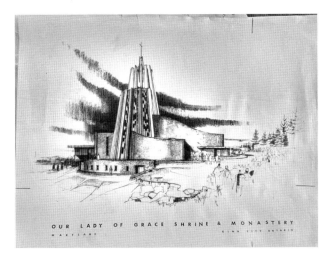

Left: Cauley's Marylake Shrine concept drawing. *Archives of the Roman Catholic Archdiocese of Toronto, Item PH 27A/29D.*

Below: Slaby's Marylake Shrine concept drawing. *Archives of the Roman Catholic Archdiocese of Toronto, Item PH 27A/30D.*

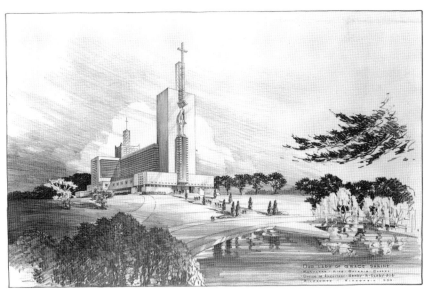

In stark contrast to Cauley's submission, which appeared almost fluid and worked with versus against the topography, Slaby's structure was tall, cutting, imposing, erect and could almost be described as cold in structure. For those who have been to Marylake and have seen the current shrine, the picture of Slaby's submission will be very hard to imagine on the bucolic grounds of Marylake.

Like the development of the farm school at Marylake, which took place on the heels of the back-to-the-land settlement scheme in Canada, the current shrine at Marylake was also in development during a period of ecclesiastical architectural revival in Canada. In November 1961, the Ontario Association of Architects sponsored the first-ever Ontario Conference on Church Architecture. A report from this conference was provided by none other than John Stuart Cauley in the December 1961 issue of the RAIC journal. Cauley reports that the conference keynote, Harold Wagoner, past president of the Church Architectural Guild of America, stated that the "puritanical conservatism which had governed so much of the church building in the United States was rapidly disappearing." Wagoner felt that the 1960s represented a "revolution in church architecture." There were about 200 delegates at this conference, 125 of whom were clergy and lay officials representing six different faith groups.

The conference was the first time that the Roman Catholic Church had participated in an event or discussion of this kind. His Excellency F.A. Marrocco, DD, auxiliary bishop of Toronto, Diocese of the Roman Catholic Church, offered a real concern the Catholic Church had with the new look of religious houses that "with the influx of new Canadians who have grown up in the shade of ancient churches and of ancient architecture in general, might militate against any rapid development of contemporary architecture here." Marrocco continued, "It is a great challenge for the architect to build churches in which new Canadians can feel close to the same god they loved in their own countries." Clearly, when the concept for the Marylake Shrine was being considered, there was a real transformation in religious houses; Cauley, the winning architect, was deeply involved in this transformation. The submissions for Marylake spoke to the strength of this shift, as neither Cauley nor Salby's designs represent what could be described as a traditional church in Canada at the time.

Cauley's vision for the new Marylake Shrine and Monastery was a three-floor sweeping structure flowing toward the lake. His sketches were approved in November 1961, a month after the first Ontario Conference on Church Architecture. The building is made from field stone quarried from Marylake

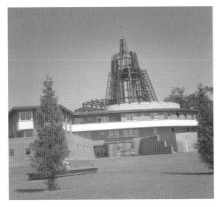

This page: Shrine construction. *Marylake Archives.*

and surrounding farms. This special feature allows it to blend in with many of the original Pellatt structures on the property. It may also have been a feature that placated those concerned with the look of the church being too futuristic, as the quarried stones gave the shrine an almost medieval air. The facility had thirty-three private rooms for residents, three for guests and eleven for small retreat groups. The infirmary took up four of the thirty-three rooms. The massive structure is shaped like a fortress but sprawls toward the lake, giving the appearance that the land has enveloped it and not the other way around.

Large, irregularly shaped pieces of coloured glass reach to the incredible height of the shrine's bell tower. The tower extends one hundred feet high and two hundred feet above the lake (about five stories high). Its positioning

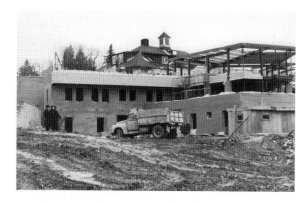

This page: Shrine construction. Note the original monastery/Pellatt's Bungalow in the background of the picture on the left before it was demolished. *Marylake Archives.*

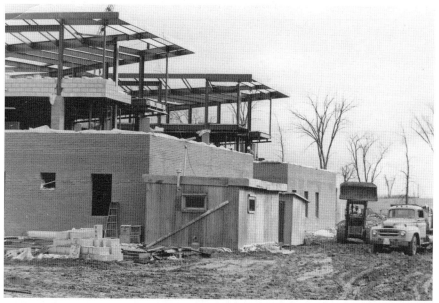

provides it with a vantage point of most of the property, and the cross at the steeple is a landmark that welcomes visitors who walk the property. On a sunny day in the shrine, patrons are wrapped in a kaleidoscope of light. The bell tower was made of bronze in Troy, New York, and it weighs a staggering 2,500 pounds. It used to sound on the musical tone E above middle C and was activated automatically by a programmed clock.

The bell is engraved appropriately as a memorial to Alexander Sampson and reads, "In memory of A.G. Sampson 1900–1964." Today, the bell is silent and no longer reminds local farmers when to come in for lunch or when children will soon make their way home from school. For many years, this bell was a welcome sound to residents in the area. Marylake has

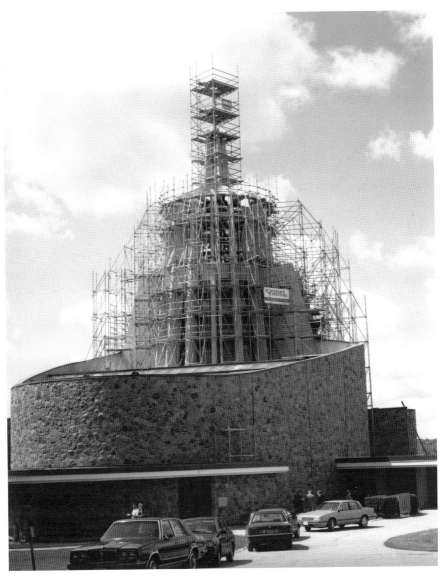

Shrine construction. *Marylake Archives.*

plans to restore the bell so that its music can once again toll throughout King Township. Longtime King resident Beverly Flanagan mentioned nostalgically in an interview for this book that she missed the comforting and consistent toll of the Marylake bell and hopes to hear it chime again.

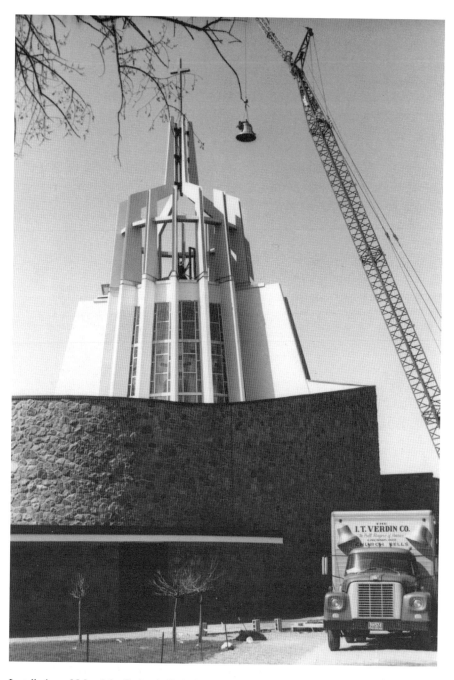

Installation of Marylake Shrine bell. *Archives of the Roman Catholic Archdiocese of Toronto, Item PH 11/41P.*

Fast-forward six years, on Friday June 1, 1962, the Augustinian Fathers of Marylake "are happy to announce the beginning of construction of the new Shrine and Monastery of Our Lady of Grace" in an ad they purchased in the *Toronto Daily Star*. The ad goes on to say that "the solemn ground-breaking will take place on Sunday June 3 at 3:00pm," and they "wish to extend a cordial invitation to all our friends and pilgrims to attend ceremonies."

Perhaps the best way to describe the Our Lady of Grace Shrine and Monastery at Marylake in King City, Ontario, is through the words of the very architect who designed it. Released in the summer of 1962, architect John Stuart Cauley wrote:

> *The new Shrine to Our Lady of Grace will be erected on the spacious grounds of the Augustinian Fathers at Marylake, near King City, which is about twenty miles north of Toronto.*
>
> *The building will contain a large Shrine and a chapel dedicated to Our Lady and will have complete living and working quarters for the priests, brothers and postulants who comprise the personnel of Marylake.*
>
> *This popular place of retreat and pilgrimage will, on completion of the new quarters, assume the proportions of a major Shrine to Our Lady. The brothers who work the land, and priests who conduct the retreats here and across Canada, and the postulants will all have at last proper facilities for the expansion of their labors in their particular field of work for the Church.*
>
> *In order that the Shrine Church might dominate the building group and allow ample space for the thousands of pilgrims who attend outdoor devotions during the summer, the church was located on the level of the present monastery and the new monastery buildings were arranged in three levels down towards the lake.*
>
> *When construction is completed, the present temporary building will be demolished and a large grassed plaza will accommodate the summer outdoor services as well as providing year round access both to the Shrine and Monastery.*
>
> *The Shrine itself is of ellipsoidal form with the main entrance on the axis of the ellipse and at the lowest point of the roof. As one approached the sanctuary the ceiling gradually rises until just at the circular communion step, suddenly, the full height of the shaft over the altar becomes visible. This tower, which rises sixty-five feet from the sanctuary floor, is circular in form and as well as being the dominant feature of the Shrine will flood*

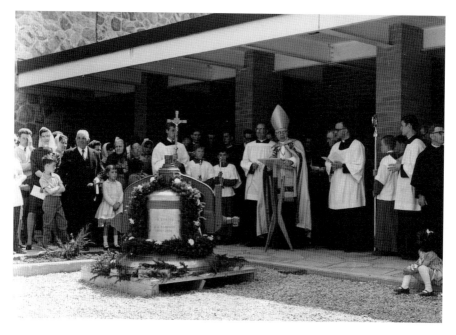

Blessing of the Marylake Shrine bell by Archbishop Philip F. Pocock. *Archives of the Roman Catholic Archdiocese of Toronto, Item PH 27A/27P.*

the circular sanctuary with light through the stained glass windows which comprise most of the infilling between the struts.

In the semi-circle behind the main altar and between the base of the major arches, will be six altars for use by the priests of the monastery and each dedicated for private devotion.

A side chapel seating one hundred people on opening on to the Shrine Church will be used for daily Mass. This chapel, also ellipsoidal in form, groups the congregation closely around the sanctuary. A gently sloping ramp will allow pilgrims in wheelchairs to be brought directly into the chapel from where they may assist at Divine Services in the Shrine.

The priests' choir and the brothers' choir where the Divine Office is chanted are located behind the Shrine sanctuary on an upper level accessible from the cloister. The monastery has been designed to accommodate twenty brothers, eight priests, ten oblates, and include Prior's and Provincials' quarters as well as accommodation for four visitors and a suite for visiting prelates. A two-bedroom infirmary isolated from the other rooms and served directly from the kitchen has also been included.

The building will be constructed mainly of split field stone native to the site. The major struts of the Shrine tower will be copper-clad and the basic structure throughout will be of reinforced concrete.

Poised on the height of land overlooking beautiful Lake Marie, the buildings have been designed to provide adequate facilities for the work of the Augustinian Fathers, an inspirational setting for the devotional worship of pilgrims and retreatants and a beautiful Shrine to the Mother of God under her title of Our Lady of Grace.

At the time of its construction, Marylake Shrine was an ecclesiastical and architectural marvel. Someone described it as "having the bravura of Beethoven and the magic of Mozart blended in one symphonic evocation." It is a landmark in its own right and remains so today. On June 7, 1964, His Eminence Cardinal McGuigan laid the cornerstone for Our Lady of Grace Shrine and Church. There were two thousand visitors in attendance. McGuigan proclaimed to the crowd that after twenty-three years, the Augustinians' dream had finally come to fruition.

Even though the designs were approved in 1961, the groundbreaking in 1962 and the cornerstone laid in 1964, many newspapers were writing for quite some time afterward that the shrine was not complete. On Friday December 10, 1965, the *Globe and Mail* did a special feature on Marylake titled "Order Opens New Headquarters." In the article, the Augustinians

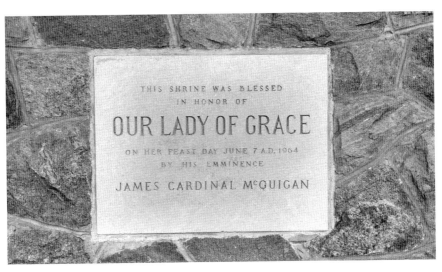

Marylake Shrine dedication plaque. *Author's photo.*

This page: Monastery and Shrine complete. *Marylake Archives.*

are said to have said of the new facility, "The chapel is a parable in field stone and stained glass combining as it does the solidity of a mighty fortress with the tenderness of an Ave Maria." The article continued, "There is still some work to be done on the interior, and a few finishing touches are needed on the exterior." An astonishing twelve years later, on September 13, 1977, the *York Regional Topic* quoted Father Allan Charnon, then prior at Marylake: "It hasn't been finished yet, things were held up for a while because of changes in the Catholic church." Prior Cyril Smetana said to the *Globe*, "Cardinal McGuigan asked the Order to establish a Shrine for the veneration of Mary, the mother of Jesus, in the Archdiocese of Toronto. They were asked to establish a Retreat House." The article went on to claim that since 1942, over thirty-three thousand men of all ages and walks of life had come to Marylake.

The building of the shrine and monastery did not go without incident. On October 19, 1962, the *Toronto Daily Star* ran an article titled "Bishop Told Church Uses Non-Union Men." Roman Catholic union leaders had protested to Archbishop Philip Pocock about "non-union labor in construction of a church and shrine near King City." Pocock was asked to "at least attempt to straighten out the thinking of the orders in [his] diocese. At this point in time, the project at Marylake for the Oblate and Augustinian Fathers is being picketed by the Plumbers and Steamfitters Union." They were criticizing Pocock because he had promised in an earlier speech that "all construction would be performed by union labor."

An article for the *Richmond Hill Liberal* on November 16, 1965, reported that "Major Superiors of the various religious orders and congregations in Metropolitan Toronto were present at a reception and luncheon at Marylake Monastery, King Township, November 15, marking the official opening of headquarters of the Augustinians vice-province." The article went on to say that the opening "moved the headquarters from New York, creating a definite step towards a full-fledged Canadian Province of the world-wide Augustinian Order." A week later the entire cover page of the *Aurora Banner* was dedicated to this story, but still it was mentioned in all articles that the shrine was not yet complete.

Coinciding with Canada's centennial year in 1967, the Augustinians were celebrating twenty-five years at Marylake. Almost every local paper ran a story about the festivities to take place between September 3 and 10 at Marylake. The most noteworthy item from all of the articles was that three of the four former superiors at Marylake would be in attendance for a mass of Thanksgiving on Labour Day to celebrate their anniversary

year. The community from near and far was invited to attend. The current prior, Reverend Cyril Smetana, said that this event "would be an excellent opportunity to meet the three dignitaries who guided the development of Marylake." Those three distinguished guests were: Reverend Athanasius Pape, OSA, of Würzburg, Germany; Reverend Suitbert Moors, OSA, prior of St. Augustine Monastery in Nova Scotia; and Reverend Arnulf Hartman, OSA, prior of Mother of Consolation Monastery in Ladnder, British Columbia. The forth superior, Reverend Leo Ebert, who was stationed in Cologne, Germany, at that time, was not able to attend.

Each article spoke to the significant contributions of each of the four dignitaries. Leo Ebert was the first prior of Marylake in 1942 and years later returned as shrine director and retreat promoter. Athanasius Pape was the vicar provincial in 1942 when Marylake was opened and was responsible for its establishment. It was Pape who accepted the invitation of Archbishop McGuigan to open a retreat house and a shrine in honour of Mary in the Diocese of Toronto. Five years later, Pape became the prior of Marylake. Pape was responsible for the expansion of the retreat house to its present size. Father Moors, one of the pioneers of Marylake, was the bursar for the first five years. Later, in 1953, he was appointed prior. The very first sketches for the new shrine and monastery were developed under Moors's leadership. The new shrine and monastery were built when Father Hartman was prior. These four men were instrumental in the development of what we know today as Marylake Shrine and Monastery. To quote the *Era Banner*, "This celebration is a testimony to these four men who guided the development of Marylake and impressed on this locale their character and spirit of zeal and love."

The 1967 celebration Mass also gave special mention to the late A.G. Sampson of Oak Ridges, who was credited with captaining the fundraising drive for the shrine and introducing the idea to enlarge the retreat house. Sampson was also acknowledged for giving both time and financial aid to the establishment of Marylake. This is the first and only reference to financial support from A.G. Sampson, who passed away in 1964.

In a memorandum on the Augustinian Province of St. Joseph letterhead dated October 8, 1977, Father Cyril Smetana writes to the Shrine and Monastery Building Committee consisting of Fathers Arnold, Othmar and John and Brothers Vincent and Stanislaus with the heading "Completion of Marylake Shrine":

The Ordinary Chapter of 1975 recommended unanimously that the Shrine be completed. There were two conditions: problem of water leakage solved; cost no more than $150,000.00. (#501) The leakage has been solved by Bro. Stanlisaus's labours and we hope to have a preliminary cost estimate by the time of the Prov. Council's meeting Oct. 24 and 25[th]. The Priors brought home the architect's proposals. Please read and let me know before our meeting any criticisms, suggestions or caveats you would like to make. Fr. Cyril, Office of the Provincial

One of the biggest concerns around the development of the shrine and monastery, aside from the length of time it took to complete, was the total cost. In an article for the *Newmarket Era* on December 4, 1968, reporter Suzanne Zwarun reported that "the new church cost more than anyone wants to say. It started as a $600,000 building but went so far over estimates it leaves Father Forerius shaking his head in dismay." Zwarun later refers to the shrine as the "million dollar church," which in today's dollar would be just over $7 million. Zwarun compares the Augustinian development as being comparable with those of a previous owner, Sir. Henry Mill Pellatt, once one of the richest men in the Dominion. "Sir

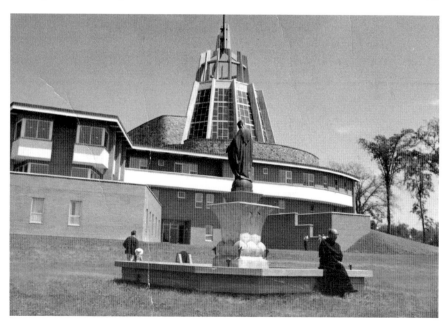

Monastery and shrine complete. *Marylake Archives.*

Henry still haunts the place. His enthusiasms and ambitions, his grandiose ideas and utter disregard for costs linger." Zwarun was a tough critic, but the costs did run to double original estimates, and ten years were added to the originally anticipated completion date.

The early 1960s were a busy and prosperous time for the OSA. The very month that Cauley's sketches were approved for the new shrine, on November 11, 1961, Philip Pocock, co-adjudicator bishop of Toronto, officially established the Parish of Sacred Heart in King Township, entrusting it to the care of the Augustinians at Marylake. Sacred Heart is located on the same Concession IV block as Marylake in King City to the northwest, specifically the northwest corner of the west half of Lot 14, at the intersection of Jane and 16 Sideroad. The roots of the parish for this church go back to the McGoey days of the Mount St. Francis Colony and earlier when it was a mission church of St. Patrick's in Schomberg.

Sacred Heart Parish has a cemetery for its parishioners in King Township, on the west side of Jane just south of 16 Sideroad. The Sacred Heart cemetery has a plot dedicated to the Augustinians. The first Augustinian to be buried there was one of the original five Augustinians to arrive at Marylake, Father Suitbert Bernard Moors, OSA. Moors passed away on November 10, 1970. Tragically, his death made newspaper headlines, as he died as a result of injuries sustained in a car accident on October 26, 1970, in New York State. At the time of his death, Moors was the prior of Marylake. As a result of the car accident, he suffered a cerebral concussion and a broken leg. Three other members of the community were injured in the crash: Reverend Stanislaus Treu (prior provincial at the time), Brother Ninian Marsh and Brother Joseph Walker. The driver of the other vehicle was charged with failure to yield the right of way. Some of the earliest birthdates among the Augustinian inhabitants at Sacred Heart Parish Cemetery are from the late 1890s and early 1900s. See Appendix E for a list of those buried at Sacred Heart Parish Cemetery in King City in the Augustinian Plot.

On November 15, 1965, the provincial headquarters of the Canadian Augustinians was transferred from New York to Marylake. From July 8 to 12, 1968, the first provincial chapter of the Augustinians, Province of St. Joseph in Canada, was held at Marylake. Today, the Augustinians in Canada operate under the name of the Province of St. Joseph. Though the Province of St. Joseph is recognized as its own independent Augustinian province within the Catholic Church, it is under the jurisdiction of the Province of Our Mother of Good Counsel. This province, informally known as the "Midwest Augustinians," is headquartered in Chicago, Illinois.

Augustinian sign at Sacred Heart Parish Cemetery. *Author's photo.*

The Marylake property is a jewel in and of itself. But housed within the walls of the shrine and scattered among the rolling hills are many treasures. One item of distinction is the pipe organ in the shrine. The pipe organ was obtained by Marylake in the 1960s through two incredibly generous donations. The history of the pipe organ at Marylake is significant historically, not only in the rarity of the instruments themselves but of the famous Canadian families who donated them. What is now considered one instrument was, at one point, two. This history involves the Seagram family of the distillery fame and the Eaton family of the department store fame. The organ at Marylake is unique in that it is the melding of two exquisite instruments. Both organs are Aeolian-Skinner Duo-Art made in the same factory in the same year, 1928. Remarkably, they are unique in that they are successive opus and are two of only five known to exist in Canada. In 1928, these instruments were valued at $13,000 each, equivalent to approximately $200,000 each today. Given then the work undertaken to merge these two instruments together, the value today would be priceless. In an undated article, Reverend Cyril Smetana refers to the merged instruments as "the Rolls-Royce of organs."

In 2005, the Knights of Columbus Sacred Heart Council began a fundraising campaign called the Marylake Monastery Pipe Organ Restoration Project. In its request for support, it provided the following information on the organ at Marylake:

Between 1968–1973 the elaborate task of combining the two organs was completed over a five year period by the painstaking volunteer services of Mr. Harry Livingston, a scientist and electronic engineer, and Mr. Stewart Duncan, a retired organ company executive and organ builder. The task was enormous and the finished project had over 3,050 pipes alone, not to mention the intricate console, electro-pneumatic, and wind supply work.

The bulk of the Seagram pipework was installed on the west side of the church forming the Great and Choir Divisions, separately enclosed. On the opposite east side, some 60 feet away, the entire Eaton pipework, Swell, Great, and Pedal was installed in a single chamber, straddling the wall between the shrine and the side chapel with swell shutters opening onto both sides. The two manual Eaton consoles were installed in the side chapel. On the shrine console, the combined Eaton organ formed the Swell division of the three manual Seagram console.

After installation and the undertaking of several processes that induced the shuffling around of ranks of the organ, eliminating some duplication, incorporating ranks from other sources, constructing chambers, constructing an extensive wind supply system for numerous chest and pneumatic actions, and restoring the 1928 electro pneumatic action, the organ was combined and was played for the first time at midnight mass in 1973. Ever since, Marylake has been blessed with the delicate, gentle, romantic, yet powerful sounds of a classic bone fide theatre organ of great heritage and descent.

On one side of the organ there is a small plaque that reads "To the memory of John David Eaton and the Eaton Family." On the other side of the organ console is another plaque:

> *This Aeolian-Skinner Organ (1928) is dedicated to the memory of Harry Philip Livingstone (1912–1981) who gave generously of himself and his talents to the Marylake Community for over a quarter of a century. Between 1970 and 1974 he devoted countless hours to the rebuilding of this organ and by a generous bequest [through the Livingston Estate] provided for its continued maintenance. (April 11, 1982, The Augustinian Community).*

In a letter dated January 10, 1970, Harry Livingston wrote on his personal stationery to Father Michael J. Oliver, CSB, who had been the man responsible for the Basilian management of Marylake between 1935 and

Left: Picture of part of the organ at Marylake. *Photo by Mark Pavilons*, King Weekly Sentinel.

Below: Father Cyril Smetana on the organ. *Marylake Archives*.

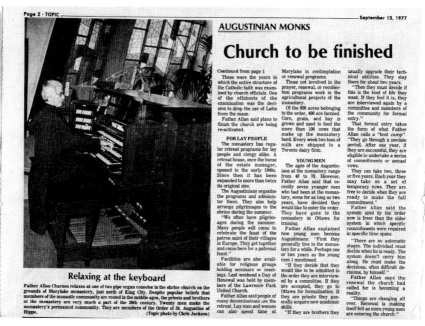

Page 2 · TOPIC September 13, 1977

AUGUSTINIAN MONKS

Church to be finished

Relaxing at the keyboard

Father Allan Charnon relaxes at one of two pipe organ consoles in the shrine church on the grounds of Marylake monastery, just north of King City. Despite popular beliefs that members of the monastic community are rooted in the middle ages, the priests and brothers at the monastery are very much a part of the 20th century. Twenty men make the monastery's permanent community. They are members of the Order of St. Augustine of Hippo.
(Topic photo by Chris Jackson)

Continued from page 1

Those were the years in which the entire structure of the Catholic faith was examined by church officials. One of the offshoots of the examination was the decision to drop the use of Latin from the mass.

Father Allan said plans to finish the church are being re-activated.

FOR LAY PEOPLE

The monastery has regular retreat programs for lay people and clergy alike. A retreat house, once the home of the estate manager, opened in the early 1940s. Since then it has been expanded to more than twice its original size.

The Augustinians organize the programs and administer them. They also help arrange pilgrimages to the shrine during the summer.

"We often have pilgrimages during the summer. Many people will come to celebrate the feast of the patron saint of their villages in Europe. They get together and come here for a patronal feast."

Facilities are also available for religious groups holding seminars or meetings. Last weekend a Day of Renewal was held by members of the Lawrence Park United Church.

Father Allan said people of many denominations use the retreat. Lay men and women can also spend time at Marylake in contimplation or renewal programs.

Those not involved in the prayer, renewal, or recollection programs work in the agricultural projects of the monastery.

Of the 800 acres belonging to the order, 400 are farmed. Corn, grain, and hay is grown and used to feed the more than 100 cows that make up the monastery herd. Every week two tons of milk are shipped to a Toronto dairy firm.

YOUNG MEN

The ages of the Augustinians at the monastery range from 40 to 78. However, Father Allan said that recently seven younger men who had been at the monastery, some for as long as two years, have decided they would like to enter the order. They have gone to the monastery in Ottawa for training.

Father Allan explained how young men become Augustinians: "First they generally live in the monastery for a while. Perhaps one or two years as the young men I mentioned.

"If they decide that they would like to be admitted to the order they are interviewed by a committee. If they are accepted, they go to Ottawa for formalization. If they are priests they generally acquire new academic skills.

"If they are brothers they usually upgrade their technical abilities. They stay there for about two years.

"Then they must decide if this is the kind of life they want. If they feel it is, they are interviewed again by a committee and members of the community for formal entry."

That formal entry takes the form of what Father Allan calls a "boot camp". "They go through a noviate period. After one year, if they are successful, they are eligible to make a series of commitments or annual vows.

They can take two, three or five years. Each year they may take on a set of temporary vows. They are free to decide when they are ready to make the full commitment."

Father Allan said the system used by the order now is freer than the older system in which specific commitments were required in specific time spans.

"There are no automatic stages. The individual must decide when he is ready. The system doesn't carry him along. He must make the decisions, often difficult decisions, by himself."

Father Allan says the renewal the church had called for is becoming a reality.

"Things are changing all over. Renewal is making itself felt as more young men are entering the church."

1942, and said several times how it had been so long since Father Oliver had been to Marylake. He thanked Oliver for a directory he had sent and his words of wisdom. In reference to a poem Oliver wrote, Livingston said, "Your poem called an 'Evening at Marylake' was very good, and I wonder when you wrote this one as it was not dated." In the letter, Livingstone indicated that he was working on the Marylake property at least four days a week, specifically on the heating, lighting and mechanical problems. In this letter, Livingstone did not mention work being done on the melding of the

two organs. Livingston also wrote to Oliver that "you may be surprised to learn that the once clear waters of the lake are no longer safe for drink, the water is very dirty in that part of the country." Livingstone goes on, "In fact, additional homes are being banned until a sewage system for the county [King] can be installed." Livingstone, a scientist and engineer, informed Oliver that he had "designed and installed at Marylake a water system complete with filters, chlorinators, etc. This system is about the same size as would be required for a small town." He continued, "As you may know, on Sundays all during spring, summer and fall as many as fifteen thousand people come to Marylake."

Today, the pipe organ renovation fund is a little more than a quarter of the way to its goal. Marylake has raised about $25,000 toward the $100,000 needed to modernize and properly restore both organs. The ongoing clothing drive at Marylake has been the main fundraising initiative to support the organ restoration project. Marylake has partnered with Oasis, another charitable institution, in this venture.

The main altar relics at Marylake are vaulted in the altar of the shrine. They are the relics of Saint Justin and Saint Maria Goretti. The main relic of note at Marylake is that of Saint Rita of Cascia, a great Augustinian saint. Marylake is currently in the process of cataloguing many of the many relics it has.

The Blessed Sacrament Chapel is located on the east side of the church. It is here that the community celebrates the daily liturgies of the mass and hours. The tabernacle of the Blessed Sacrament weighs two and a half tons, is of travertine marble and was sculpted by Mr. Earl Neiman, who also fashioned the celebrant's chair and lectern in the same material. His wife, Maria, executed the bronze crucifix candleholders and sanctuary lamp, as well as the terra-cotta stations of the cross. The fifteenth station, "The Resurrection," is an innovative concept.

The Augustinians at Marylake have the largest rosary in the world in King City, Ontario. This site has been designated as a site of pilgrimage for the Jubilee of Mercy. Ted Harasti, an Ontario-based sacred artist, sculptor, muralist and iconographer specializing in Greek and Russian Byzantine style devotional icons, designed the Rosary Path. Set upon twenty acres of breathtaking natural beauty, rolling hills and old farm fields, Marylake has constructed a one-and-a-half-kilometer serpentine path with an eighteen-foot Great Crucifix at the beginning and fifty-nine Our Father and Hail Mary beads.

Left: The Rosary Path commemoration stone and plaque at Marylake. *Marylake Archives.*

Below: The Great Crucifix at Marylake. *Author's photo.*

The Great Crucifix that leads to the Rosary Path is a phenomenal work of art and significance. Created by renowned Canadian sculptor Timothy Schmaltz, the Great Crucifix is made of specially processed stainless steel. The scroll above the head of Christ reading "Jesus of Nazareth, King of the Jews" was designed by Ted Harasti and is authentically inscribed in abbreviated form in three languages—Hebrew, Latin and Greek—consistent with the Gospel narrative of Christ's Passion.

Giving the importance Saint Augustine placed on preaching *and* teaching, it is not surprising that an academic institution had always been planned for Marylake. After 58 years of waiting and planning, a Catholic school finally arrived on the campus. There had not been a school proper on the grounds of Marylake since the Marylake Boys School, overseen by Basilian leadership, closed in the spring of 1942. Villanova College is an independent Catholic Augustinian middle and high school, offering instruction for fourth through twelfth grades. As an Augustinian school, Villanova adheres to the traditions of the educational philosophy and mission of the Augustinian schools established in North America 175 years ago, in 1842. Thomas of Villanova (1486–1555) was known for his promotion of studies and missions in the Order of Saint Augustine and for his love and care for the poor. Appropriately, the motto of the school is *Unitas, Veritas, Caritas*, which means "Unity, Truth, Charity."

In 1998, St. Thomas of Villanova Catholic School Foundation was established, and the school leased thirty-three acres at the south side of Marylake Campus on the 15 Sideroad. In the spring of 1999, twenty-six students were registered for classes that coming fall. St. Thomas of Villanova College was established at Marylake by lay educators Paul Paradiso and Grant Purdy. In September 1999, Villanova opened its doors in its first temporary home at Sacred Heart Parish Hall in King City. Four months later, on Monday, January 24, 2000, the founding classes moved into the

Villanova College. *Author's photo.*

twelve-thousand-square-foot school on the grounds of Marylake. For the 2016–17 academic year, Villanova had approximately 525 students and a staff and faculty of 70. Villanova College is affiliated with the Augustinian Secondary Education Association, the Conference of Independent Schools and the National Catholic Education Association.

Villanova founder Paul Paradiso is the current president of Villanova College. Integral to the foundation of the school, Paul continues to oversee its operation and growth. Paul's vision, dedication and passion for Catholic education have made Villanova College a school known for its academic excellence. In the spring of 2017, Villanova celebrated the graduation of 110 students who collectively received over five hundred university acceptance offers and scholarship offers totaling $1.9 million dollars. Villanova College is home to one of the finest athletic facilities of any high school in the province of Ontario. Perhaps it's just a coincidence that the team name for Villanova is the Knights, which could be seen an appropriate homage to the man who pieced together the parcel of land they enjoy today, Sir Henry Mill Pellatt, Knight Bachelor.

The administration and Augustinians at Marylake play a significant role in the life of the school. Joseph Gennaro, executive director at Marylake, is a governor on the Villanova Board of Governors, and the Very Reverend Bernard Sciana, OSA, is a governor ex officio. The Augustinians at Marylake fulfill an important role in the spiritual lives of the students and in the delivery of religious education and experience under the leadership of Brother Paul Koscielniak, OSA, local superior Marylake Monastery and Shrine.

Today, the Augustinian Fathers (Ont) Inc., the owner of the Marylake Monastery and Shrine, is managed by a group of directors, administrators and trustees. (See Appendix F for a list of current trustees, directors and administrators of the Augustinian Fathers (Ontario) Inc.) This group is responsible for the budget, ministry, property maintenance and delegation of activities at Marylake Monastery and Shrine.

It's difficult to believe that for all the incredible architecture at Marylake, only the Marylake Entrance Gate and Gatehouse have a heritage designation. According to By-Law Number 84-107, the reasons for designating the "Augustinian Monastery Gatehouse and Entrance Gates," which are part of the east half of Lot 11, Concession IV, are:

> *The major significance concerning the entrance gates and gatehouse is historical, and their relationship to the development of this property by*

Sir Henry Mill Pellatt, C.V.O., D.C.L., V.D. (1859–1939) and to his property in Toronto known as Casa Loma, a Heritage Landmark. Sir Henry early in this century assembled the property and developed it into a country estate. The Basilian order from Toronto bought the property in 1936 [technically incorrect, as they never owned the property and they arrived on the land in 1935], *forming an agricultural association of lay people and clergy, and renamed it Marylake. The Augustinian Order from Toronto then bought the property in 1942 for their main retreat centre for their Marylake Shrine. The architectural significance is not major, however, the entrance gates, stone fences and gatehouse are similar in style and construction to the Casa Loma Castle in Toronto, designed by E.J. Lennox, based on Norman and Scottish castle architecture, and are built of finely cut stone trim with fieldstone infill.*

Dated September 24, 1984, a letter to Father Cyril Smetana, OSA, from Township of King clerk Mr. C.H. Duncan informed Smetana of the designation. The specifications of the designation include "all of the main iron and stone entrance gates on the west side of the 4th Concession Road [Keele Street] and attached stone fences, the exterior only of the adjacent stone gatehouse and the immediate lands on which they stand, under the

Marylake gatehouse today. *Author's photo.*

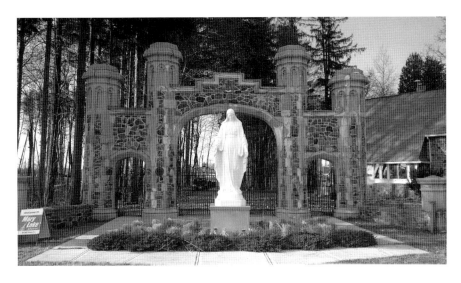

Above: Marylake stone entrance today. *Author's photo.*

Left: Heritage plaque on the Marylake gatehouse and entrance today. *Author's photo.*

Ontario Heritage Act." The By-Law was signed by Mayor C.W. Jessop and passed on September 4, 1984.

Ten months later, on Monday July 1, 1985, at 11:00 a.m., the Local Architectural Conservative Advisory Committee (LACAC) of the Township of King invited the community to Marylake on Canada Day for the unveiling of the Ontario Heritage Plaque. Two days later, the *King Weekly* reported on the event with a photo of the unveiling on the front cover. Delegates in attendance included Councillor Jim Connell, Mayor Clarence Jessop, Councillor Murray Sheardown and Father Cyril Smetana, among many others.

Throughout the 1980s and '90s there was no shortage of Marylake in the news. Marylake was often featured in the local papers and almost

always with dreamy titles, such as "Want to Get Away from It All," "Marylake Monastery, Peaceful, Holy, Place," "Body and Soul Rejuvenated in Splendor of Monastery Grounds," "Marylake Monastery Offers Peace of Mind for All People," "In Search of Inner Peace" and "Shrine Offers Sense of Family," to name a few. One can read page after page of the comforting, countryside setting, the farming operations, the monks who toil the land, the thousands of pilgrims who frequent the site every year and the retreatants who leave Marylake more complete than when they arrived. Marylake has touched the lives of so many and, in turn, has been touched by those that have happened upon it.

On December 11, 1974, Brother Leo Ebert addressed an audience of King Township Lion's Club. It was King resident Ray Love who introduced Ebert to the audience and described him as their "frocked guest, an Augustinian and a dirt farmer." Ebert indicated that there were three main operations at Marylake: the shrine, the retreat centre and the farming, with "the Retreat work being the most important apostolates." Only two of these activities continue today, with the farming activities having ceased in 1998. Like the changing seasons, Marylake continues to evolve. In addition to the ongoing shrine and retreat work, Marylake is intimately involved with Villanova College, Sacred Heart Church, the Rosary Path, fundraising for restorative projects and more. The newly launched website, with a refreshed look and beautiful imagery, speaks to the Augustinians' willingness and ability to reinvent themselves. The very fact that there is a page on the Marylake website titled "Our Bold New Vision" speaks to the Marylake Augustinians' excitement for the future.

Marylake: The Road Ahead

You not only have a glorious history to remember and recall, but also a great history still to be accomplished.
—Pope Francis from the Apostolic Letter of His Holiness to all consecrated people on the occasion of the year of consecrated life, 2014

Population growth has transformed a great majority of pastoral hamlets, villages and mill towns throughout Ontario into chains of strip-mall suburbs, each of which painfully gives way to the convention of convenience. Where horses once sauntered and cows pastured there are cookie-cutter homes and characterless plazas offering the very conveniences of a life and lifestyle that many look for retreat and respite from today. Marylake continues to offer such respite. King Township has, to date, done a very good job at dodging the ugly industrial hand that has befallen so many towns around it. But it, too, is under pressure to increase its resource-draining inhabitant capacity.

One can only hope, and pray, that the future will remain kind to Marylake and that the rolling hills, kettle lake and the very road to Marylake itself will have a future as bucolic as its past. If we are not careful, where people once fled to King Township to escape the noise of everyday life, we will one day find ourselves looking to escape the noise and everyday life of King Township.

Marylake has evolved over the years, and though it no longer feeds or fuels the belly through its farming venture, it continues to feed and fuel the soul

as a place for reflection and solitude. What the future holds for Marylake is a mystery. Today, the community at Marylake is small but mighty. There are four brothers (two are off site at a senior's home), four sisters, two full-time administrators, two full-time operations and one part-time operations staff. At its peak, Marylake was home to over thirty persons at any given time and, in its heyday, had a herd of Holstein cattle, which more than tripled the number of human inhabitants.

The times have changed, yet after seventy-five years of Augustinian ownership, the primary issues facing the Augustinians have not: the church has competition, fewer people are going into the church services and attrition numbers remain a concern among all religions. Though the number of active friars has diminished, those at Marylake believe that "the Shrine of Our Lady of Grace remains a living sign of permanence and continuity with a rich heritage of sanctity, scholarship and spiritual direction, as well as communion with men and women throughout the world who take the example and Rule of Saint Augustine as their guide."

In the words of Father Allan Charnon, prior at Marylake from 1975 to 1983, "We humans are not like computers, we cannot push the 'profound' button and expect instant results. We need ambiance, we need to be away from noise and confusion if we're to sort through it all and find a sense of order, get beyond the details that beguile us all, and down to the heart of the matter."

The Augustinians are stewards, like the Basilians, Sir Henry Pellatt and the pioneers before them. Marylake belongs to everyone, and as long as the Augustinians are the shepherds of Marylake, all will be welcome. Marylake does not turn people away, but it has done as much to time. At Marylake, time stands still. At Marylake, man is forced to slow down, not because he has to but because he wants to, he needs to and he can.

A Bold New Vision was launched at Marylake three years ago in September 2014 under the passion and leadership of Executive Director Joe Gennaro. The Bold New Vision commenced when Marylake broke ground for the Rosary Path. "Our plan is to provide a space of reverent and enriching meditation upon the prayers of the Rosary, and a rewarding spiritual experience each time you visit," according to Gennaro. Future plans for the Rosary Path include finishing the stations of the Way of the Cross (including the Tomb of the Resurrection), a Marian fountain, statues of the Mysteries, gazebos, benches, lights and trees, as signs reminding people of the worldly wisdom of Saint Augustine.

But the new vision doesn't start and stop with the Rosary Path. Gennaro shared, "Our goal is to create a world-class destination for Marian devotion, which includes many other exciting initiatives." Marylake is currently using the shrine as a Catholic education and entertainment centre for speakers, concerts and conferences. Excitingly, Marylake hopes to return to its farming roots and plans to start a Marylake Fair to promote local produce, artisanal goods and good stewardship of the land. In addition to this, Marylake will soon initiate the Marylake Barn Project, with plans to refurbish Sir Henry Mill Pellatt's almost 120-year-old barn to create a facility to serve its faith and community. For so many years, Pellatt's barn acted as a community hub for King Township, and it can do so again.

In addition, Marylake has plans to restore the Marylake shrine bell so that its music can once again toll throughout the township, ushering in farmers at the end of their workday. Other projects on the horizon include the Marylake Reception Centre, the organ restoration project, hermitage retreats, the Marylake Hallelujah Choir Competition, Camp Marylake, Marylake Christian Music Festival, Marylake under the Stars and Marylake Environmental and Agriculture Centre, to name a few. With a full-time administrative team of just two persons, these plans are ambitious to say the least. But with financial and in-kind support from the community and a little faith, Marylake, under the leadership of the Augustinians, will continue to play an important role at the heart of the community.

Perhaps the Marylake website says it best: "This is a glorious time in Marylake's history where we are reinventing ourselves. There's a radiant window of opportunity opening up. Anything is possible…."

Marylake…to its past, present and future!

CONCESSION IV

CONCESSION IV

LOT 11 (EAST AND WEST HALF)

DATE	INSTRUMENT	FROM	
April 7, 1911	B&S 12598	John Taylor (widower)	
June 20, 1921	B&S 17105	Sir Henry M. Pellatt	
November 15, 192?	Mortgage 19565	Henry M Pellatt	

CHART OF LAND TRANSFERS
FOR LAKE MARIE ESTATE

CHART ABBREVIATIONS

"B&S" stands for Bargain & Sale. Often incorrectly referred to as Bought
& Sold.

"ac" stands for acres.

"Int al" stands for *inter alia* in Latin meaning *among other things*.

"et ux" stands for *et uxor* in Latin meaning *and wife*.

"?" means the letter, number or word was illegible.

To	VALUE	NOTE
Sir Henry M. Pellatt	$10,000	200 acres all
Lady Mary Pellatt	$1	All (Int al)
Howard C. Hirsch	$20,000	All (Int al) Not reg in full. Dec. of celibacy attached

Date	Instrument	From	
January 9, 1931	Grant 19585	Sir Henry M. Pellatt, Ext Mary Lady Pellatt & Sir Henry Pellatt	
August 5, 1935	Agreement 20725	Howard C. Hirsch	
August 22, 1935	Agreement 20804	Caledon Securities Ltd	
October 14, 1942	Grant 22819	Caledon Securities Ltd; Marylake Agricultural School & Farm Settlement Association of 3rd part	
November 9, 1942	Grant 22822	Augustinian Fathers (Ontario) Inc.	

Concession IV

Lot 12 (west half)

Date	Instrument	From	
March 1903	B&S 10086	Daniel Urquhart	
May 1914	B&S 12003	Thomas Harrison	
November 1915	B&S 14281	The Standard Cement Co.	
June 20, 1921	B&S 17105	Sir Henry M. Pellatt	
March 16, 1925	Grant 17855	Henry M. Pellatt	
November 15, 192?	Mortgage 19565	Henry M. Pellatt, widower late dispose Mary Lady Pellatt	
November 15, 192?	Mortgage 19566	Estates Holding Company Ltd.	
January 9, 1931	Grant 19585	Sir Henry M. Pellatt, Ext Mary Lady Pellatt & Sir Henry Pellatt	

To	Value	Note
Caledon Securities Ltd.	$1	All. Dec. of celibacy attached
Caledon Securities Ltd	$1	All (Int al)
Mary Lake Agricultural School & Farm Settlement Association	$95,000	All (Int al)
Augustinian Fathers (Ontario) Inc.	$1	All (Int al)
Roman Catholic Episcopal Corp for the Dioccsc of Toronto in Canada	$6,000	West Lots 11 &12

To	Value	Note
Standard Cement Co. Ltd.	$1	20 ac pt $W^{1/2}$ (Int al)
Sir Henry M. Pellatt	$4800	80ac $W^{1/2}$ less part sold in #9796
Sir Henry M. Pellatt	$1	20 ac pt $W^{1/2}$ (Int al)
Lady Mary Pellatt	$1	20 ac pt $W^{1/2}$ (Int al)
Estates Holding Co. Ltd	$1	$W^{1/2}$ (Int al) less #9796 [80 ac]
Howard C. Hirsch	$20,000	20 ac pt of $W^{1/2}$ (Int al). Not reg in full. Dec. of celibacy attached
Howard C. Hirsch	$1	80 ac pt of $W^{1/2}$ (Int al).
Caledon Securities Ltd.	$1	20 ac pt of $W^{1/2}$ (Int al) Dec. of celibacy attached

DATE	INSTRUMENT	FROM	
January 9, 1931	Grant 19586	Estates Holding Company Ltd.	
August 5, 1935	Agreement 20725	Howard C. Hirsch	
August 5, 1935	Agreement 20725	Howard C. Hirsch	
August 22, 1935	Agreement 20804	Caledon Securities Ltd	
October 14, 1942	Grant 22819	Caledon Securities Ltd; Marylake Agricultural School & Farm Settlement Association of 3rd part	
November 9, 1942	Grant 22822	Augustinian Fathers (Ontario) Inc.	

CONCESSION IV

LOT 12 (EAST HALF)

DATE	INSTRUMENT	FROM	
March 6, 1903	B&S 10086	Daniel Urquhart	
November 1915	B&S 14281	Standard Cement Co. Ltd.	
June 27, 1921	Mortgage 16324	Sir Henry M. Pellatt et ux	
June 20, 1921	B&S 17105	Sir Henry M. Pellatt	
November 15, 1924	Mortgage 19285	Henry M. Pellatt, widower late dispose Mary Lady Pellatt	
January 9, 1931	Grant 19585	Sir Henry M. Pellatt, Ext Mary Lady Pellatt & Sir Henry Pellatt	
January 9, 1931	Grant 19586	Estates Holding Company Ltd.	
August 5, 1935	Agreement 19723	Howard C. Hirsch	

To	Value	Note
Caledon Securities Ltd.	$1	80 ac pt of W½ (Int al) Dec. of celibacy attached
Caledon Securities Ltd	$1	20 ac pt of W½ (Int al)
Caledon Securities Ltd	$1	80 ac pt of W½ (Int al)
Mary Lake Agricultural School & Farm Settlement Association	$95,000	All (Int al)
Augustinian Fathers (Ontario) Inc.	$1	All (Int al)
Roman Catholic Episcopal Corp for the Diocese of Toronto in Canada	$6,000	West Lots 11 &12

To	Value	Note
Standard Cement Co. Ltd.	$1	100 ac E½ (Int al)
Sir Henry M. Pellatt	$1	100 ac E½ (Int al)
Lucy Cook, Florence M. McCoy, James W. Barn	$11,000	100 ac E½. Not reg in full
Mary Lady Pellatt	$1	E½ (Int al)
Howard C. Hirsch	$30,000	E½ (Int al) Dec. of celibacy attached.
Caledon Securities Ltd.	$1	E½ (Int al) Dec. of celibacy attached.
Caledon Securities Ltd.	$1	E½ lying between east line of ? and Bales Lake (Inc al)
Caledon Securities Ltd	$1	100 ac E½ (Int al)

DATE	INSTRUMENT	FROM	
August 22, 1935	Agreement 20204	Caledon Securities Ltd	
October 15, 1936	Mortgage 21070	Florence M. McCoy, John AR Fraser, Samuel D. McCoy Trustees of Estate of John L. Cook	
February 1, 1937	Mortgage 21133	Arthur W. Holmstead, Ethel M. Haight, Exts of William W. Near	
September 30, 1942	Discharge Mortgage ?	Howard C. Hirsch	
October 6, 1942	Discharge Mortgage 22818	Arthur W. Holmstead, Ethel M. Haight, The Toronto General Trusts Corp., Trustees of William W. Near	
October 14, 1942	Grant 22819	Caledon Securities Ltd; Marylake Agricultural School & Farm Settlement Association of 3rd part	
November 9, 1942	Grant 22822	Augustinian Fathers (Ontario) Inc.	

CONCESSION IV

LOT 13 (EAST AND WEST HALF)

DATE	INSTRUMENT	FROM	
March 6, 1903	B&S 9982	Abigail Burrows	
March 6, 1903	B&S 10086	Daniel Urquhart	
January 21, 1905	B&S 10490	Abigail Burrows	
April 29, 1911	B&S 12596	Bernard McCabe et ux	
January 15, 1912	B&S 12831	George Burrows & Abigail Burrows	

To	Value	Note
Mary Lake Agricultural School & Farm Settlement Association	$95,000	All (Int al)
Arthur W. Holmstead, Ethel M. Haight, Exts of William W. Near	$8,227.23	100 ac E$\frac{1}{2}$ (Int al). Not registered in full. See original re appointments
Arthur W. Holmstead, Ethel M. Haight, The Toronto General Trusts Corp., Trustees of William W. Near	$1	100 ac E$\frac{1}{2}$ (Int al). Not registered in full.
Caledon Securities Ltd.	$0	See mortgage #19685
Caledon Securities Ltd.	$0	See mortgage #16324 #21070 #21133
Augustinian Fathers (Ontario) Inc.	$1	All (Int al)
Roman Catholic Episcopal Corp for the Diocese of Toronto in Canada	$6,000	W pt Lots 11 &12

To	Value	Note
Daniel Urquhart	$350	14 ac pt SE$\frac{1}{4}$
Standard Cement Co. Ltd.	$1	14 ac pt SE$\frac{1}{4}$ (Int al)
Standard Cement Co. Ltd.	$250	10 ac pt NE$\frac{1}{4}$
Sir Henry M Pellatt	$15,000	100 ac W$\frac{1}{2}$
Sir Henry M Pellatt	$1	76 ac E$\frac{1}{2}$ See #9982, #10490 (Int al)

Date	Instrument	From	
November 1915	B&S 14281	Standard Cement Co. Ltd.	
April 1921	Mortgage 16248	Sir Henry M. Pellatt	
June 20, 1921	B&S	Sir Henry M. Pellatt	
March 23, 1925	Mortgage 16238	Sir Henry M. Pellatt, Ext. Lady M. Pellatt, Ext. Trustee of Mary Lady Pellatt	
March 30, 1925	Agreement ?	The Standard Bank of Canada Sir Henry M. Pellatt in his individual capacity as well as Ext. Trustee of Lady Mary Pellatt	
March 1925	Grant ?	Sir Henry M. Pellatt	
November 15, 1924	Mortgage 19565	Sir Henry M. Pellatt Henry M. Pellatt, widower late dispose Mary Lady Pellatt	
1930	Mortgage 19566	Estates Holding Co. Ltd	
January 9, 1931	Grant ?	Sir Henry M. Pellatt, Ext Mary Lady Pellatt & Sir Henry Pellatt	
January 9, 1931	Grant ?	Estates Holding Co. Ltd	
February 25, 1931	?	Caledon Securities Ltd. Sir Henry M. Pellatt personally as Ext. Mary Pellatt	
?	Discharge Mortgage 19592	The Bank of Montreal	
August 15, 1935	Agreement 20723	Howard C. Hirsch	
August 15, 1935	Agreement 20724	Howard C. Hirsch	
August 22, 1935	Agreement 20804	Caledon Securities Ltd.	
October 1, 1936	Discharge Mortgage 22942	The Royal Trust Co. Ext. Trustee of Walter D. Beardsmore	

To	VALUE	NOTE
Sir Henry M. Pellatt	$1	14 ac pt SE¼ & 10 ac pt NE¼ (Int al)
The Bank of Montreal	$8,500	100 ac W½ (Int al)
Lady Mary Pellatt	$1	E½ (Int al)
The Royal Trust Co. Ext. Trustee of Walter D. Beardsmore	$8,500	E½ (Int al) Not reg in full
The Royal Trust Co. Ext. Trustee of Walter D. Beardsmore	$1	E½ (Int al) postponing mortgage #16328
Estates Holding Co. Ltd.	$1	W½ (Int al)
Howard C. Hirsch	$30,000	E ½ (Int al) Not reg in full
Howard C. Hirsch	$1	W½ (Int al)
Caledon Securities Ltd.	$1	E½ (Int al) Dec of celibacy attached
Caledon Securities Ltd.	$1	W½ (Int al)
The Royal Trust Co. Exts. Walter D. Beardsmore	$0	E½ (Int al) Extending time of payment of mortgage
Sir Henry M. Pellatt	$1	Discharging mortgage No. 16248
Caledon Securities Ltd.	$1	E½ (Int al)
Caledon Securities Ltd.	$1	W½ (Int al)
Mary Lake Agricultural School & Farm Settlement Association	$95,000	All (Int al)
Arthur W. Holmstead, Ethel M. Haight, Exts of William W. Near	$8,819.11	E½ (Int al) Not reg in full

DATE	INSTRUMENT	FROM	
February 1, 1937	Assume Mortgage 21132	Arthur W. Holmstead, Ethel M. Haight, Exts of William W. Near	
September 30, 1942	Discharge Mortgage 22807	Howard C. Hirsch	
September 30, 1942	Discharge Mortgage 22807	Howard C. Hirsch	
September 30, 1942	Discharge Mortgage 22807	Howard C. Hirsch	
October 14, 1942	Grant 22819	Caledon Securities Ltd.; Marylake Agricultural School & Farm Settlement Association (of 3rd part)	

CONCESSION IV

LOT 14 (EAST AND WEST HALF)

DATE	INSTRUMENT	FROM	
January 15, 1912	B&S 12639	George Lloyd et ux	
January 15, 1912	B&S 12831	George Burrows and Abigail Burrows	
June 4, 1912	Deed 13008	Annie Gillham, Celena L. Gillham, William H. Gillham, Arthur T. Gillham & FW Harcourt Official Guardian re: Estate of Alfred Gillham	
June 20, 1921	B&S 17105	Sir Henry M. Pellatt	
March 23, 1925	Mortgage 19605	Sir Henry M. Pellatt in his Sir Henry M. Pellatt, Ext. Trustee of Lady Mary Pellatt	

Appendix A

To	Value	Note
Arthur W. Holmstead, Ethel M. Haight, The Toronto General Trusts Corp., Trustees of William W. Near	$1	E½ (Int al) not reg in full
Caledon Securities Ltd.	$0	See mortgage No. 19565
Caledon Securities Ltd.	$0	See mortgage No. 19566
Caledon Securities Ltd.	$0	See mortgage No. 17608, 21042, 21132
Augustinian Fathers (Ontario) Inc.	$1	All (Int al)

To	Value	Note
Sir Henry M. Pellatt	$800	20 ac E½
Sir Henry M. Pellatt	$1	80 ac E½ except 20 ac
Sir Henry M. Pellatt	$6,250	100 ac W½ Sub to Mort
Mary Lady Pellatt	$1	All (Int al)
The Royal Trust Co. Ext. Trustee of Walter D. Beardsmore	$8,500	E½ (Int al)

DATE	INSTRUMENT	FROM	
March 30, 1925	Postponement of Agreement 17644	The Standard Bank of Canada Sir Henry M. Pellatt in his individual capacity as well as Ext. Trustee of Lady Mary Pellatt	
November 15, 1930	Mortgage 19565	Henry M. Pellatt widower of late Mary Lady Pellatt	
January 9, 1931	Grant 19555	Sir Henry M. Pellatt Ext. Mary Lady Pellatt and Sir Henry Pellatt	
February 25, 1931	Agreement 19587	Caledon Securities Ltd. Sir Henry M. Pellatt personally and as Ext. of Mary Lady Pellatt	
August 15, 1935	Agreement 20723	Howard C. Hirsch	
August 22, 1935	Agreement 20804	Caledon Securities Ltd.	
October 1, 1936	Assume Mortgage 21042	The Royal Trust Co. Ext. Trustee of Walter D. Beardsmore	
February 1, 1937	Assume Mortgage 21132	Arthur W. Holmstead, Ethel M. Haight, Exts of William W. Near	
September 30, 1942	Discharge Mortgage 22807	Howard C. Hirsch	
September 30, 1942	Discharge Mortgage 22808	Howard C. Hirsch	
October 1, 1942	Dis. Mortgage 22810	Arthur W. Holmstead, Ethel M. Haight, Exts of William W. Near	

To	Value	Note
The Royal Trust Co. Ext. Trustee of Walter D. Beardsmore	$1	E½ (Int al) Postponing of mortgage 16328
Howard C. Hirsch	$30,000	All
Caledon Securities Ltd.	$1	All Dec. of celibacy attached
The Royal Trust Co.	$0	E½ (Int al)
Caledon Securities Ltd.	$1	All
Mary Lake Agricultural School & Farm Settlement Association	$95,000	All (Int al)
Arthur W. Holmstead, Ethel M. Haight, Exts of William W. Near	$8,819.11	E½ (Int al) Not reg in full
Arthur W. Holmstead, Ethel M. Haight, The Toronto General Trusts Corp., Trustees of William W. Near	$1	E½ (Int al) not reg in full
Caledon Securities Ltd.	$0	See mortgage No. 19565
Caledon Securities Ltd.	$0	See mortgage No. 19566
Caledon Securities Ltd.	$0	See mortgage No. 17608, 21042, 21132

DATE	INSTRUMENT	FROM	
October 14, 1942	Grant 22819	Caledon Securities Ltd.; Marylake Agricultural School & Farm Settlement Association (of 3rd part)	

CONCESSION IV

LOT 15 (14 ACRES EAST HALF)

DATE	INSTRUMENT	FROM	
January 15, 1912	B&S 12831	George Burrows and Abigail Burrows	
March 23, 1925	Mortgage 19605	Sir Henry M. Pellatt, Ext. & Trustee of Lady Mary Pellatt	
March 16, 1925		Henry M. Pellatt	
November 15, 1930	Mortgage 19566	Estates Holding Co. Ltd.	
January 9, 1931	Grant 19556	Estates Holding Co. Ltd.	
February 25, 1931	Agreement 19587	Caledon Securities Ltd. Sir Henry M. Pellatt personally and as Ext. of Mary Lady Pellatt	
August 15, 1935	Agreement 20723	Howard C. Hirsch	
August 22, 1935	Agreement 20804	Caledon Securities Ltd.	
October 1, 1936	Assume Mortgage 21042	The Royal Trust Co. Ext. Trustee of Walter D. Beardsmorc	
February 1, 1937	Assume Mortgage 21132	Arthur W. Holmstead, Ethel M. Haight, Exts of William W. Near	
September 30, 1942	Discharge Mortgage 22808	Howard C. Hirsch	

To	Value	Note
Augustinian Fathers (Ontario) Inc.	$1	All (Int al)

To	Value	Note
Sir Henry M. Pellatt	$1	14 ac pt E$\frac{1}{2}$
The Royal Trust Co. Ext. Trustee of Walter D. Beardsmore	$8,500	pt of E$\frac{1}{2}$
Estates Holding Co. Ltd.	$1	pt of E$\frac{1}{2}$
Howard C. Hirsch	$1	14 ac pt of E$\frac{1}{2}$
Caledon Securities Ltd.	$0	14 ac pt of E$\frac{1}{2}$
Caledon Securities Ltd.	$0	14 ac pt of E$\frac{1}{2}$
Caledon Securities Ltd.	$1	14 ac pt of E$\frac{1}{2}$
Mary Lake Agricultural School & Farm Settlement Association	$95,000	All (Int al)
Arthur W. Holmstead, Ethel M. Haight, Exts of William W. Near	$8,819.11	E$\frac{1}{2}$ (Int al) Not reg in full
Arthur W. Holmstead, Ethel M. Haight, The Toronto General Trusts Corp., Trustees of William W. Near	$1	14 ac pt of E$\frac{1}{2}$
Caledon Securities Ltd.	$0	See mortgage No. 19566

Date	Instrument	From	
October 1, 1942	Discharge Mortgage 22810	Arthur W. Holmstead, Ethel M. Haight, Exts of William W. Near	
October 14, 1942	Grant 22819	Caledon Securities Ltd.; Marylake Agricultural School & Farm Settlement Association (of 3rd part)	

CONCESSION III

CONCESSION III

LOT 11 (NORTH AND WEST HALF)

Date	Instrument	From	
March 22, 1913	B&S 13180	Walter Scott, et ux	
January 5, 1913	B&S 13269	John L. Ferguson, et ux	
October 2, 1916	B&S 14483	Elizabeth F. Hurst	
July 10, 1919	B&S 15433	Hugh Mitchell et ux	
March 22, 1921	Mortgage 16261	Sir Henry M. Pellatt et ux	
January 16, 1922	B&S 16492	Sir Henry M. Pellatt et ux	

CONCESSION III

LOT 12 (WEST HALF)

Date	Instrument	From	
September 20, 1915	B&S 14155	Col. James Mason et ux	
March 22, 1921	Mortgage 16261	Sir Henry M. Pellatt et ux	
January 16, 1922	B&S 16492	Sir Henry M. Pellatt et ux	

To	Value	Note
Caledon Securities Ltd.	$0	See mortgage No. 17608, 21042, 21132
Augustinian Fathers (Ontario) Inc.	$1	14 ac pt of E½

To	Value	Note
Sir Henry M. Pellatt	$1	195 ac (N&S ½ less 3 parcels)
Sir Henry M. Pellatt	$600	2 ¾ ac (Int al)
Sir Henry M. Pellatt	$1	¼ ac SE corner
Sir Henry M. Pellatt	$1	¼ ac of SE ¼
Walter Wily	$60,000	All (Int al) Not reg in full. Assumption of mortgage
Dame Florence McCrea Eaton	$1	All (Int al) Sub to a Mort

To	Value	Note
Sir Henry M. Pellatt	$1	100 ac W½ (Int al)
Walter Wily	$60,000	W½ (Int al) Not reg in full. Assumption of mortgage
Dame Florence McCrea Eaton	$1	W½ (Int al) Sub to Mort

CONCESSION III

LOT 13 (WEST HALF)

DATE	INSTRUMENT	FROM	
April 16, 1913	B&S 13201	John Cairns et ux	
September 20, 1915	B&S 14158	Col. James Mason et ux	
March 22, 1921	Mortgage 16261	Sir Henry M. Pellatt et ux	
January 16, 1922	B&S 16492	Sir Henry M. Pellatt et ux	

To	Value	Note
Sir Henry M. Pellatt	$5,000	85 ac, W½ less mill pond
Sir Henry M. Pellatt	$1	15 ¼ ac, part of west half (Int al)
Walter Wily	$60,000	W½ (Int al) Not reg in full Assumption of mortgage
Dame Florence McCrea Eaton	$1	W½ (Int al) Sub to Mort

Marylake Farm Machinery and Implements Inventory as of January 1, 1937

Prepared by Father Michael J. Oliver, CSB

Power

2	McCormick-Deering tractors (about ten years old)

Tillage Implements

2	two-bottom tractor ploughs
1	two-bottom riding plough
4	walking ploughs
1	riding plough
2	stiff-tooth cultivators (for the tractors)
1	spring-tooth cultivator (for horses)
2	single-disk harrows (for horses)
1	double-disk harrow (for tractor)
2	land rollers
5	sets spike-tooth harrows
3	single-horse scufflers
2	corn cultivators

Planting Implements

3	seed drills
1	corn planter
2	root drills

Haying Implements

2	moving machines
2	hay tedders
1	dump rake
1	side delivery take
1	hay loader

Harvesting Implements

2	grain binders
1	corn binder

Dairy

1	two-unit milking outfit
1	cream separator

Miscellaneous

Forks, shovels, saws, axes, small tools, etc., etc.

GENERAL

1	grain separator
2	manure spreaders
1	hay press
1	ensilage cutter
2	fanning mills
3	root pulpers
1	power aaw
1	grain grinder
5	wagons
4	sets sleighs
3	dump carts
1	bain wagon
1	express wagon

Inventory of Furniture at the Lake Marie Bungalow, circa 1935

West Room, Downstairs

Brass bed
Two chairs, old English-carved oak
Walnut bureau and glass
One pair walnut wall cabinets
Small walnut cupboard
Rug—Donegal
Three wicker chairs
Two tables
One small Japanese cupboard

East Room, Downstairs

Metal bed
Inlaid table
Bureau (ash)
Wardrobe (ash)
Wardrobe (canvas)

Armchair—English oak
Two chairs—English oak
Bookcase—English oak
Table
Armchair—horsehair
Armchair—unholstered [upholstered]
Pictures—family and military, military certifications
Scales
Cupboard

DINING ROOM

Table
Twelve chairs
Long serving table
Folding serving table
Folding walnut card table
Wicker desk
Two wicker chairs (desk)
Desk lamp
Bookcase—old English oak
Pictures—family
Pictures—Kricohoff, Martin, Moss, Zenlot
Bronze cat and dog
Two porcelain dwarfs
Rug—Donegal
Tablecloth
French rug

LIVING ROOM

Piano
Piano bench
Sideboard—old English walnut
Table—old English carved oak

Five green wicker chairs
Three brown wicker chairs
Two leather armchairs
Chesterfield
Eight heads (deer, etc.)
Large Chinese vase
French clock—large
Desk lamp
Floor lamp
Two hanging iron lamps
Two hanging Italian lamps
Gramophone and records
Two pewter jugs and trays
Bronze hawk on stand
Fifty (about) birds, etc., stuffed
Pictures—family & military
Pillows, ornaments, etc.

North Bedroom

Three brass beds
Two inlaid bureaus
Bureau
Two wash stands
Chest
Four chairs
Rug—Donegal
Screen
Towel rack
Adjustable table

South Bedroom

Three brass beds
Inlaid walnut bureau and glass

Bureau
Wash stand
Screen
Chest
Four chairs
Towel rack
Medicine cupboard
Glass

SERVANTS' WING

Upstairs (Three Rooms)

Two iron beds
Two bureaus
Three wash stands
Two chairs
Table
Two chairs
Sofa
Sewing machine
Lamp (electric)
Bureau

Downstairs (Three Rooms)

Refrigerator
Four chairs
Table
Three cupboards
Stove
Three tables
Six chairs
Sideboard

HALL

Hall seat
Carved oak bench
Twenty-four pairs green curtains
Curtains, etc.
Linen, dishes, china, glass, silver, etc.

Appendix D

List of Those Who Have Served in a Spiritual Leadership Capacity at Marylake

Priors at Marylake

1942–1947	Father Leo Ebert
1947–1953	Father Athanasius Pape
1953–1959	Father Suitbert Moors
1959–1966	Arnulf Hartmann
1966–1968	Father Cyril Smetana
1968–1970	Father Suitbert Moors
1970–1975	Isidore Geiss
1975–1983	Father Allan Charnon
1983–1987	Father Cyril Smetana
1987–1991	Father Louis Campbell
1991–2000	Father Eugene Tramble
2000–2007	Father Leo Cameron
2007–2014	Father Eugene Tramble
2014–2017	Brother Paul Kosielniak (Local Superior)
2017–	Father John Paul Szura (Local Superior)

PRIOR PROVINCIAL OF THE AUGUSTINIANS IN CANADA

1931–1947	Father Athanasius Pape
1947–1953	Father Tarcisius Rattler
1953–1959	Father Francis Roth
1959–1965	Father Oswald Malzer
1965–1975	Father Stanislaus Treu
1975–1983	Father Cyril Smetana
1983–1991	Father Michael Martell
1991–1991	Father Allan Charnon
1992–1996	Father Cyril Smetana
1996–2004	Father Laurence Clark
2004–2012	Father Francis Galvan
2012–	Father Bernard Scianna

PRIESTS WHO HAVE SERVED AT SACRED HEART PARISH

1960–1972	Reverend Reinhard A. Burchhardt, OSA
1972–1975	Reverend Frederick A. Brossler, OSA
1975–1982	Reverend Reinhard A. Burchardt, OSA
1983–1984	Reverend Louis Campbell, OSA (Administrator)
1984–1987	Reverend Michael B. Martell, OSA
1987–1990	Reverend John Bosworth, OSA
1990–1991	Reverend Michael B. Martell, OSA (Administrator)
1991–1996	Reverend Louis Campbell, OSA
1996–1998	Reverend Leo Cameron, OSA
1998–2011	Reverend Paul L. O'Brien, OSA (on loan from Ireland Province)
2011–	Reverend Michael B. Martell, OSA

Appendix E

LIST OF THOSE BURIED AT THE SACRED HEART PARISH CEMETERY IN THE AUGUSTINIAN PLOT

** Indicates that they were one of the first five Augustinians to come to Marylake

FATHERS

Father Rudolph E. Arbesmann, OSA
July 25, 1895–December 4, 1982

Father Frederick A. Brossler, OSA
March 24, 1904–June 10, 1988

Father Reinhard P. Burchhardt, OSA
Decemember 6, 1914–January 16, 1997

Father Allan Charnon, OSA
August 20, 1932–May 23, 2008

Father Laurence Clark, OSA
June 24, 1937–February 17, 2011

Father Arnold Diederich, OSA
July 15, 1914–July 9, 2006

Father Ludger A. Grosse, OSA
December 5, 1909–February 4, 1989

Father John P. Kelleher, OSA
April 29, 194–September 21, 1974

Father Valentine A. Kellner, OSA
October 26, 1907–September 20, 1982

Father Anastasius Linder, OSA
September 4, 1914–December 14, 1996

Father Henry McErlean, OSA
September 28, 1932–February 15, 2015

Father Jim Mombourquette
July 26, 1932–May 5, 2005

Father Suitbert Bernard Moors, OSA**
June 26, 1905–November 10, 1970

Father Othmar Mussmacher, OSA
November 27, 1913–July 5, 2007

Father Alexius Noeth, OSA
April 18, 1907–October 14, 1999

Father Rhaban F. Peterson, OSA
November 21, 1989–May 15, 1988

Father Tarcisius Rattler, OSA
May 26, 1903–October 16, 1997

Father Charles Schlereth, OSA
August 19, 1905–January 19, 2002

Father Patrick Skaria, OSA
February 13, 1941–December 30, 2011

Father Cyril Smetana, OSA
May 5, 1920–March 19, 2005

Father Damasus Trapp, OSA
September 3, 1907–December 23, 1996

Father Stanislaus Treu, OSA
March 4, 1910–February 17, 1998

Father Placidus A. Vollmer, OSA
November 30, 1902–February 4, 1991

BROTHERS

Brother Ephram N. Alice, OSA
February 15, 1918–December 29, 1971

Brother Macarius A. Bieber, OSA
May 28, 1906–November 25, 1984

Brother Basil Bogan, OSA
February 12, 1913–January 20, 2000

Brother Mark Borukski, OSA
April 27, 1919–January 17, 2010

Brother Lambert Bosmans, OSA
March 17, 1936–April 20, 2014

Brother Vincent Burton, OSA
July 1, 1927–March 20, 2002

Brother Stanislaus Buszko, OSA
May 21, 1920–March 25, 2011

Brother John J. Cassidy, OSA
October 2, 1949–June 13, 1982

Brother Wilfred Curtin, OSA
April 23, 1935–March 6, 2000

Brother Stephen Donnelly, OSA
March 24, 1928–June 23, 2009

Brother Louca Gabriel, OSA
October 26, 1921–January 24, 1996

Brother Pirmin Aloysius Haberkorn, OSA**
July 5, 1906–September 22, 1984

Brother Emmanuel G. Haendel, OSA
August 27, 1909–September 9, 1998

Brother Paul E. Herbst, OSA
November 12, 1911–February 21, 1985

Brother Cornelius A. Keller, OSA
February 24, 1906–November 5, 1990

Brother Gratia W. MacDonald, OSA
September 17, 1920–August 18, 1986

Brother Lawrence MacQuarrie, OSA
January 29, 1930–October 21, 2006

Brother Ladislaus Ignatius Marcinek, OSA**
November 17, 1905–June 12, 1996

Brother Beatus E. Mueller, OSA
November 19, 1909–February 15, 1989

Brother Sturmius O. Nuszkowski, OSA
September 15, 1900–March 16, 1991

Brother Anthony Sirignano, OSA
September 26, 1925–March 23, 2010

Brother Andrew P. Valka, OSA
April 29, 1910–January 17, 1992

Br. Joesph Walker, OSA
April 24, 1911–March 12, 2011

CANADIAN FORCES

Gregoire Belanger, OSA, PTE RCASC
1917–2000 "Lest We Forget"

SISTERS

Sister Mary Teresita McErlean, MPH
January 9, 1937–June 7, 2013

ADMINISTRATORS

Executive Director: Joseph Gennaro
Administrative Assistant: Enza DeMedicis

SPIRITUAL LEADERSHIP

Very Reverend Bernard C. Scianna, OSA, PhD
Prior Provincial of the Midwest Augustinians and the Province of
St. Joseph (Canada)

LOCAL SUPERIOR, MARYLAKE SHRINE OF OUR LADY OF GRACE

Father John Paul Szura OSA, Local Superior as of July 1, 2017

PARISH AFFILIATION

Sacred Heart Church
Father Michael Martell, OSA

SCHOOL AFFILIATION

St. Thomas of Villanova College
Paul Paradiso, president

Bibliography

Books

Adam, M.G. *History of Toronto and County of York Ontario*. Vol. 1. Toronto: C. Blackett Robinson, 1885.

————. *History of Toronto and County of York Ontario*. Vol. 2. Toronto: C. Blackett Robinson, 1885.

Clarke, Brian P., and Mark McGowan, eds. *Catholics at the Gathering Place: Historical Essays on the Archdiocese of Toronto, 1841–1991*. Toronto: Canadian Catholic Historical Association, 1990.

Freeman, Bill. *Casa Loma: Canada's Fairy-Tale Castle and Its Owner, Sir Henry Mill Pellatt*. Toronto: James Lorimer & Company Ltd., 1998.

Griffin, Frederick. *Major General Sir Henry Mill Pellatt: A Gentleman of Toronto*. Toronto: Ontario Publishing Company, 1940.

Hanley, Ruth, and Christine Horgan. *St. Clare's Church: Celebrating 100 Years of Faith and Service*. N.p.: self-published, 2015.

Hogan, Brian Francis. "Salted with Fire: Studies in Catholic Social Thought and Action in Ontario, 1931–1961." Thesis, University of Toronto, 1986.

Johnson, Arthur. *Breaking the Banks*. Toronto: Lester & Orpen Dennys Publishers, 1986.

Lundell, Liz. *The Estates of Old Toronto*. Erin, ON: Boston Mills Press, 1997.

Mathews, Kelly. *Eaton Hall: Pride of King Township*. Charleston, SC: The History Press, 2015.

McClure Gillham, Elizabeth. *Early Settlements of King Township, Ontario.* Toronto: self-published, 1975.

McCorkell, Edmund J. *Henry Carr: Revolutionary.* Toronto: Griffin House, 1969.

Morgan, James Henry. *The Canadian Men and Women of the Time-Second Edition: A Handbook of Canadian Biography of Living Characters.* Toronto: William Briggs, 1912.

Oreskovich, Carlie. *Sir Henry Pellatt: The King of Casa Loma.* Whitby, ON: McGraw-Hill Ryerson, 1982.

Osbaldeston, Mark. *Unbuilt Toronto: A History of the City that Might Have Been.* Toronto: Dundurn Press, 2008.

Platt, Philip Wallace. *Dictionary of Basilian Biography: Lives of Members of the Congregation of Priests of Saint Basil from Its Origins in 1822 to 2002.* 2nd ed., revised and augmented. Toronto: University of Toronto Press, 2005.

Rattler, Tarcisius A. *Rooted in Hope. The Story of the Augustinian Province of St. Joseph in Canada.* King City, ON: self-published, 1988.

Stuart, Jacqueline. *An Aurora ABC: Stories from Aurora's Forgotten Past.* Aurora, ON: self-published, 2016.

Thompson, Austin Seaton. *Spadina: A Story of Old Toronto.* Toronto: Pagurian Press Limited, 1975.

West, Bruce. *Toronto.* Toronto: Doubleday Canada, 1967.

Articles, Magazines and Journals

Beck, Jeanne Ruth. "Henry Somerville and Social Reform: His Contribution to Canadian Catholic Social Thought." *Catholics at the Gathering Place: Historical Essays on the Archdiocese of Toronto, 1841–1991.* Toronto, ON: Canadian Catholic Historical Association, 1990.

Berry, Paul. "The Home Bank of Canada." *Bank of Canada Review* (Autumn 2009).

Burchill, Aemon, OSA. "Augustinians Forty Years at Marylake: 1943–1983." 40th Anniversary Pamphlet created for/by Marylake Monastery.

Dexter, Grant. "Spent on Unemployment." *Maclean's* (August 1932): 21, 37–28.

Echlin, Erland L. "The Dutch Did It Here." *Maclean's* (February 1937): 21, 28.

Editorial. "Unemployment: A Permanent Problem." *Maclean's* (May 1936).

Knowles, R.E., Jr. "Good-by Relief." *Maclean's* (October 1936): 26, 27.

McGoey, Reverend Francis. "Back to the Land: Turning an Ancient Slogan into a Remarkable Reality." Circa 1938. Pamphlet located at the Marylake Archives.

Oliver, Father Michael, CSB. "Flee to the Country." *The Basilian* 1, no. 1 (March 1935): 7, 8, 14.

———. *Marylake Farm School, King, Ontario: An Outline of Its Work and Objectives.* Toronto: St. Michael's College, 1939. Brochure located at the Marylake Archives (created by St. Michael's College).

"The Relief Problem." *Maclean's* (May 1937): 63, 64.

Rutledge, J.L. "Pellatt the Plunger: A Few Stories about a Spectacular Figure in Finance." *Maclean's* (March 1920).

Sacred Heart Parish. "Sacred Heart Church—50th Anniversary." 2011 Pamphlet created for/by Sacred Heart Church.

Shook, Very Reverend L.K. "Marian Pilgrimages of the Archdiocese of Toronto." *Canadian Catholic Historical Association Report* (1954): 53–65.

Turlcy-Ewart, John. "The Bank that Went Bust." *The Beaver* (August–September 2004).

Yaeger, Francis. "More Back to the Land." *The Basilian* 3 (April 1937): 79, 80.

Other Sources

Archives of Ontario
Archives of the Roman Catholic Archdiocese of Toronto
Canadian Catholic Historical Association
Casa Loma Archives
The Catholic Canadian Register
City of Toronto Archives
General Archives of the Basilian Fathers
King Township Archives
King Township Heritage Advisory Committee
King Township Historical Society
King Township Museum & Cultural Centre
King Township Public Library
Marylake Archives
Metro Toronto Reference Library
Newmarket Era Newspaper Archives
Oak Ridges Trail Association Trail Talk Archived Issues

Queen's Own Rifles of Canada Archives
The Royal Architects Institute of Canada Journal
St. Michael's College Archives
Toronto Daily News Archives
York Region Branch Ontario Genealogical Society

Websites

Hill, Robert G. "Biographical Dictionary of Architects in Canada 1800–1950." www.dictionaryofarchitectsincanada.org.

University of Toronto/Université Laval (2003–2017). *Dictionary of Canadian Biography*. http://www.biographi.ca/en/index.php.

INDEX

ABOUT THE AUTHOR

\mathcal{K}elly Mathews was born in Cobourg, Ontario, but grew up in Chilliwack, British Columbia, and then Thornhill, Ontario. Kelly credits a library book sale and the purchase of a twenty-five-cent book called *Legacy* by Susan Kay—a historical fiction book about the life of Queen Elizabeth I, which she first read at age twelve—for inciting a lifelong love of British and Commonwealth history. Kelly is related to the famous Canadian author and environmentalist Farley Mowat through her paternal grandmother as well as to Sir Oliver Mowat, one of the Fathers of Canadian Confederation.

Kelly admits that she is not a trained researcher, writer or historian but feels compelled to learn and write about interesting local land histories. *Eaton Hall: Pride of King Township* was her first book, and almost from day one of writing about Eaton Hall, Kelly knew that the history of Marylake would be next.

Kelly holds a bachelor of arts degree from York University as well as a certificate in sport administration. Kelly is currently a manager at Seneca College and is responsible for the operation of the Seneca College Outdoor Education Centre, summer camps and community recreation programs.

Kelly is a board member for the King Township Historical Society and the Ontario Camps Association. She is also a member of the Aurora Historical Society and the Town of Aurora Canada150 Ad Hoc Committee. Kelly serves on the King Township Heritage Advisory Committee, is a honourary life member of the Oak Ridges Trail Association and is a founding member of the King Women of Influence Giving Circle for Seneca College.

When she is not working or writing, Kelly enjoys running, hiking and snow-shoeing through the beautiful trails in her community and at Marylake. Kelly loves the outdoors, is a voracious reader of anything nonfiction and often has several books on the go. Kelly's guilty pleasures are Coronation Street and period dramas. She loves all four Canadian seasons—the fall being her favourite—extreme weather, good jokes and her favourite smells, coffee and campfire. A perfect day for Kelly would include a rain or snowstorm, a book, a fire and a cuppa tea.

You can follow Kelly on Twitter and Instagram via @allthingsregal.